The Animal Art of Bob Kuhn

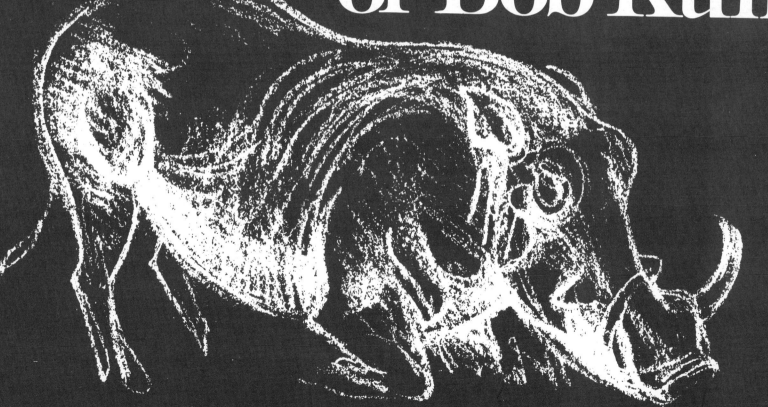

The Animal Art

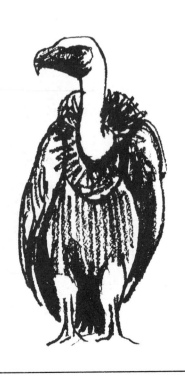

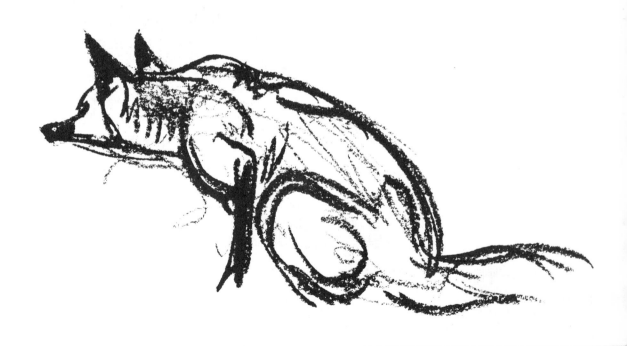

of Bob Kuhn

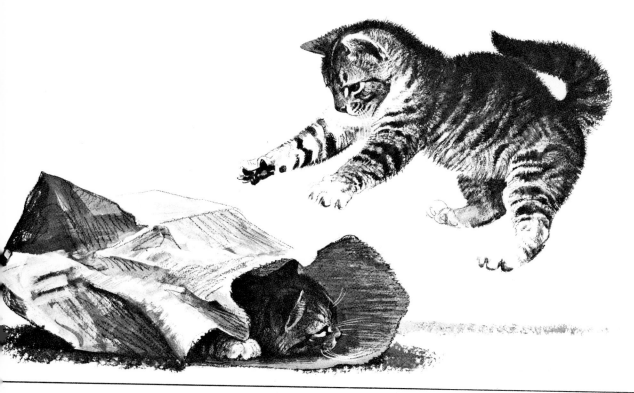

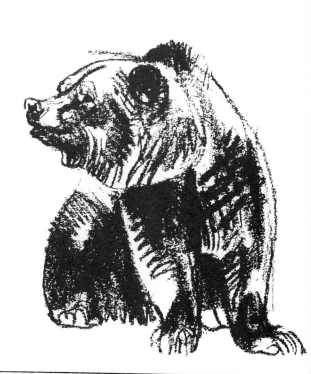

North Light Publishers Fairfield, Connecticut 06430

Published by North Light, an imprint of Writer's
Digest Books, 9933 Alliance Road, Cincinnati,
Ohio 45242.

Manufactured in U.S.A.

First Printing 1973.
Revised for soft cover printing 1982.
Library of Congress Catalog Card Number 82-19048
ISBN 0-89134-050-5

Designed and edited by Howard Munce
Composed in Caslon by John W. Shields, Inc.
Color printed by Connecticut Printers, Inc.
Printed and bound by Halliday Lithograph
Corporation

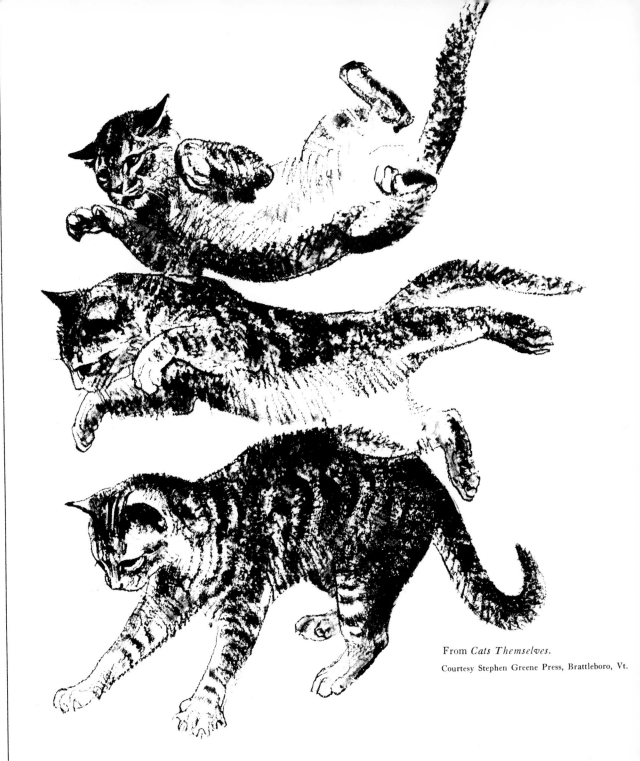

From *Cats Themselves.*
Courtesy Stephen Greene Press, Brattleboro, Vt.

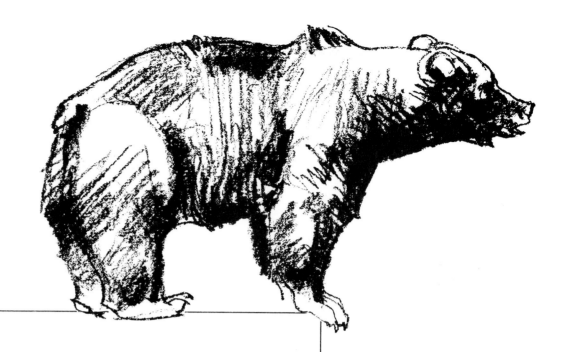

ACKNOWLEDGMENTS

Many patient friends and colleagues have helped me put this book together. Bill Fletcher, Publisher, by his refusal to let me off the hook; Howard Munce, Editor, by pulling and cajoling until he got what he wanted; Walt Reed, by his quiet, reassuring presence, Barry Roberts, teacher and writer, for asking probing questions; Paul Bransom, for giving me help and good advice when I was young and truly needed them; Tony Dyer, for first showing me wild Africa; Myles Turner, for revealing more of it to me; George Schaller for opening his file of magnificent game photographs to me. There are others but these come first to my mind and were I to go on, would still head the list.

This book is dedicated to my wife, Libby, who has cheerfully put up with my monomania for over thirty years and to my late father, whose support was lifelong and total.

CONTENTS

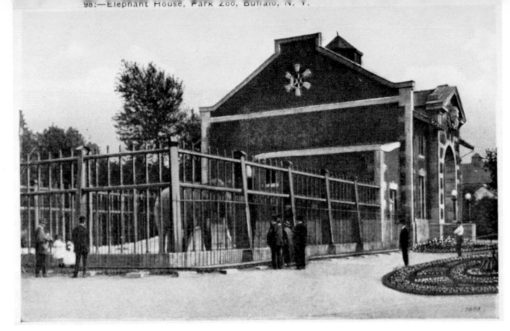

Introduction

If someone asked me how I ever got so totally involved with my lifelong specialty—the depiction of animals, I couldn't come up with a very satisfactory answer. As a very small child, I lived near the sorry little zoo in Buffalo, N.Y. My father and grandfather took me there often. The handful of moth-eaten refugees caused me to flip on sight. What strange assortment of genes arose from the pool provided by my parents to cause this affinity, I can only guess. The preoccupation was there when I made my first scribbles and it is still there.

This singleminded (some might say Simple Minded) involvement with one subject is motivated, at least in part, by a healthy urge for self-preservation. There are many very talented artists, now as always, who are virtually immobilized by their inability to find a new subject or a new art language on which to expend their creative energy. The specialty which I have embraced is so complex, requires such everlasting study and has lagged so far behind the general evolution of painting, from realism to impressionism to abstractionism to nihilism, that one can ply this trade in any existing mode of painting and produce things which are fresh and still exciting.

It is not my intention to make this book a short course in animal painting. Certain specifics will inevitably creep into it but my objective is much more general. It is to give the reader some idea of how one practitioner approaches the problems of his craft. My methods are neither ideal nor are they totally applicable. My procedure is largely intuitive, rather than systematic, and therefore does not lend itself to explanation. I hope the pages of sketches and landscape studies will re-enforce the basic premise of the book—it speaks to those who wish to express a deep feeling for animal life in some form of art language. It has little to say to the artist or craftsman who doesn't much care if he's rendering the exterior of an elephant or an engine. The audience for this book very much *cares*. Perhaps the paintings reproduced on these pages, the drawings or an observation or two will help to translate that concern or love, if you prefer, into a better and therefore more gratifying, performance with brush and paint.

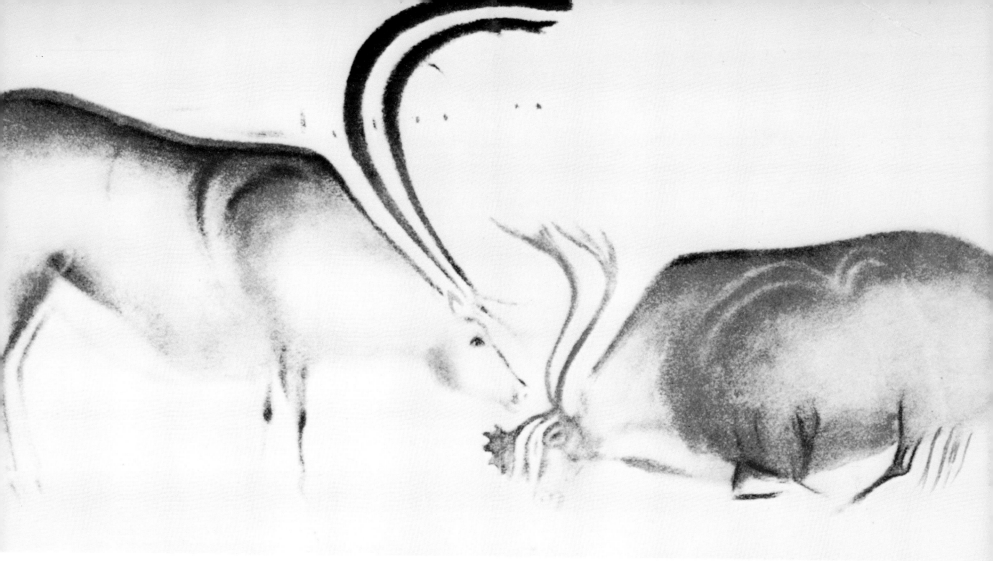

Courtesy of the American Museum of Natural History.

The cave paintings of early man succeed in doing what later efforts have largely lost. They capture an essence. Two factors undoubtedly made these first known attempts of man to recreate his world so true. One was his essential innocence. Little had been done before to tempt him into emulation. But, more important, his implements were too crude to permit the sort of exactitude that always tempts the modern painter. Having undergone the evolution from simple, flat symbols of the animals around them to the total realism of today, animal painters are now confronted with the challenge of somehow moving away from the unquestioning recording of the visual to a more inventive statement, perhaps a reverse evolution back to the simplicity of the cave.

9

Several years ago I had the problem of filling a catalogue page, opposite one containing a list of paintings for sale, with some observations on my particular approach to painting animals. What I said then still applies.

Animal painting is a special calling. If one is addicted to it, he is likely to die with the addiction. In any generation, a handful of those involved in putting brush to board devote themselves to this specialty. The animal painter of today is both helped and challenged by the advent of photography. Helped because he has access to a vast library of movies and stills depicting wildlife in a limitless variety of attitudes and circumstances. Challenged because he must go beyond the purely visual image so amply covered by the photographer to interpret his subject matter in new and more personal ways. Yet he cannot make his interpretation so private that only he is moved by it. It is in the blending of a clear eye, a solid foundation of knowledge and a discernible love for his subjects that the animal painter can still make a valid comment on the creatures which roam the earth during this twilight of the age of mammals.

In the group of paintings on display at this meeting of Game Conservation International, one may see a glimmer here and there of a more adventurous approach to picture making than simple realism might warrant. It is my intention to continue to push out in new directions, bearing in mind that to do so is to court occasional failure. We who paint animals have an obligation to bring the craft into the twentieth century. I think we can do it without affronting those who feel that, even in a painting, a lion should be readily identifiable as the king of beasts.

If you have a special interest in painting wildlife, or perhaps I should say animals, this book may supplement your information. Better still, it may induce you to push ahead with your own quest for greater knowledge which is the cornerstone of this special craft. To be an animal artist is to be a lifelong student. There are a number of successful people in the field at this writing whose principle contribution to the world of art is a dazzling ability to re-create animals or birds hair for hair or feather for feather. Audubon to the contrary, there is more to the thing than that. To function as an artist you must know your subject, understand its structure, its temperament and behavior pattern. You must have some familiarity with its habitat. You are an artist to the degree that you arrange, edit, and occasionally even bend the facts to the end that the viewer of your work is excited, and surprised, not simply impressed with your skills.

You do not have to go very far to find suitable subjects. The cat lounging on your sofa, the horse down the road, yours or your neighbor's dog; all are proper subjects and all will give knowledge which can later be broadened by trips to the nearest zoo or museum. My old friend and counselor, Paul Bransom, was the man who first urged me to go to the zoo, and to draw and draw and draw. Even the best reference sources do not

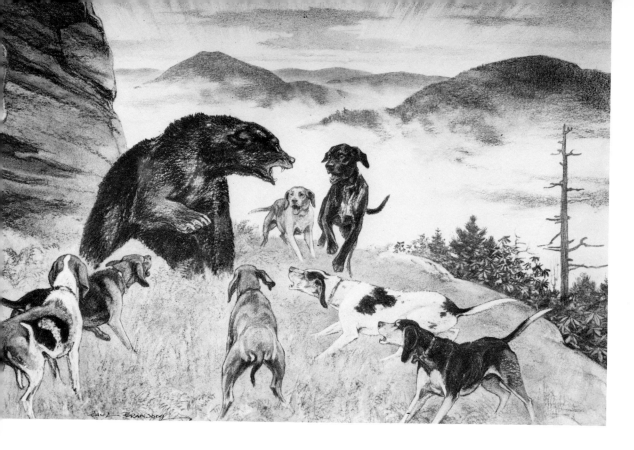

Of all the wildlife artists discussed here, none so profoundly affected me as did Paul Bransom. To a degree, this may have been due to the fact that he was the most active professional during my childhood. More importantly, I was captivated by his confident, sure touch with animals done simply and with knowledge. His pictures were typically bathed in a soft, flat light, reminiscent of a Japanese print. Value, not color, was his primary concern.

When I finally worked up the courage to write him, I was unprepared for his response. It was one of interest and encouragement. I eventually met him and visited him and his wife a number of times during my art school days in New York. He was always generous with his praise, but he could be very tough when he thought I was off target.

He was a loyal and thoughtful friend and I consider myself lucky to have known him.

take the place of real knowledge of animal structure. That can only be gained by putting in your time with the animals.

This book may provide some quick answers to painters who have the need to include an occasional animal in a painting. It may suggest some means by which one may improve his performance in this field. But the real teachers are the animals themselves. They will not provide you with aesthetic judgment that you are blest with or you are not. But unless and until you have the confidence to manipulate your subject matter, the aesthetics are going to be given short shrift.

Perhaps a word or two is in order in the place of animal painting in the history of art. It has been, by and large, a neglected corner of the broad field of painting. This, in spite of the fact that the very earliest of man's graphic efforts, still preserved on the walls of caves in Europe and Africa. Rubens painted great opulent canvases of hunting scenes replete with horses, hounds, tortured wild beasts and the lot. Many of the Dutch painters portrayed them though mostly dead, in still life formats or in bucolic settings. There were a number of painters, principally from countries with a sporting tradition, who specialized in painting horses, these usually done in stylized attitudes of motion which bear little resemblance to the true dynamics of animal action. Delacroix created a race of wild beasts all his own usually in deadly embrace with some beleaguered Moor or distressed maiden. France also produced Rosa Bonheur and England Sir Edward Landseer, both of whom turned their attention almost exclusively to animals. But to me, and

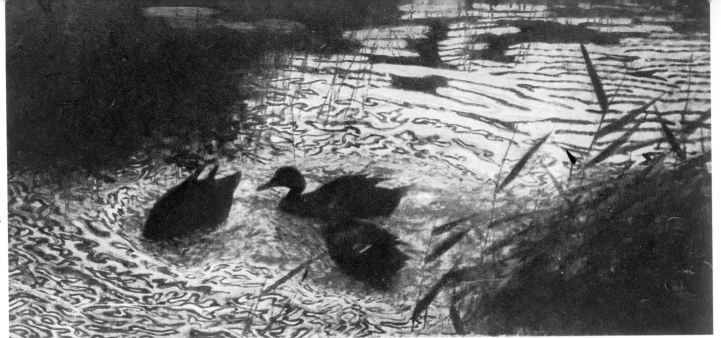

Although time seems to have passed him by, Bruno Liljefors reigned during his lifetime as the preeminent wildlife painter of Scandinavia. One has to look behind the façades of museums now to see and thrill at his mastery of the moods of the sea and the forest. His animals and birds were almost always treated as focal points in larger settings. All were done with knowledge and the sureness of an artist in control of his subject.

to many of my colleagues, the greatest of all lived well into this century and plied his trade in the forests and shores of Scandinavia. His name is Bruno Liljefors.

Something should be said about a succession of Germans who painted the larger animals in a realistic and, for their time, sound and knowledgeable way. Among them were Specht, Friese, Kuhnert and a man who, though trained in the European tradition, emigrated to America and became the greatest portrayer of our large game animals, Carl Rungius. All these men were lifelong students of animals and, though out of fashion now, were honored in their time. With the possible exception of Specht, about whom I know too little to venture an opinion, their work is still highly valued among aficionados.

The first section of the book will open my sketch books to you. What you will see is the top of the iceberg. Sketches first of all give you knowledge. They plant many of the endless changes in animal form and gesture in that handiest of computers — your head. Every filled sketch book makes you a better judge of *all* source material. Contrary to the old saw, photographs *do* lie; they distort, they frequently preserve the awkward moment, they obscure areas you need to see into, and therefore you must go further. Knowledge enables you to probe the shadows, part the veil of grass or other intervening element and put down with assurance what you cannot actually see.

Your choice of subject depends on opportunity. If you know your pussy cat you are not without knowledge in drawing a tiger. Your family pooch need only be himself to give you insights into portraying the wolf, the fox or any other dog-like creature. Nowhere is the marvelous engineering of animal movement more elegantly apparent than in the horse. So you draw or paint the things that excite you — and are available.

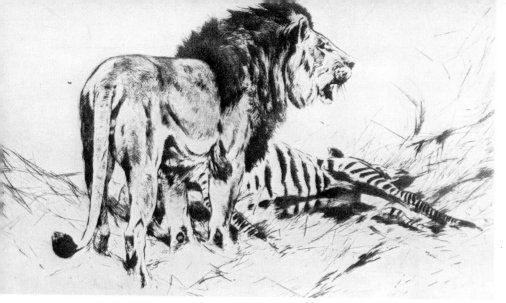

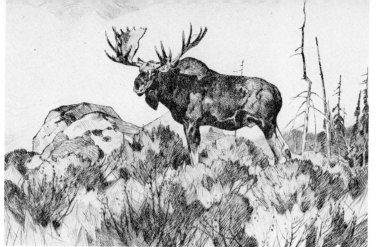

Wilhelm Kuhnert went to Africa as a young man and applied his careful training as one of a succession of German animal painters, to record the great game animals of East Africa. He was lionized (pun clearly intended) not only by his own countrymen, but by the English as well. While he painted anything that came his way, he is best remembered for the many studies, etchings and large canvases he produced portraying the lion.

Carl Rungius spent his entire long career painting North American big game. He was *the* interpreter of this varied and impressive catalog of large animals. He did them all with skill, gathering his material on extensive field trips during which he would shoot specimens and make careful studies, in both pencil and paint, of the dead animals. His ability to capture the wonderful color changes of sun light on the coats of prime wild animals was gained by this diligent research, no longer possible.

To draw animals from life is to court frustration. Unless they are asleep they seldom cooperate. Most pages in my sketch books are filled with bits and pieces, starts that were interrupted by the subject's refusal to hold still. Frequently, the quick indication of a gesture is all you can manage, and all you should attempt. You might decide to make a careful study of an animal's head, an arrangement of limbs, a paw or some other segment of the whole animal. It matters not. Nor does it matter too much if you mislay a sketch book or two. The real gain is in your growing knowledge of your subject.

If you are serious about your work with animals, you will never stop going to the source. In spite of a mountain of reference material and thousands of my own drawings, I frequently make a trip to the zoo or museum to check a detail I can't paint with authority. This, because something about the critter being painted looks

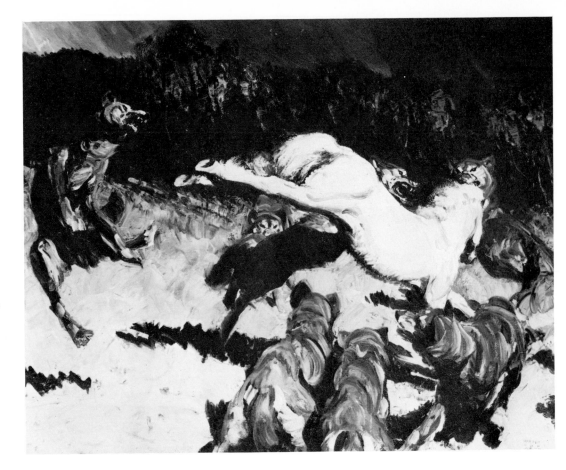

Harold Von Schmidt was a guest lecturer when I was a student at Pratt Institute. He was a very busy illustrator but he loved to talk about his trade. What I remember best of those talks was his enthusiasm. He was a fine illustrator because he was an actor and canvas was his stage. He loved to dwell on the long, intense rivalry of the red man and the white man and was proud of his ability to paint the horse. His relaxed, confident way with all animals was just another string in his bow.

wrong. The warning bell rings because long hours with the sketch book have given me a frame of reference. Even when the solution is elusive, the awareness of the problem is automatic or almost so.

It follows that the more you draw from life, the more independent you are from outside reference sources. This is not to suggest that it is unethical to work from such sources. Nonetheless, dependence on good readable source material limits what you can attempt. If you want to move animals around in your paintings, to re-create them in moments of stress (for example in prey-predator situations) then you ought to be able to construct them without resort to specific photographs of the particular gesture needed. It's a tricky business. I've had my share of unsuccessful improvisations and I'm sure most of my colleagues have. When you bring it off, though, it's worth the battle.

You will find no detailed illustrations of animal anatomy in this volume. Not because I regard such material

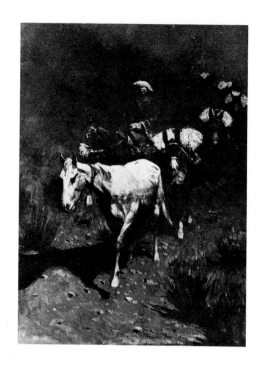

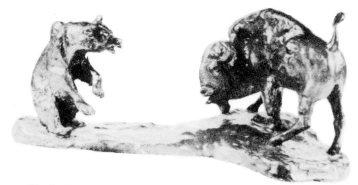

Frederic Remington got better as he grew older. There is a huge amount of his early stuff that I really don't like. After he shed the hardness of his years as an illustrator, he began to turn out paintings of sensitivity and quality. I particularly like the way he handled moonlight. The riderless mount and patient retinue demonstrate his expert treatment of subdued light as well as his sureness with the horse.

Charles Russell was first of all a great chronicler of the West. He handled the animals in his paintings with the same naturalness that he did the people. What he did with horses, how he bent and twisted them to suit his needs, has been a source of wonder and frustration to the painters of the West who have attempted to plow the same furrow. Without meaning to minimize his skill with paint, my own preference is for his bronzes of all manner of wild creatures. They are simple, unlabored and right on the mark.

as unimportant but because there is an excellent source book available. It is *An Atlas of Animal Anatomy* by Ellenberger, Publisher, Dover Press. I first discovered it in the library of Pratt Institute during my student days. It has since been reissued in a good, manageable size and belongs on the bookshelf of anyone seriously involved with portraying animals. It is *the* definitive animal anatomy book and, short of a lengthy apprenticeship with a taxidermist, doing the under-the-skin digging yourself, it is the best means of learning the secrets concealed by fur and feathers.

So now it's up to you. Further along I intend to make some observations about picture making. But the acquisition of knowledge is the first order of business and that is a frequently frustrating, occasionally exhilarating quest. You will have to pursue it with lonely dedication, in crowded zoos, museums and wherever else you find your subjects.

The Sketch

The sketches in the pages to follow are broken down into several categories. They only roughly approximate actual zoological classes of animals, but serve to give some sort of order to the drawings. Cats, though one of several predators, are given a section of their own because they make up a numerous and impressive segment of the carnivorous animals and comprise a quite large proportion of my subject matter. The general behavior of cats is quite uniform.

Whether one is observing a house cat or a leopard, they are supple, loose jointed, very quick, though not necessarily swift (with notable exception of the cheetah) very strong, but lacking in stamina. They are a painter's dream, both because of their elegant appearance and the great range of their expressions and attitudes (gestures).

CATS

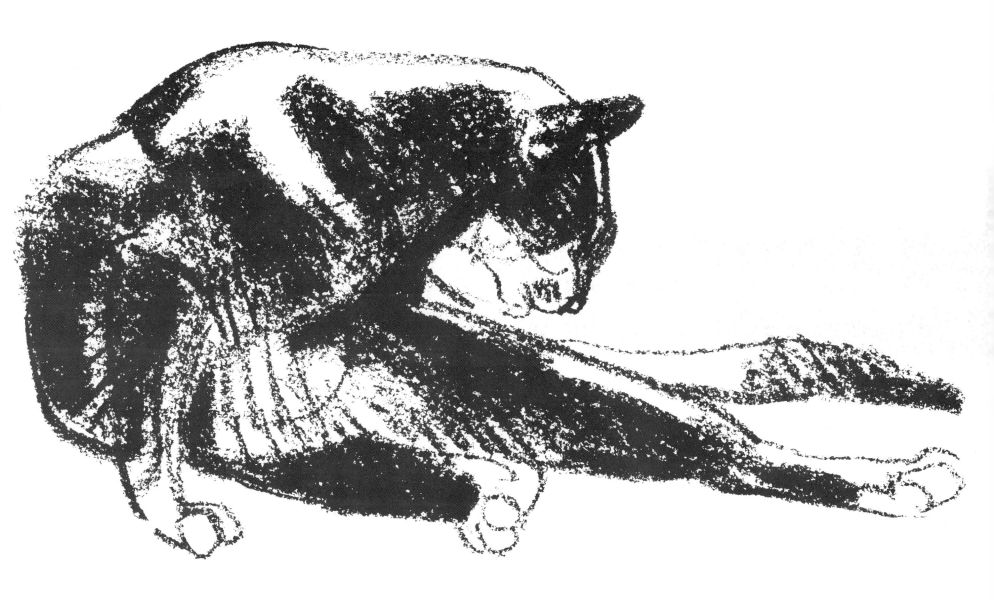

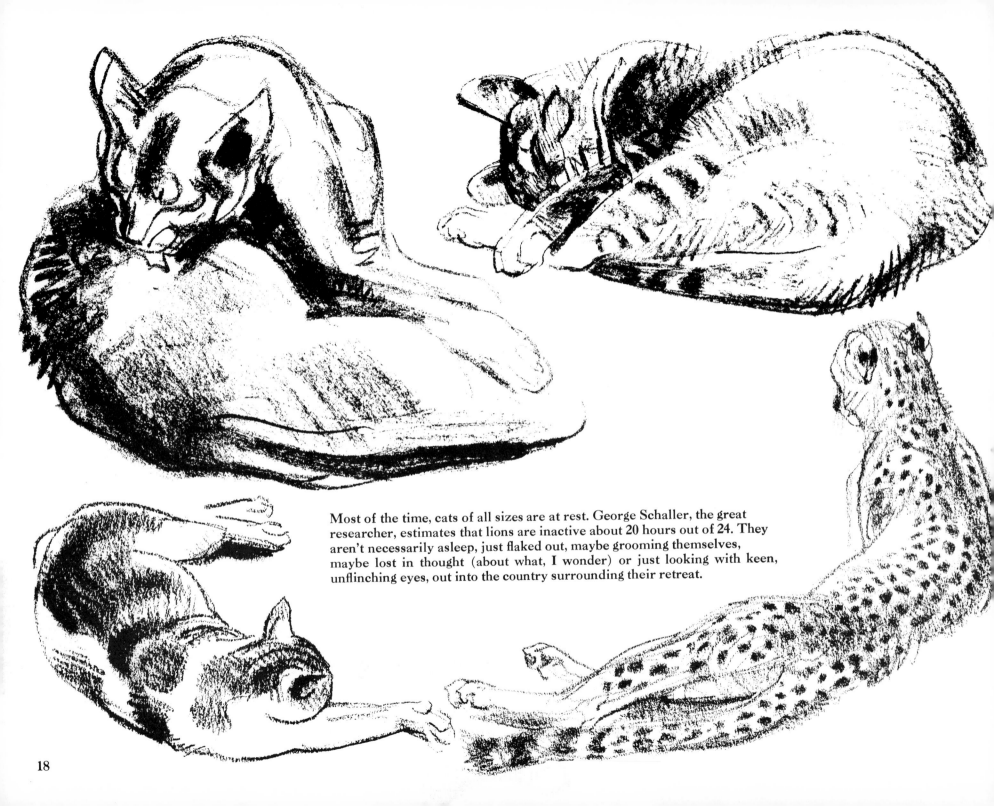

Most of the time, cats of all sizes are at rest. George Schaller, the great researcher, estimates that lions are inactive about 20 hours out of 24. They aren't necessarily asleep, just flaked out, maybe grooming themselves, maybe lost in thought (about what, I wonder) or just looking with keen, unflinching eyes, out into the country surrounding their retreat.

Tigers share with their African cousins, lions, the top of the feline pecking order. Though I know much more about lions, I must concede that, in terms of elegance, felis tigris is number one.

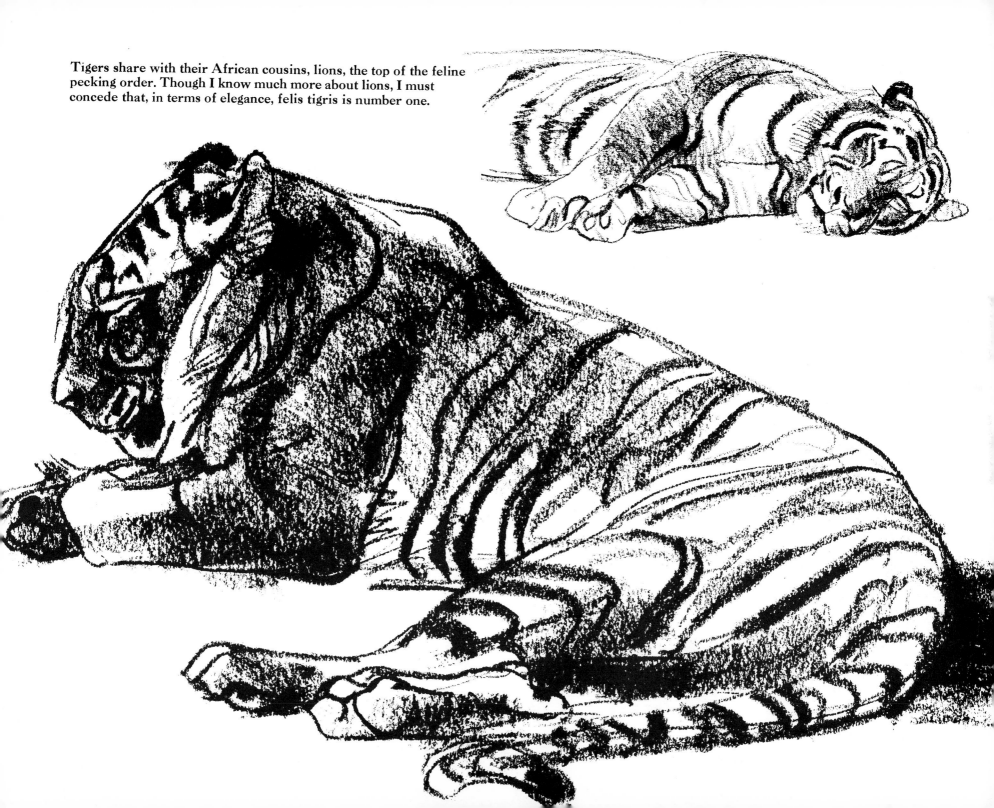

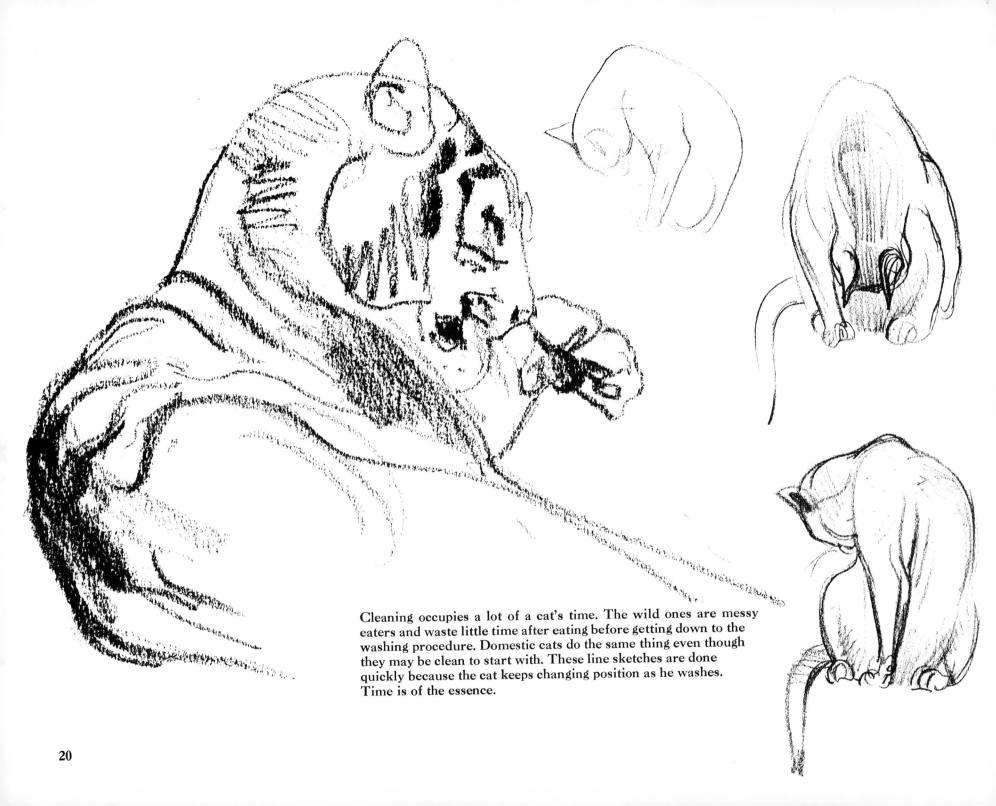

Cleaning occupies a lot of a cat's time. The wild ones are messy eaters and waste little time after eating before getting down to the washing procedure. Domestic cats do the same thing even though they may be clean to start with. These line sketches are done quickly because the cat keeps changing position as he washes. Time is of the essence.

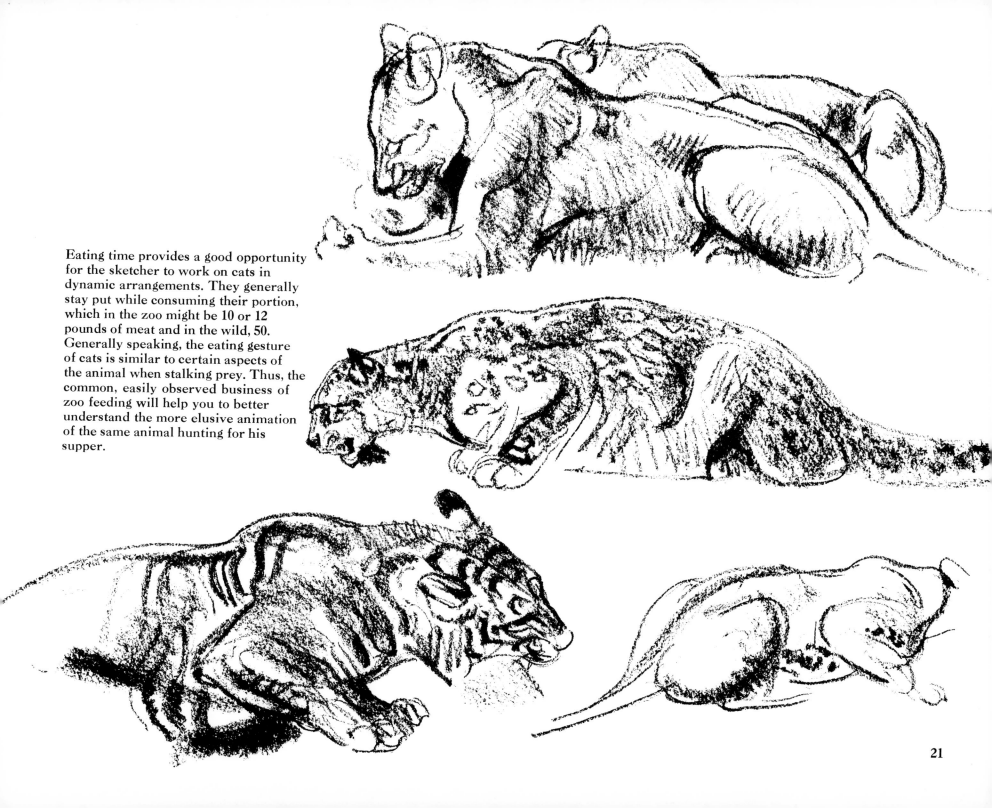

Eating time provides a good opportunity for the sketcher to work on cats in dynamic arrangements. They generally stay put while consuming their portion, which in the zoo might be 10 or 12 pounds of meat and in the wild, 50. Generally speaking, the eating gesture of cats is similar to certain aspects of the animal when stalking prey. Thus, the common, easily observed business of zoo feeding will help you to better understand the more elusive animation of the same animal hunting for his supper.

21

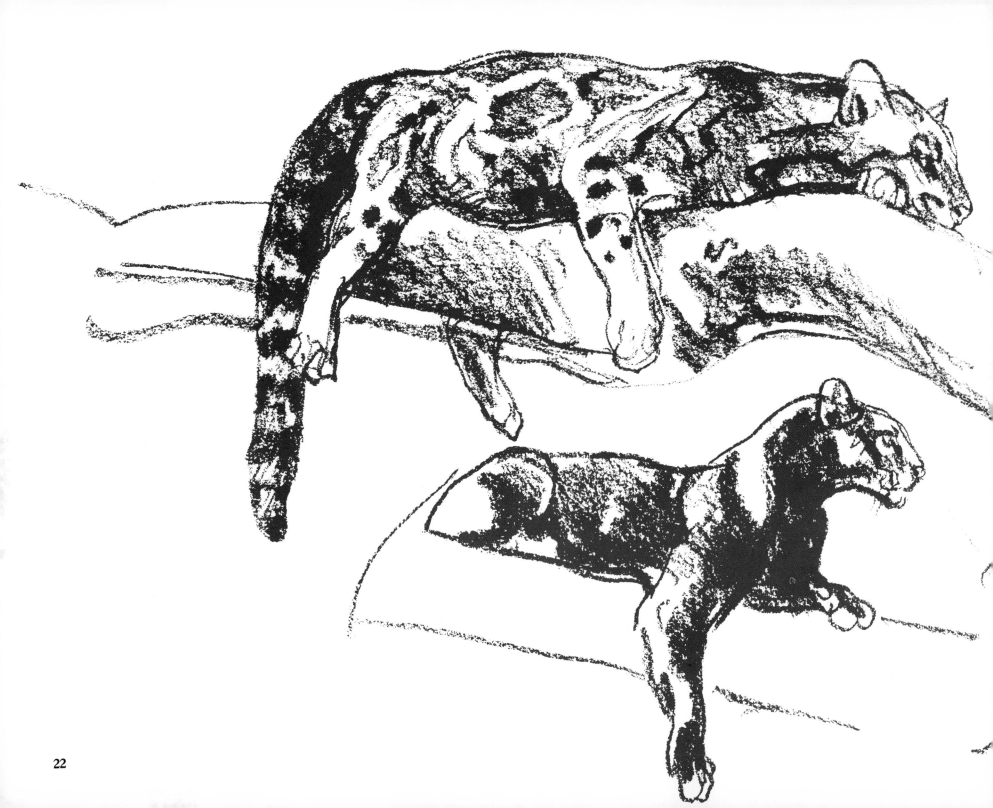

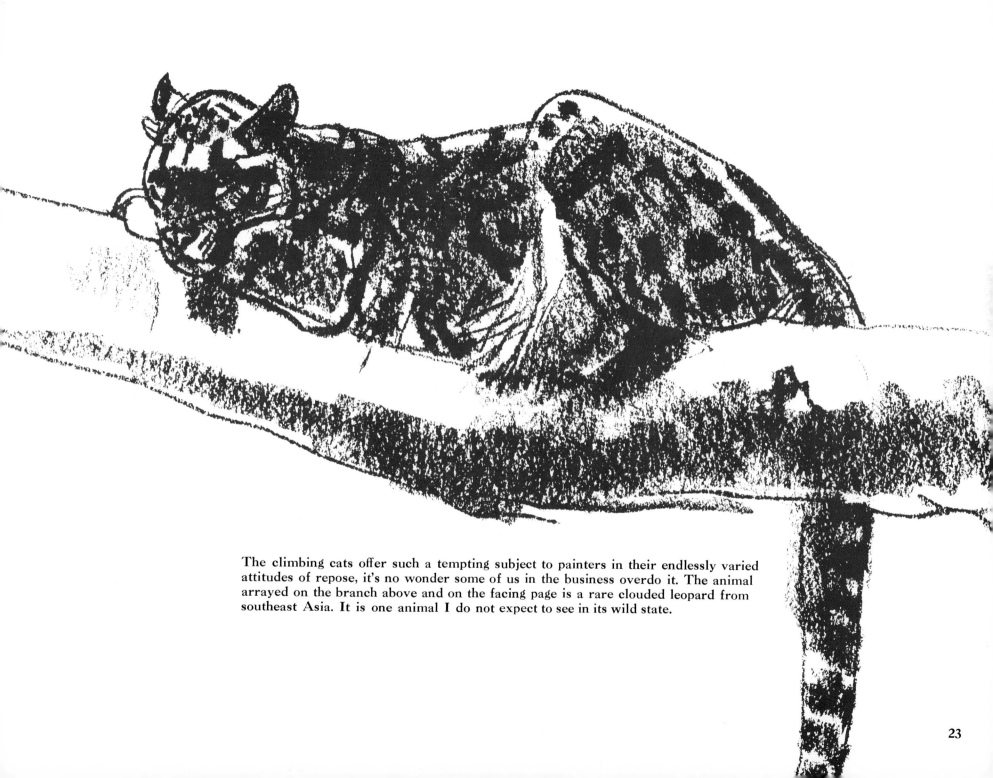

The climbing cats offer such a tempting subject to painters in their endlessly varied attitudes of repose, it's no wonder some of us in the business overdo it. The animal arrayed on the branch above and on the facing page is a rare clouded leopard from southeast Asia. It is one animal I do not expect to see in its wild state.

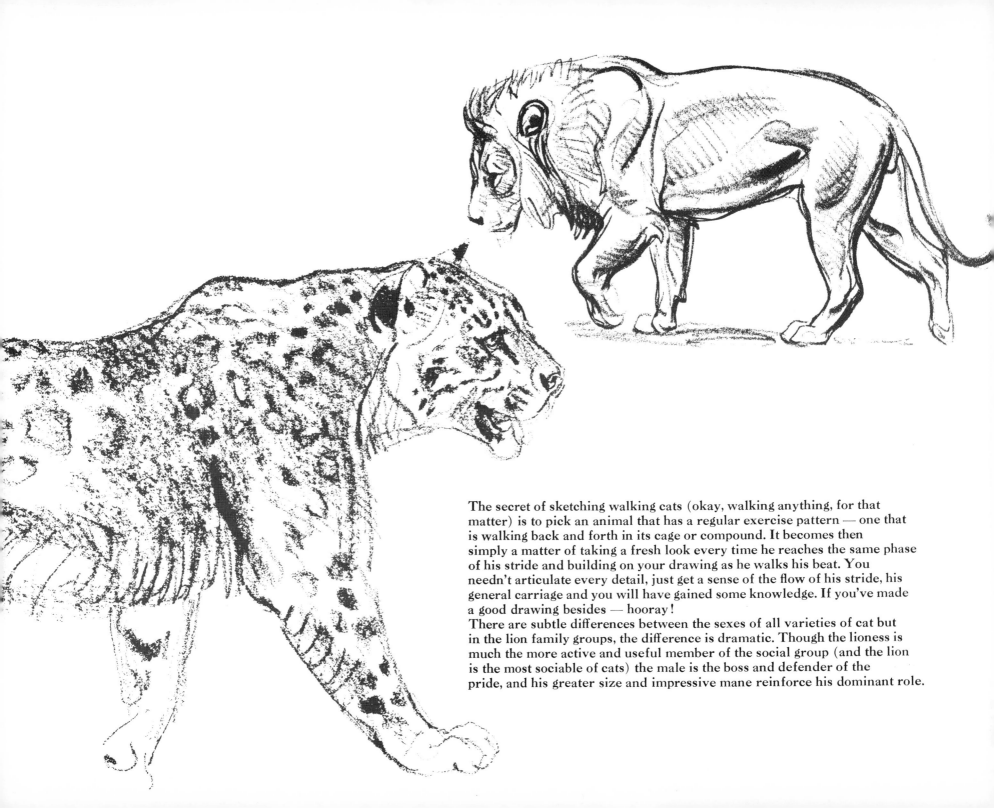

The secret of sketching walking cats (okay, walking anything, for that matter) is to pick an animal that has a regular exercise pattern — one that is walking back and forth in its cage or compound. It becomes then simply a matter of taking a fresh look every time he reaches the same phase of his stride and building on your drawing as he walks his beat. You needn't articulate every detail, just get a sense of the flow of his stride, his general carriage and you will have gained some knowledge. If you've made a good drawing besides — hooray!

There are subtle differences between the sexes of all varieties of cat but in the lion family groups, the difference is dramatic. Though the lioness is much the more active and useful member of the social group (and the lion is the most sociable of cats) the male is the boss and defender of the pride, and his greater size and impressive mane reinforce his dominant role.

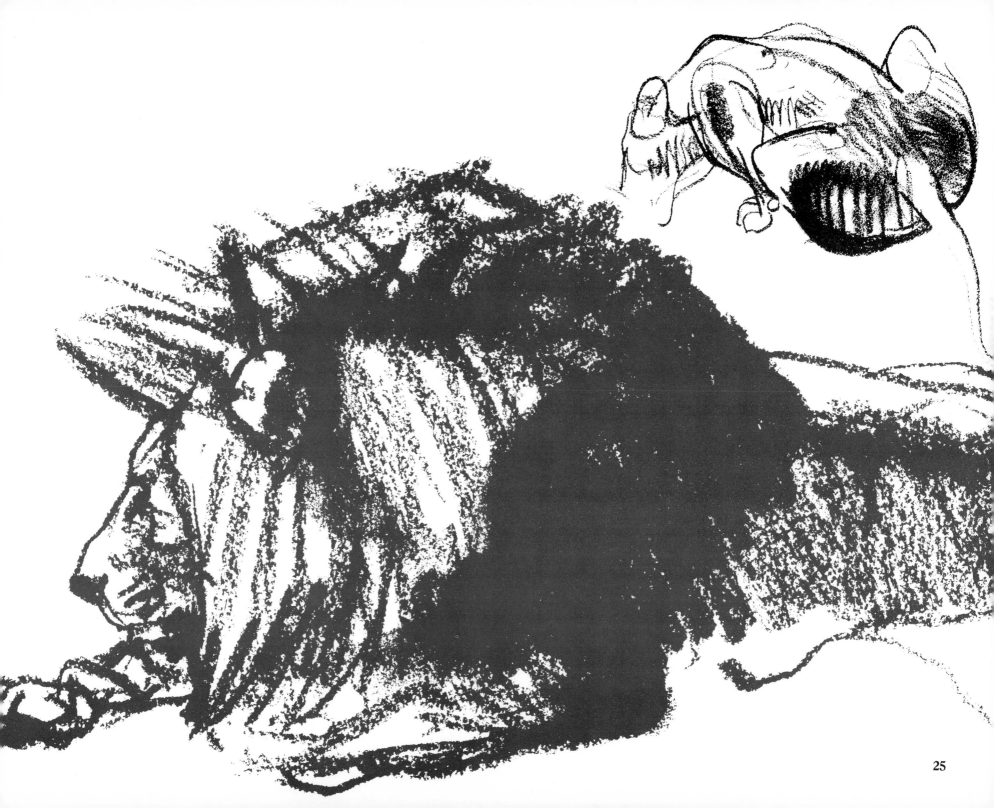

THE DOG (and his cousins)

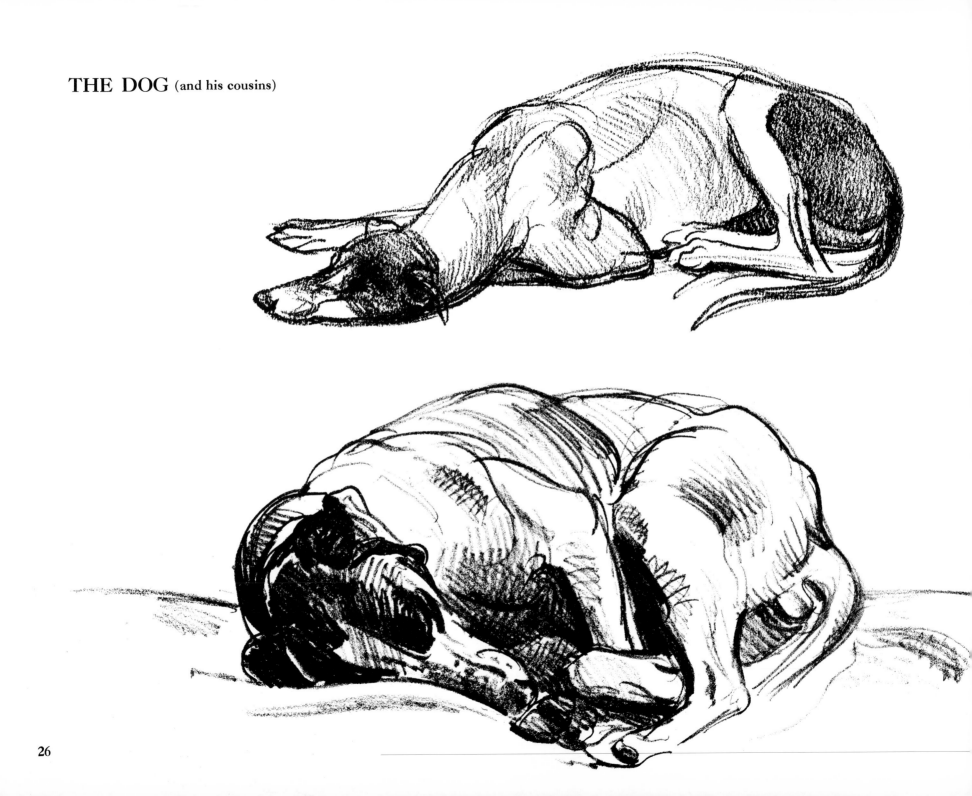

The dog has been much modified by man.
Through his intervention, the dog now comes
in a myriad of sizes, shapes and temperaments.
So demanding are the breed requirements,
(those established by breeders and judges
to distinguish one from another) that one
really needs to be a dog specialist to paint them
with professional competence. Even one such
as myself, who has painted a good many
dogs in a career as an animal illustrator,
though by no means a dog specialist, needs
to go to the source for general as well as
specific knowledge about their character and
structure. Dogs, as opposed to cats, are
designed for endurance. Their success as
predators in the wild state has always
depended on it. Some of man's improvements
on his original model have been capricious,
and some I consider cruel.

Greyhounds represent one of the more attractive modifications of the basic dog.
They are speedy-coursers and look the part. I much prefer to draw willowy
characters like these, than excessively shaggy ones where little of the underlying
form is visible.

27

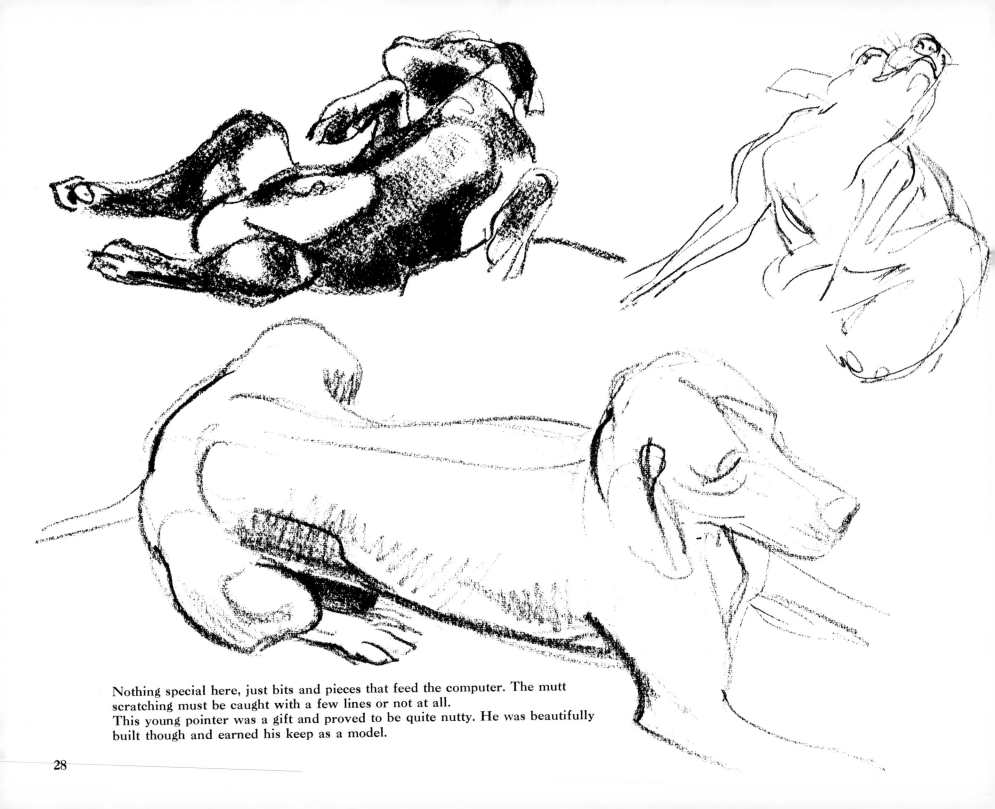

Nothing special here, just bits and pieces that feed the computer. The mutt scratching must be caught with a few lines or not at all.
This young pointer was a gift and proved to be quite nutty. He was beautifully built though and earned his keep as a model.

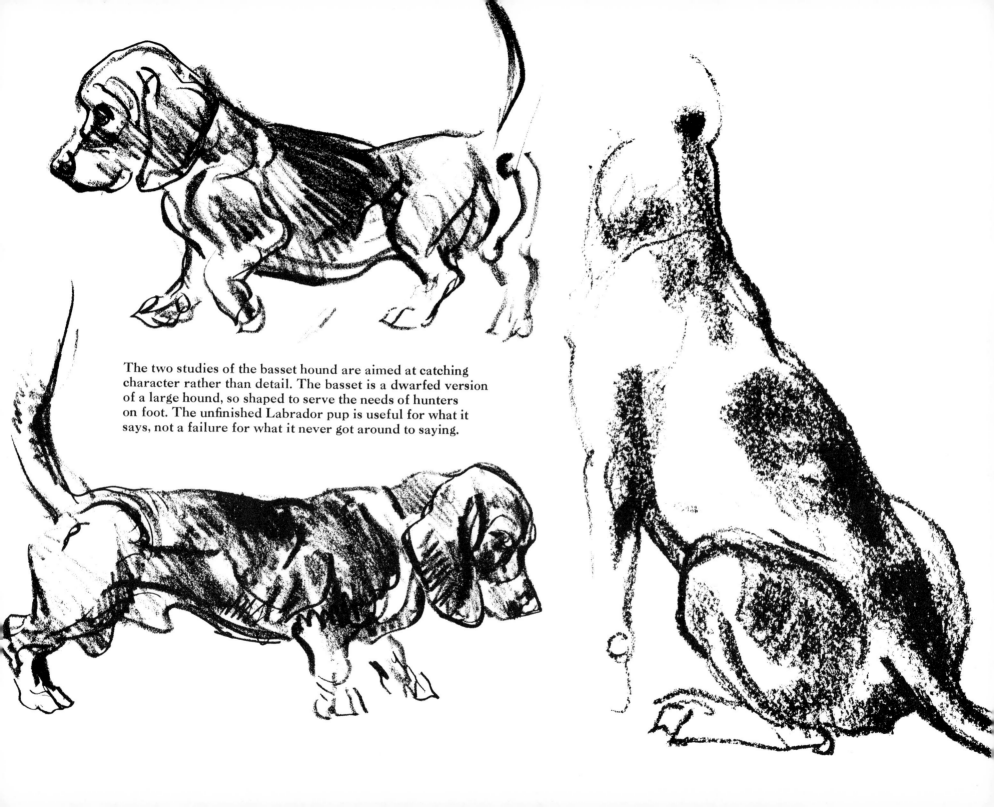

The two studies of the basset hound are aimed at catching character rather than detail. The basset is a dwarfed version of a large hound, so shaped to serve the needs of hunters on foot. The unfinished Labrador pup is useful for what it says, not a failure for what it never got around to saying.

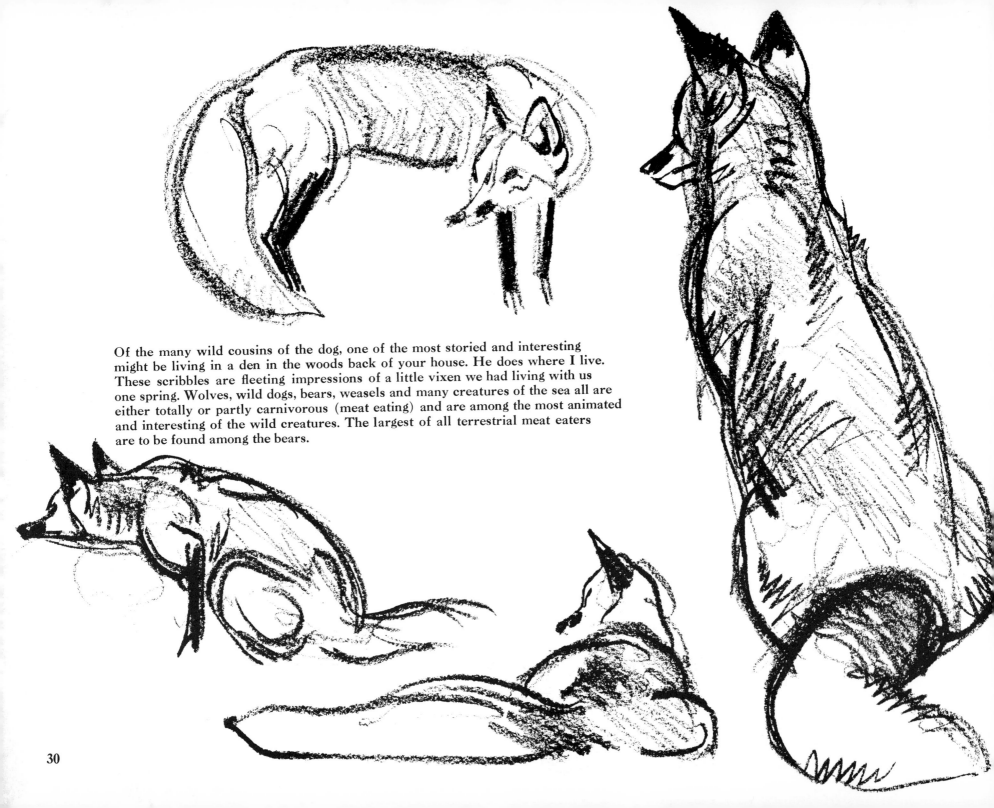

Of the many wild cousins of the dog, one of the most storied and interesting might be living in a den in the woods back of your house. He does where I live. These scribbles are fleeting impressions of a little vixen we had living with us one spring. Wolves, wild dogs, bears, weasels and many creatures of the sea all are either totally or partly carnivorous (meat eating) and are among the most animated and interesting of the wild creatures. The largest of all terrestrial meat eaters are to be found among the bears.

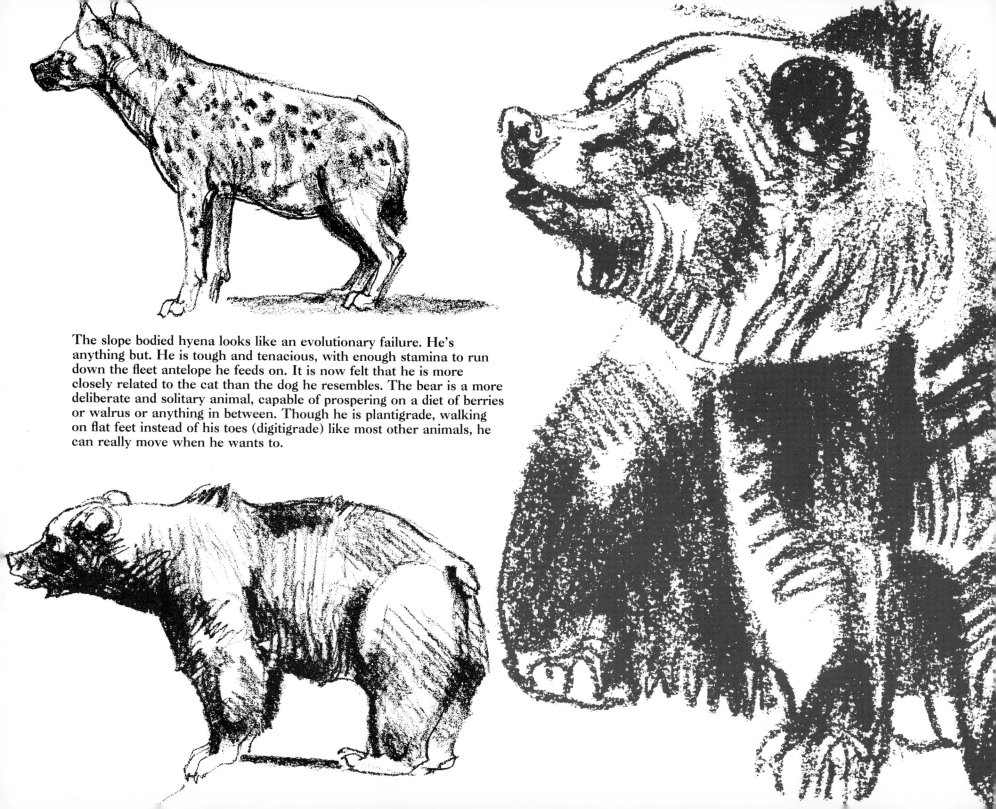

The slope bodied hyena looks like an evolutionary failure. He's anything but. He is tough and tenacious, with enough stamina to run down the fleet antelope he feeds on. It is now felt that he is more closely related to the cat than the dog he resembles. The bear is a more deliberate and solitary animal, capable of prospering on a diet of berries or walrus or anything in between. Though he is plantigrade, walking on flat feet instead of his toes (digitigrade) like most other animals, he can really move when he wants to.

The bear is such an expressive animal that
he is a joy to draw. It would be a serious
mistake to assume that his heavily furred body
is without form. The great masses of fur on
limbs, chest, buttocks have a beautiful and
characteristic shape that must be seen first,
then incorporated into your drawing. These
forms, superimposed on the sturdy frame of
the animal in such a seductive way, explain
the attraction the bear has always had for
sculptors.

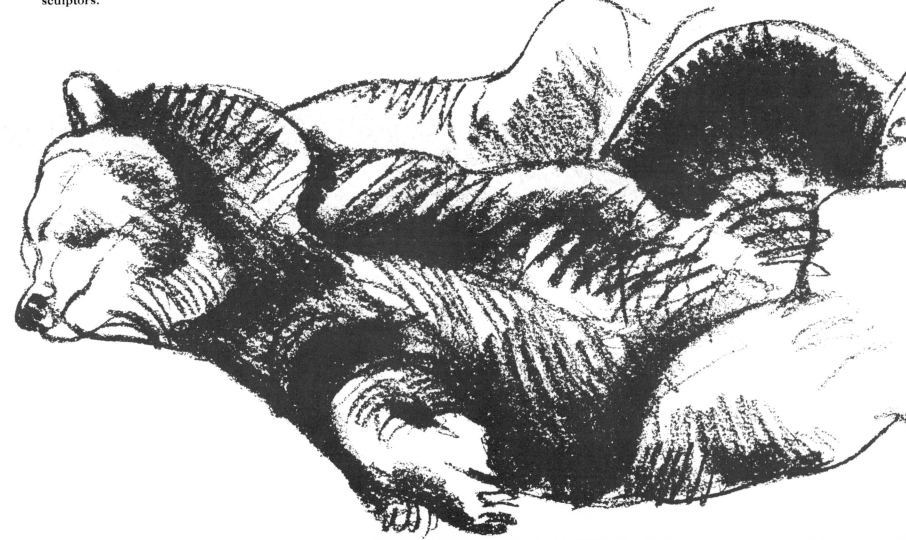

PRIMATES

Primates, a class which includes both monkeys
and the great apes, are a group of animals
that I love to sketch and almost never paint.
Possibly this is because my sketches of them
seem to work and the sketching chalk is
for me the best language. Further, the primates
are not generally included in the category
of game animals which comprise the bulk of
my subject matter. Shooting a gorilla would be
very much like doing in your Uncle Louie.
One aspect of the monkey tribe that is not
apparent in my sketches is the beautiful, rich
color patterns which abound among the many
species. Some of the loveliest color to be
found in the whole animal kingdom is theirs.
With the exception of the baboons and vervets
of East Africa, most of my experience with
apes and monkeys has been limited to the
confines of the zoo.

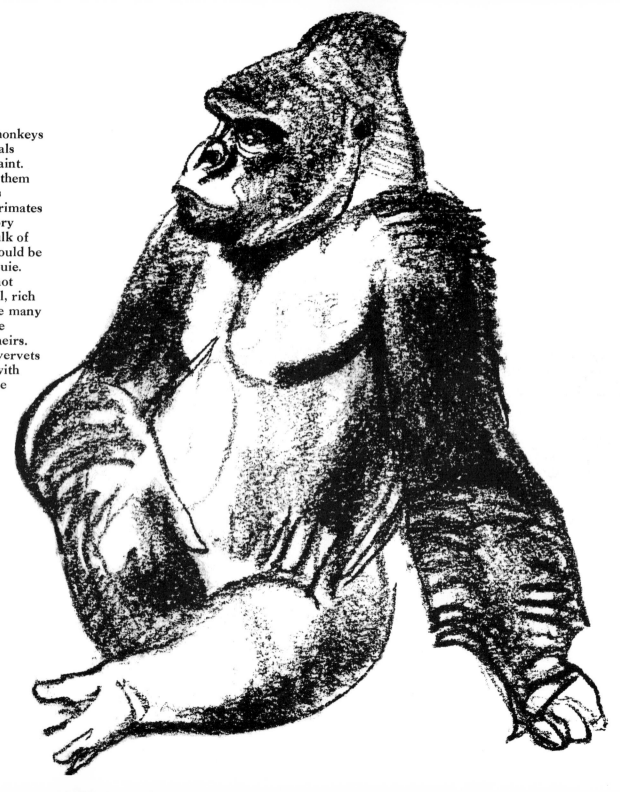

These gorilla drawings demonstrate the great fur masses so much a part of their form. The one on the left is a good example of a drawing that was finished at the very best moment. Nothing more is needed, less would put it in the fragment category.

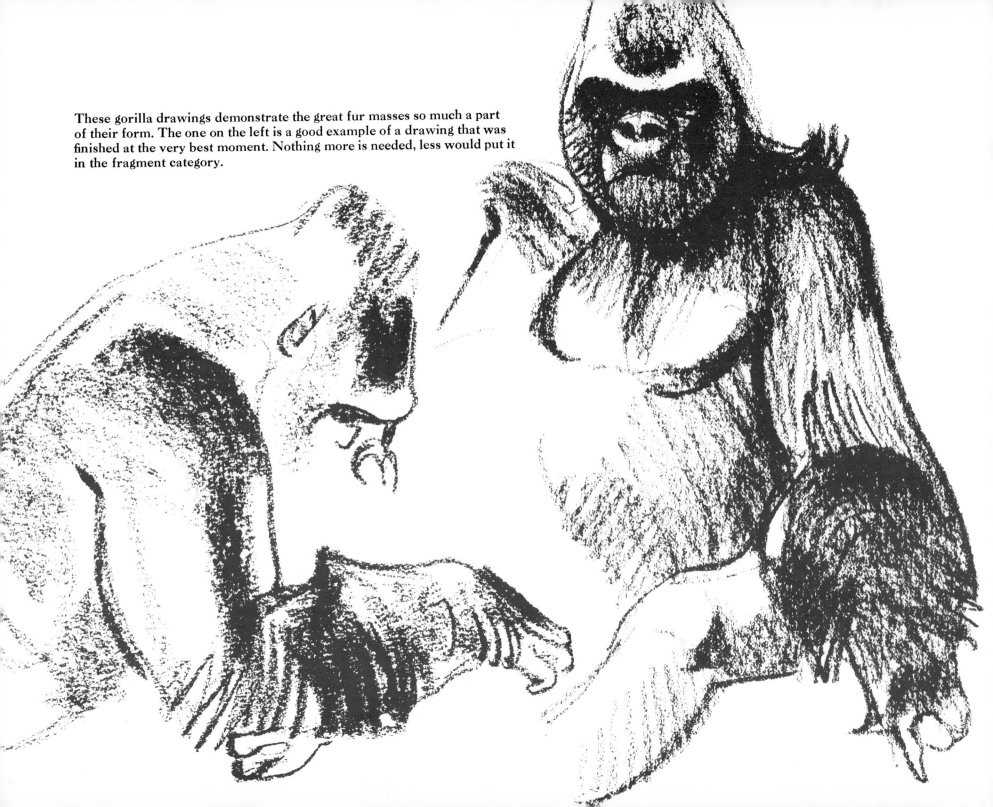

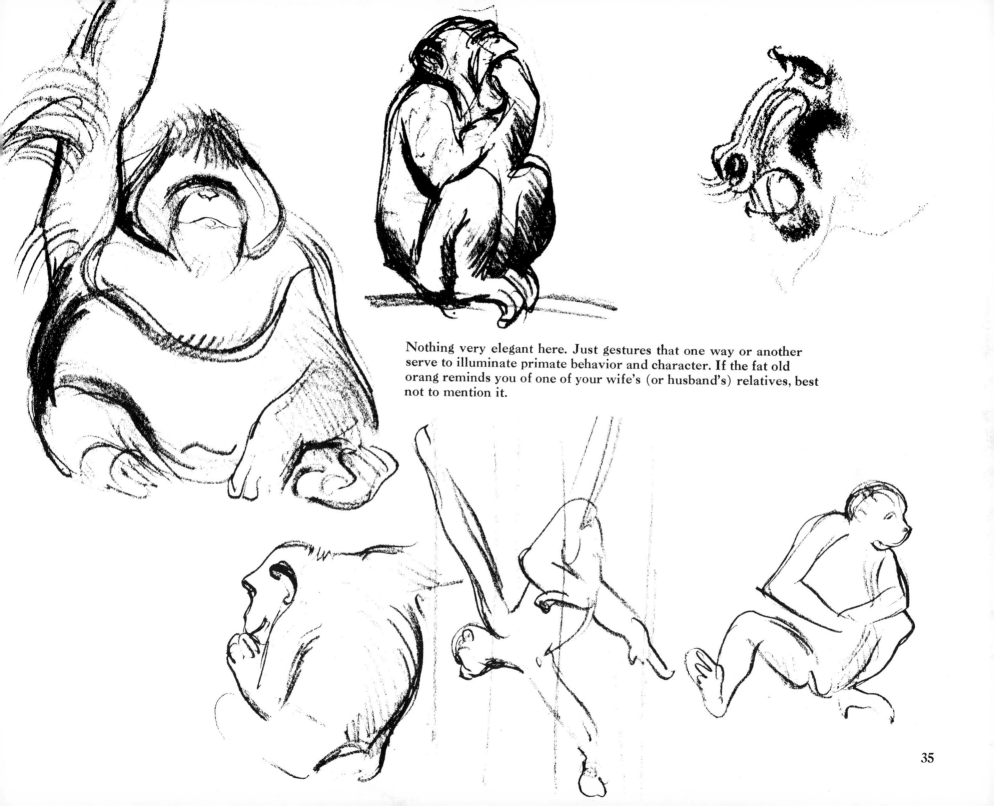

Nothing very elegant here. Just gestures that one way or another serve to illuminate primate behavior and character. If the fat old orang reminds you of one of your wife's (or husband's) relatives, best not to mention it.

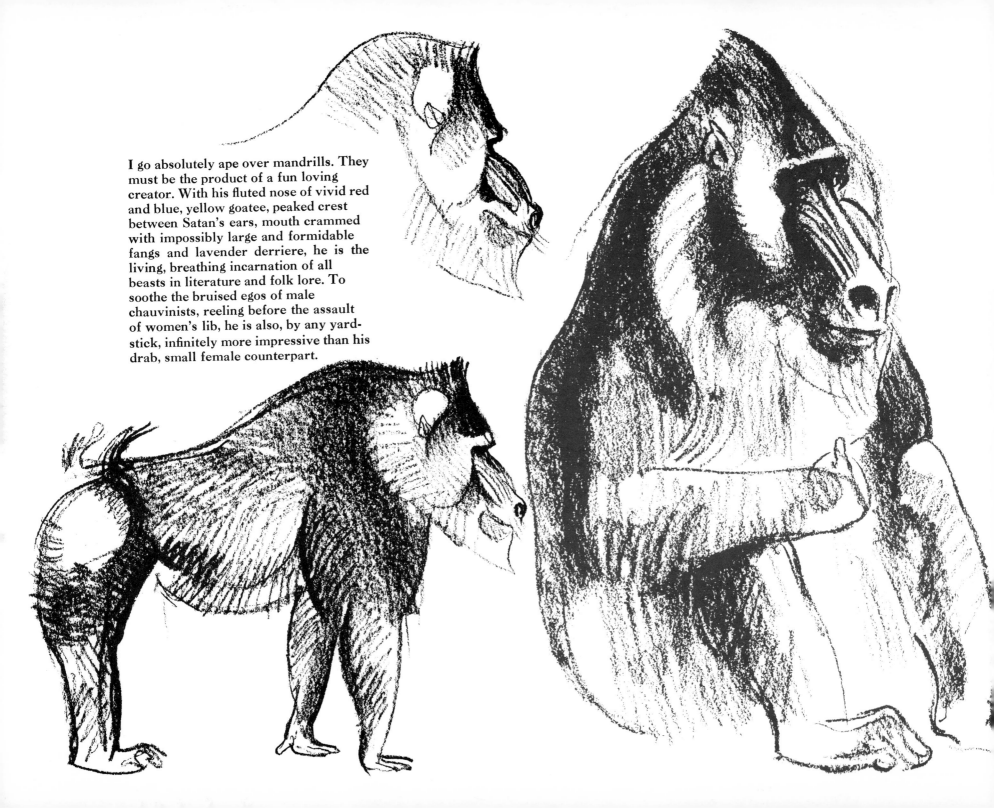

I go absolutely ape over mandrills. They must be the product of a fun loving creator. With his fluted nose of vivid red and blue, yellow goatee, peaked crest between Satan's ears, mouth crammed with impossibly large and formidable fangs and lavender derriere, he is the living, breathing incarnation of all beasts in literature and folk lore. To soothe the bruised egos of male chauvinists, reeling before the assault of women's lib, he is also, by any yardstick, infinitely more impressive than his drab, small female counterpart.

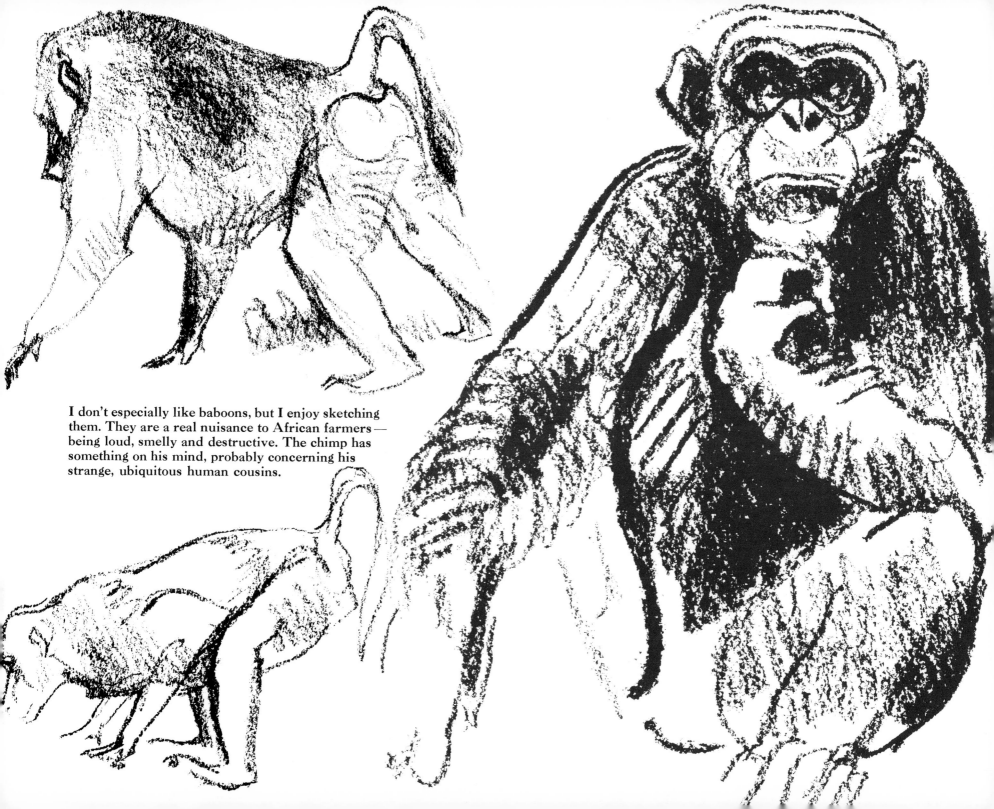

I don't especially like baboons, but I enjoy sketching them. They are a real nuisance to African farmers — being loud, smelly and destructive. The chimp has something on his mind, probably concerning his strange, ubiquitous human cousins.

THE HOOFED

The hoofed animals, made up of deer, oxen, antelope, horses, goats, swine, sheep and others are grass and leaf eaters which, except for the very largest, are preyed upon by one or more of the predators. As prey animals, they possess a variety of characteristics designed to help them survive, if not individually, at least as species. These include speed of foot, ability to climb (i.e., mountain sheep) keen eyesight and sense of smell and hearing. Such potential defensive weapons as horns, antlers and sharp hooves are used by some species and not by others. Most of the ungulates or grass eaters simply trust in their senses and speed for survival and often it is not enough. One adaptation found in this group is the placement of the eyes at the side rather than the front of the head, affording a wide field of vision. This, plus their breeding and young-rearing practices as well as territorial needs are all designed to sustain them in larger numbers than the predator. This is what is called a natural balance. Only man can wreck it.

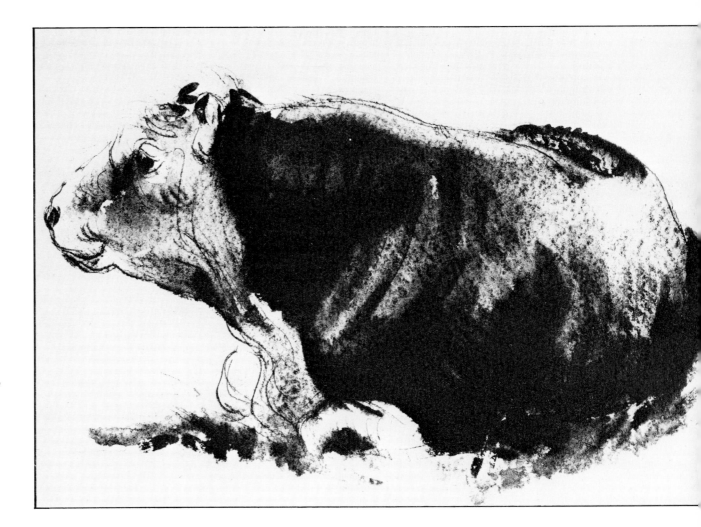

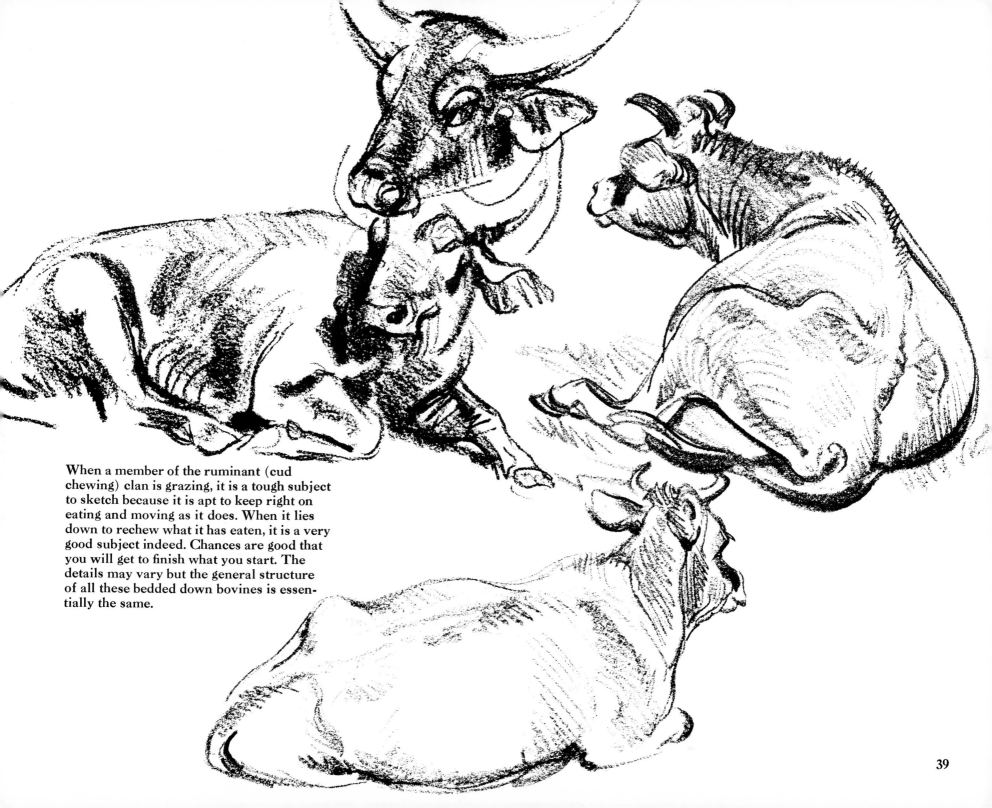

When a member of the ruminant (cud chewing) clan is grazing, it is a tough subject to sketch because it is apt to keep right on eating and moving as it does. When it lies down to rechew what it has eaten, it is a very good subject indeed. Chances are good that you will get to finish what you start. The details may vary but the general structure of all these bedded down bovines is essentially the same.

39

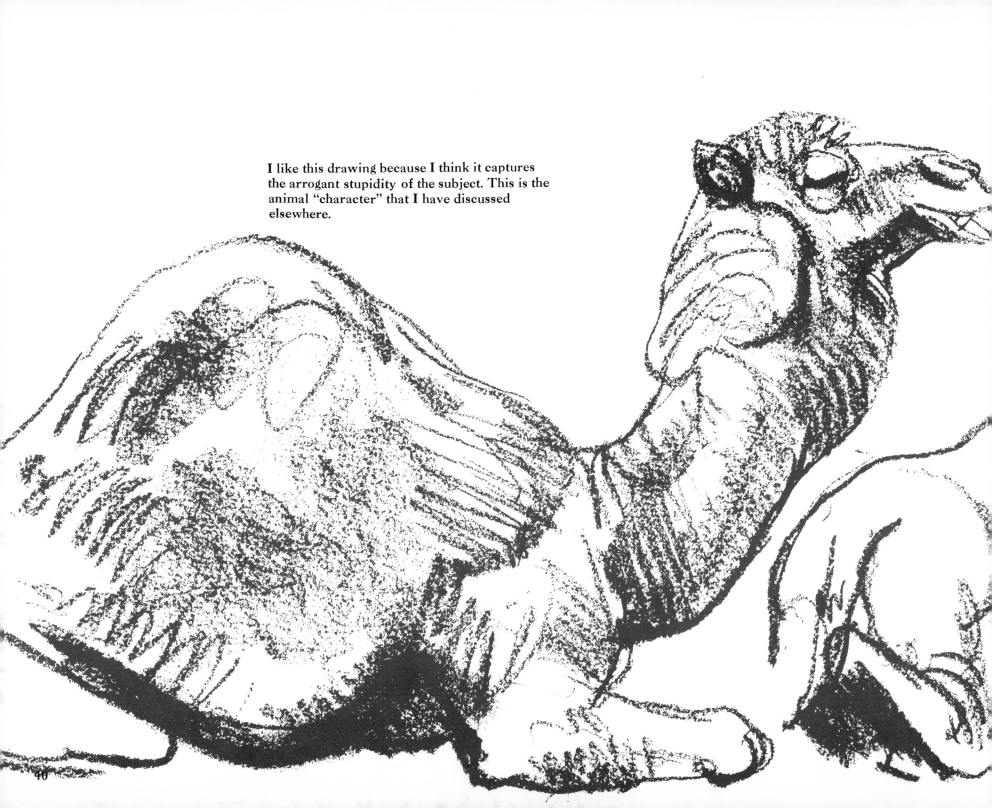

I like this drawing because I think it captures the arrogant stupidity of the subject. This is the animal "character" that I have discussed elsewhere.

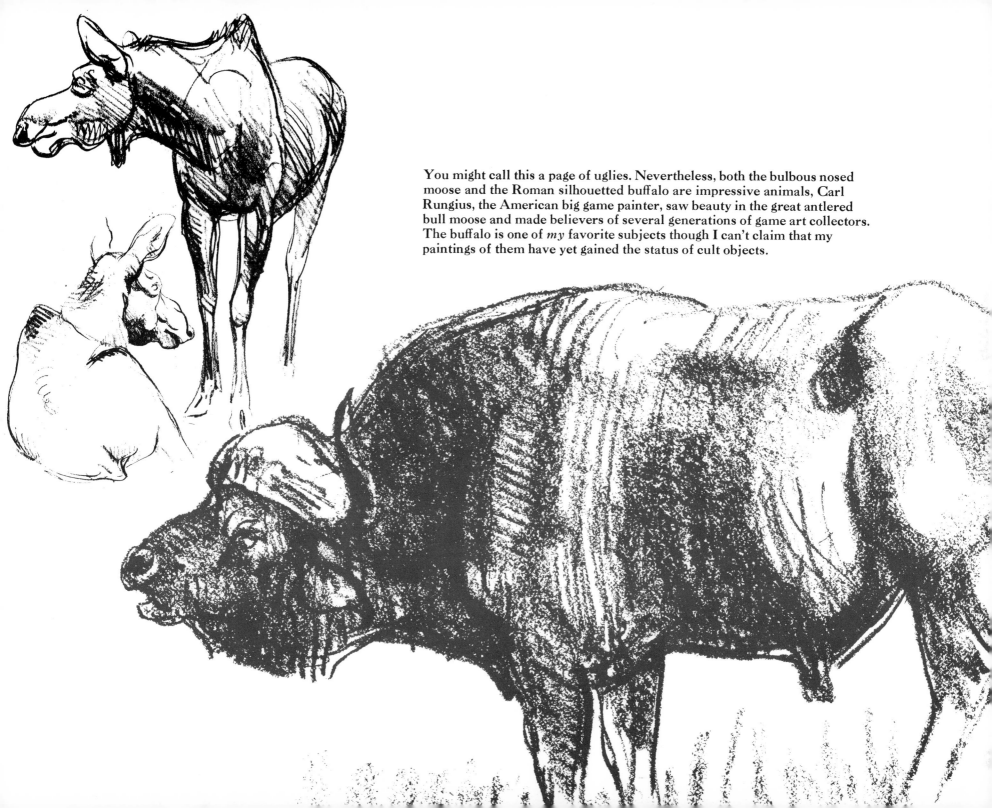

You might call this a page of uglies. Nevertheless, both the bulbous nosed moose and the Roman silhouetted buffalo are impressive animals, Carl Rungius, the American big game painter, saw beauty in the great antlered bull moose and made believers of several generations of game art collectors. The buffalo is one of *my* favorite subjects though I can't claim that my paintings of them have yet gained the status of cult objects.

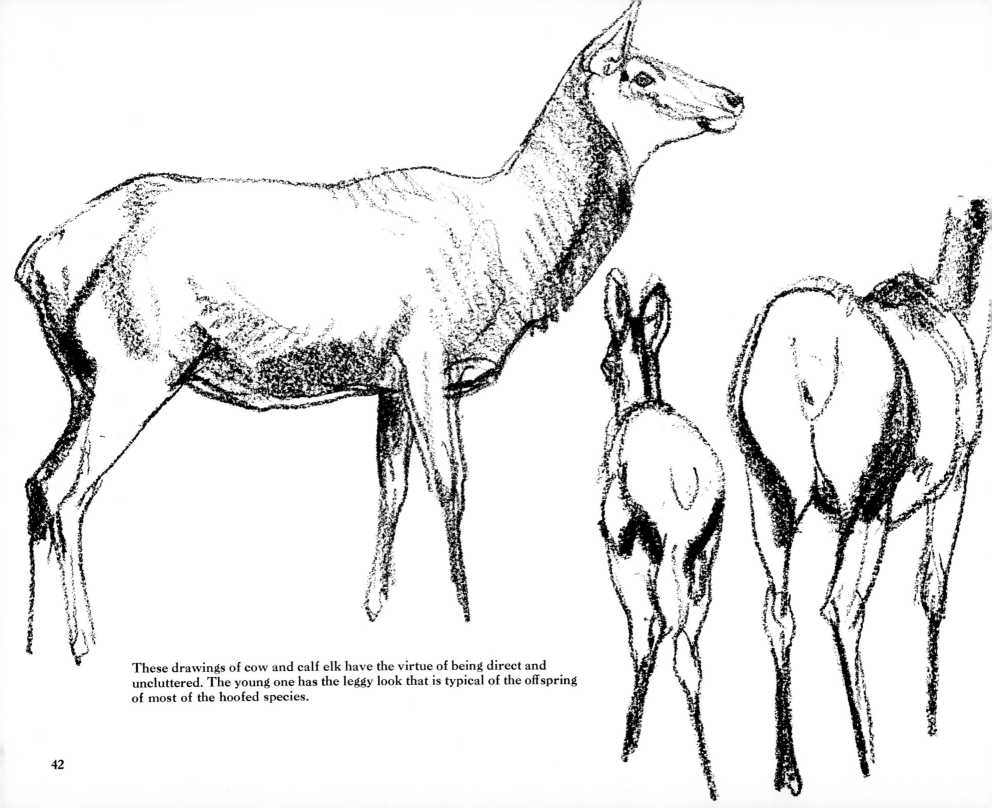

These drawings of cow and calf elk have the virtue of being direct and uncluttered. The young one has the leggy look that is typical of the offspring of most of the hoofed species.

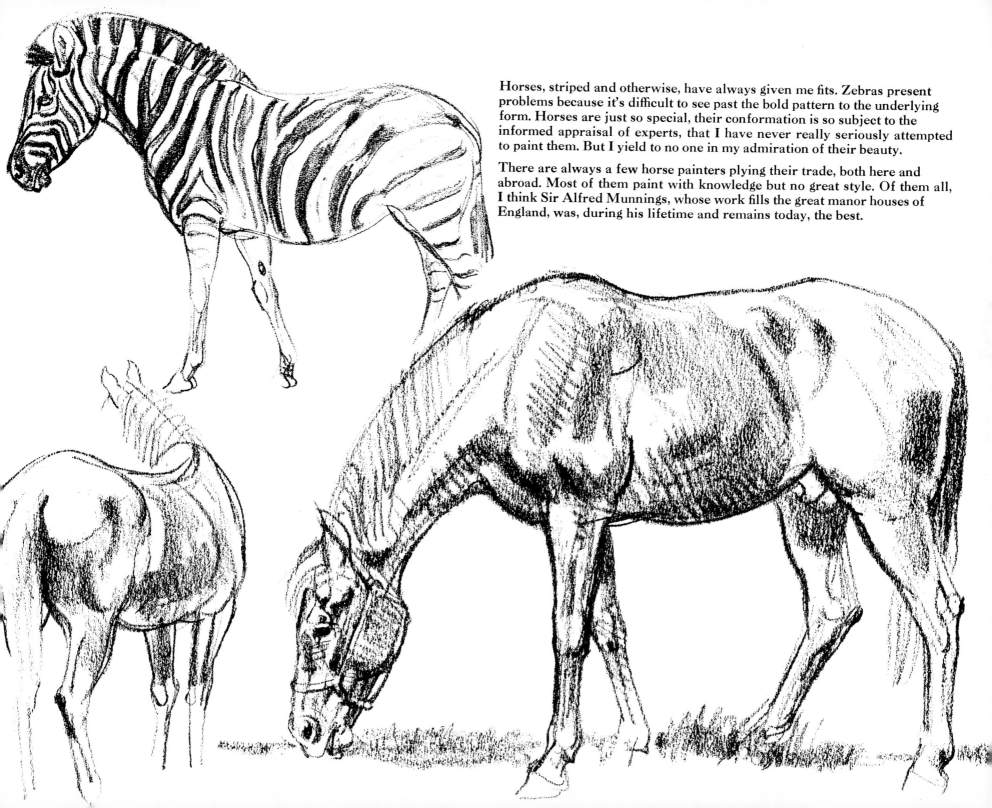

Horses, striped and otherwise, have always given me fits. Zebras present problems because it's difficult to see past the bold pattern to the underlying form. Horses are just so special, their conformation is so subject to the informed appraisal of experts, that I have never really seriously attempted to paint them. But I yield to no one in my admiration of their beauty.

There are always a few horse painters plying their trade, both here and abroad. Most of them paint with knowledge but no great style. Of them all, I think Sir Alfred Munnings, whose work fills the great manor houses of England, was, during his lifetime and remains today, the best.

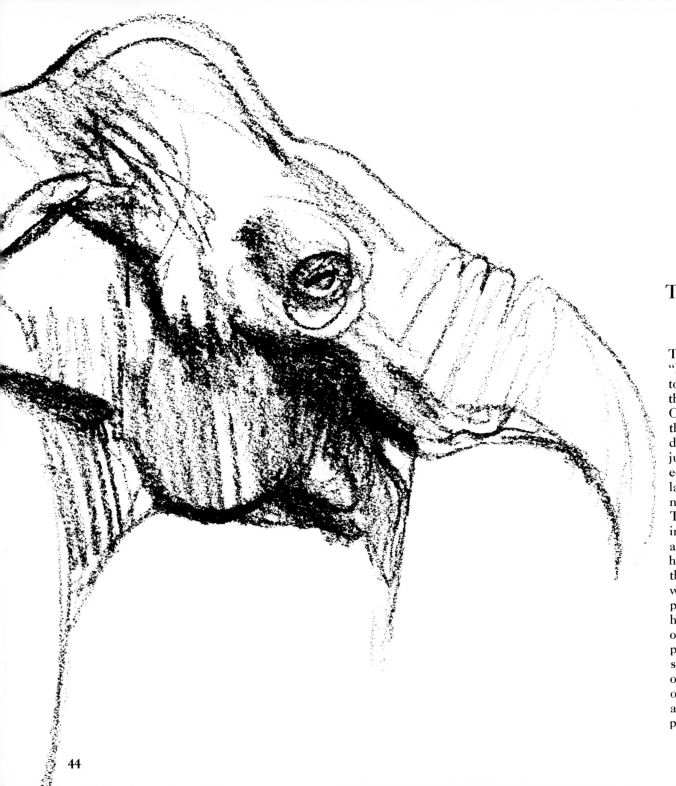

THE BEHEMOTHS

There is no such class of animals as "Behemoths" but the term serves to bring together the thick skinned, herbivorous giants that still survive on the land masses of earth. Of the three tribes, the elephant is much the most interesting. What a great and wonderful relic from the time when man was just another struggling mammal in the ecological stew. My own experience has been largely limited to the African variety, still numerous in many areas of the continent. The Indian elephant, the one that plods along in the circus parades, will soon join the camel as a no-longer-wild animal. The rhino is a half blind, bumbling, clown that trots about the African scrub with the grace of the fat guy who dances every dance. He fairly reeks of power and for that reason I like to paint him. The last member of the group is another of those that I can't resist drawing but seldom paint. Though much of the hippo's time is spent in the water, it is when he lumbers out of the wet and melts into an ear flicking blob on some sand spit or zoo enclosure that his appeal to the draughtsman becomes overpowering.

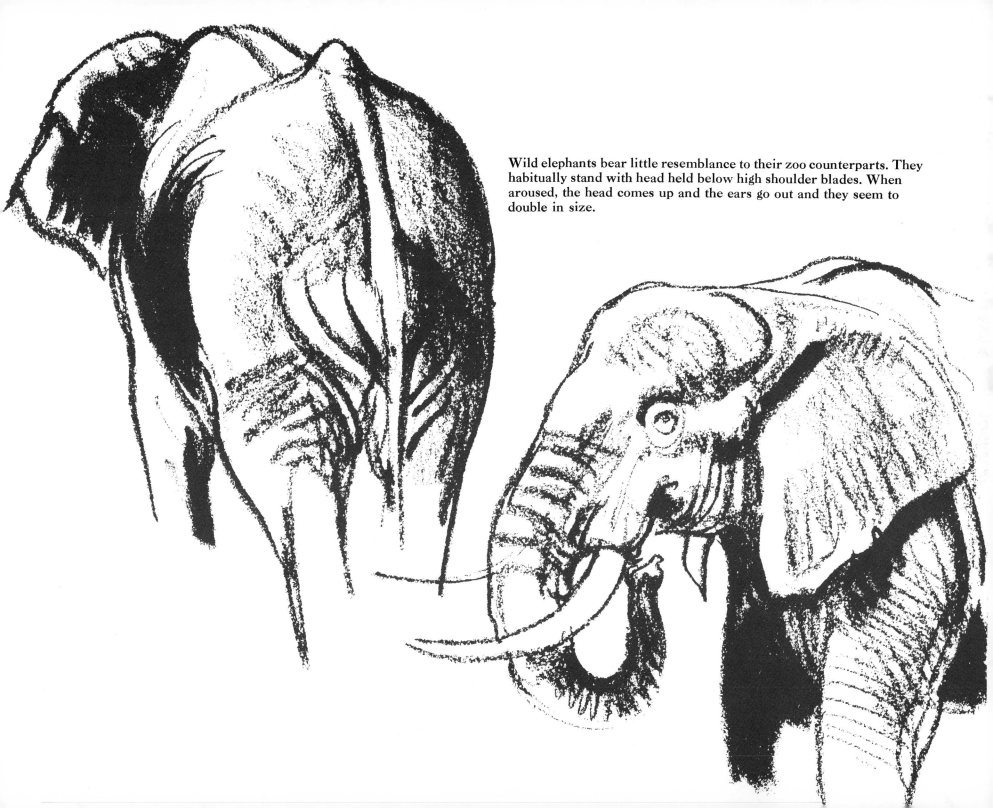

Wild elephants bear little resemblance to their zoo counterparts. They habitually stand with head held below high shoulder blades. When aroused, the head comes up and the ears go out and they seem to double in size.

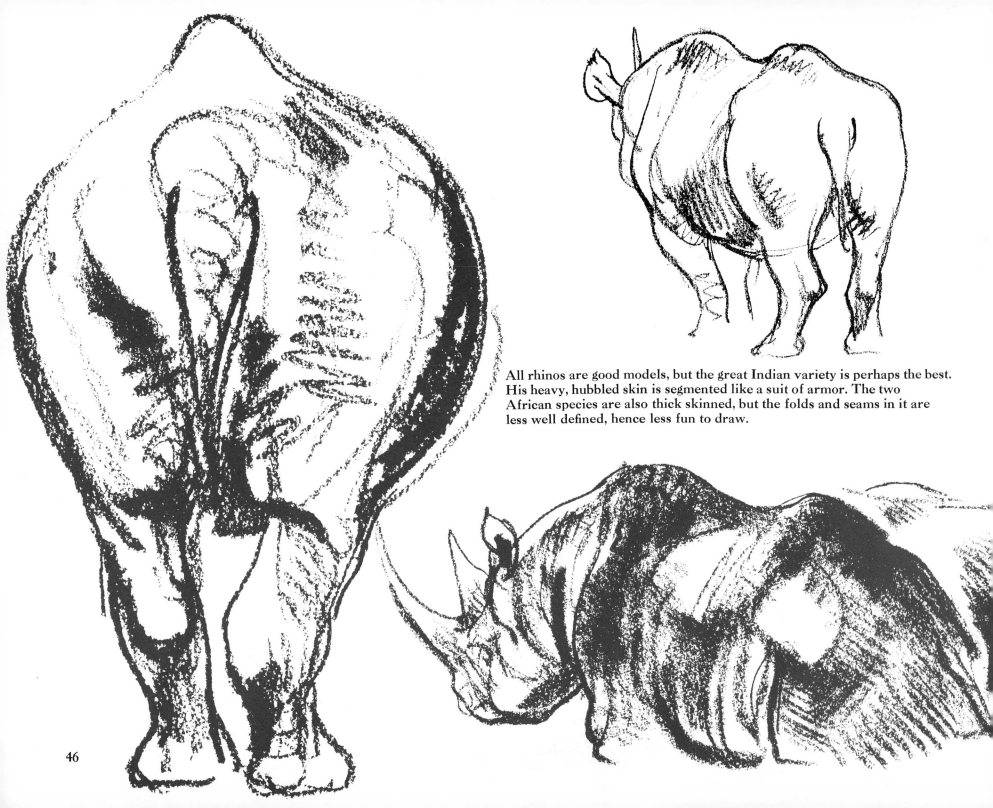

All rhinos are good models, but the great Indian variety is perhaps the best. His heavy, hubbled skin is segmented like a suit of armor. The two African species are also thick skinned, but the folds and seams in it are less well defined, hence less fun to draw.

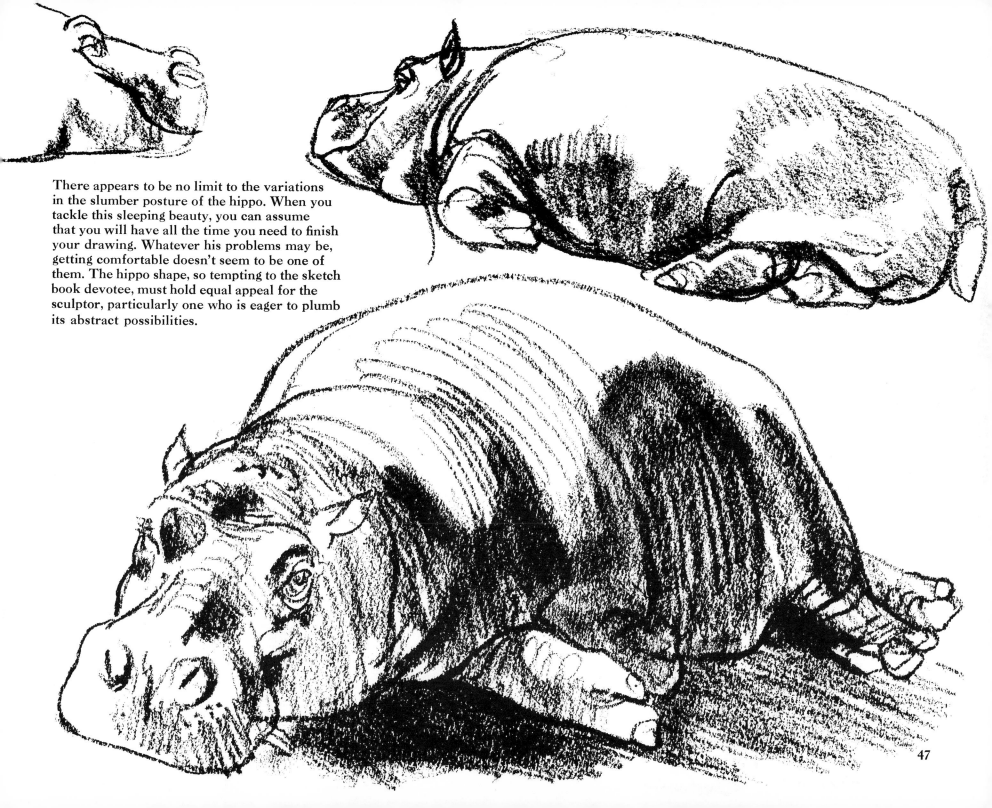

There appears to be no limit to the variations
in the slumber posture of the hippo. When you
tackle this sleeping beauty, you can assume
that you will have all the time you need to finish
your drawing. Whatever his problems may be,
getting comfortable doesn't seem to be one of
them. The hippo shape, so tempting to the sketch
book devotee, must hold equal appeal for the
sculptor, particularly one who is eager to plumb
its abstract possibilities.

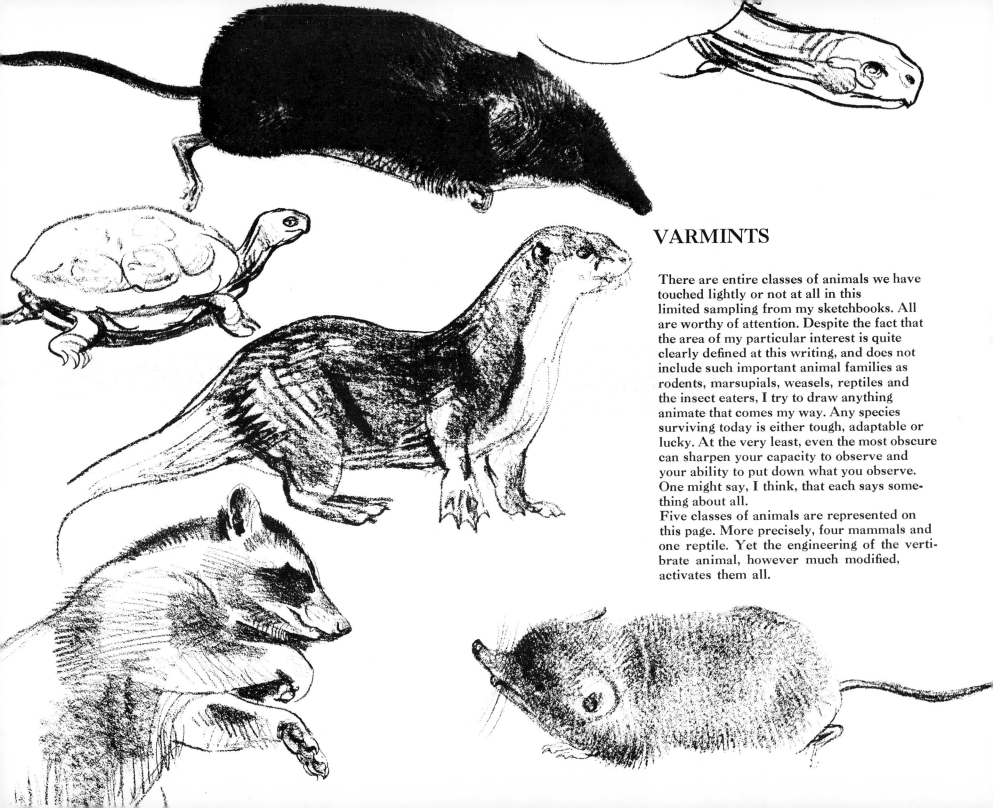

VARMINTS

There are entire classes of animals we have touched lightly or not at all in this limited sampling from my sketchbooks. All are worthy of attention. Despite the fact that the area of my particular interest is quite clearly defined at this writing, and does not include such important animal families as rodents, marsupials, weasels, reptiles and the insect eaters, I try to draw anything animate that comes my way. Any species surviving today is either tough, adaptable or lucky. At the very least, even the most obscure can sharpen your capacity to observe and your ability to put down what you observe. One might say, I think, that each says something about all.

Five classes of animals are represented on this page. More precisely, four mammals and one reptile. Yet the engineering of the vertibrate animal, however much modified, activates them all.

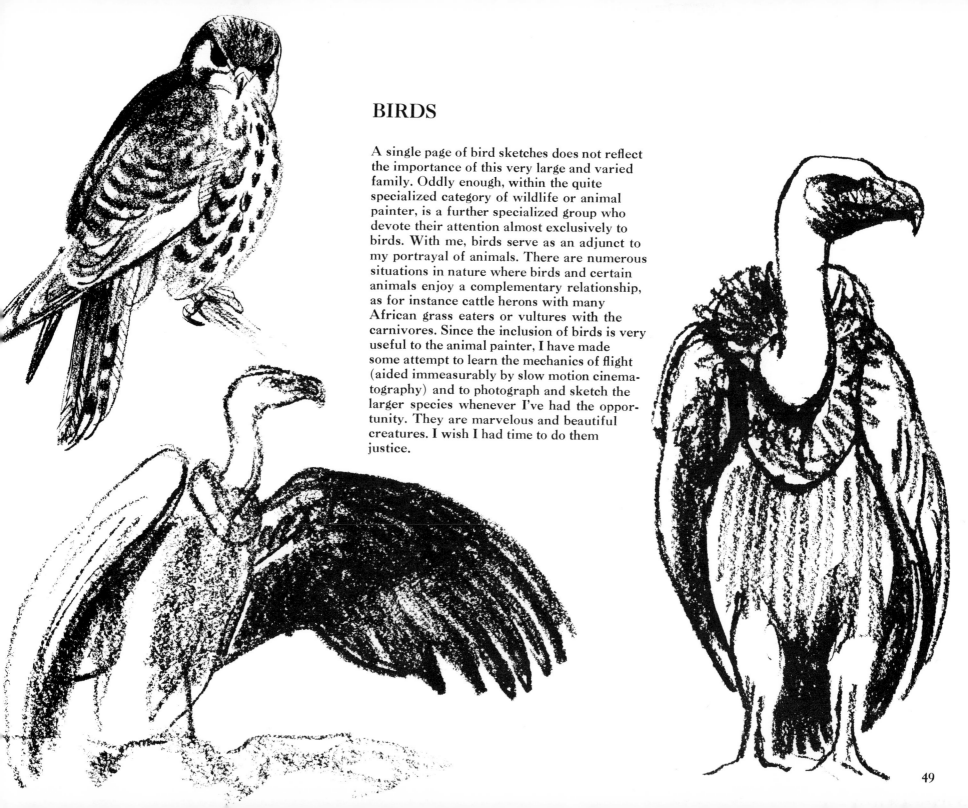

BIRDS

A single page of bird sketches does not reflect the importance of this very large and varied family. Oddly enough, within the quite specialized category of wildlife or animal painter, is a further specialized group who devote their attention almost exclusively to birds. With me, birds serve as an adjunct to my portrayal of animals. There are numerous situations in nature where birds and certain animals enjoy a complementary relationship, as for instance cattle herons with many African grass eaters or vultures with the carnivores. Since the inclusion of birds is very useful to the animal painter, I have made some attempt to learn the mechanics of flight (aided immeasurably by slow motion cinematography) and to photograph and sketch the larger species whenever I've had the opportunity. They are marvelous and beautiful creatures. I wish I had time to do them justice.

The Making of a Painting

Without meaning to suggest that my approach to the business of picture making has any special merit, it might be of interest to some of the brave souls who have purchased this book. Let us assume that I have an idea of a subject that needs painting. Perhaps it has emerged from one of my breakfast table scribbles, or one of my color slides contains ingredients that will translate well. The simplicity or complexity of the subject, as it develops in my thumbnail sketches, will help in the decision of what size and shape the finished picture ought to be. Generally speaking, a picture containing a number of elements requires a larger format than a more simple one. For the purposes of this discussion, let us assume that I have decided that 24 by 36 will best suit my purposes. I generally have a supply of 1/8 inch untempered masonite, precut by the local lumber yard to the sizes I prefer to work with, ranging from 14 by 30 to 30 by 48 or larger. Since I almost always work in acrylic paint, I mix up a batch of white dulled down with raw umber or ocher and apply a coat to the masonite. When it is dry, I add somewhat more color to the paint I have been applying. It may peek through whatever will be applied over it adding to the interest of the surface. If it builds up a little bit, creating a texture here and there on the masonite surface, so much the better.

By this time I have probably been experimenting with the major element or elements of the painting-in-progress. If I have made a small but well worked out pencil drawing of the animal to be painted, I will enlarge it mechanically to the size I think it should be in the finish on a piece of tracing paper and move it around the panel until I feel it is properly positioned. If the painting involves the relating of several major animal elements, I will draw them all on tracing paper, with or without mechanical help, and position them on the panel the best way I can. Then I make little marks along the edges of the tracing paper which extend to the surrounding panel, blacken the back of the tracings with a block of charcoal, reposition the drawings and trace them down. Most other elements of the painting, those that require some delineation before I begin to apply paint, are drawn directly on the panel. Sometimes, when a complex arrangement of tree limbs or some such is to be developed, I plan it pretty carefully first on an overlay before tracing on to the board. This might occur after basic tones of grass, sky, forest, have been painted in and a certain amount of texture added in addition to a considerable amount of work on the animal elements.

My decision to jump right into the finished painting, without any attempt at a readable color sketch is the result of too many instances when I found that all my enthusiasm was spent in producing a preliminary painting, with the result that the final version lacked any sparkle or life. I risk an occasional disaster this way but each painting provides me with its share of surprises and that keeps things interesting.

Frequently, as the painting progresses, I find that I have to pull additional slides from among my many thousands. They are filed in a rather strange way but it works for me. If I can't find what I want in the slide files, I have a library of hundreds of volumes, most devoted to wildlife of one sort or another. As a last resort, and only when the problem is serious, I can with a little trouble avail myself of the nearby zoos or the American Museum of Natural History in New York. In all the above, of course, I am discussing problems resulting from inadequate information. The aesthetic decisions which are constantly arising and upon which the success of my project rests, must be resolved by me and all my storehouse of facts won't help me if my judgment regarding them is faulty. Let us never forget that the one ingredient of the many that go into the production of a painting or a piece of sculpture that is unteachable is that which produces a work of Art. It is true now as it has always been true.

To return to the mechanics of picture making, assuming that my origional plan for the painting has some merit, I will move along, developing all areas, adding detail where it is needed, losing it where it isn't. At some point I will find that I can push the development of the painting no further. This is the time to remove it from the easel and from my mind and go on to other projects. After a few weeks, when all my passion for this particular effort has drained away and I can approximate objectivity, I will bring it back to the easel and look at it with new eyes. Flaws in reasoning and execution will leap at me and soon I can move the painting toward a conclusion that had eluded me earlier. It doesn't always work this way but often enough so that I allow a painting a fallow period whenever time permits.

I regard the frame as an integral part of my whole effort. So much so that I order the one that best fits a particular painting well before it is completed. I am fortunate to have a friend and neighbor, a very good painter in his own right, who has chosen to direct his taste and skill toward the production of beautiful custom frames. Together we decide on shape, color of gold, tone of wood, tone of linen, etc. so that the finished frame is often an extension of the painting. The occasions when someone viewing my work lavishes most of his praise on the frames represent a risk I'm prepared to live with.

The decision as to whether to apply varnish to the completed painting depends on the general tone. Deep values tend to become a little opaque and will be enriched by a coat of varnish. Paintings done in a generally high key don't seem to require it. I personally like a matte glaze but have had such trouble finding the right mix of varnishes to achieve this that I now have abandoned the brush-on approach and spray on as much or as little Hyplar gloss varnish as the picture needs, bearing in mind that the more one applies the higher the gloss will be. Applied evenly it gives a good protective coat.

Just for the record, I don't use the available medium as a thinner when applying the acrylic. I find plain water to be quite satisfactory. I can hear the screams of anguish when I admit that I regularly use a large size paper pallette block rather than the more traditional kind or a heavy sheet of glass as many painters do. It relieves me of the nuisance of forever scraping and cleaning the damn things. When the paint with which I'm working gets too messed up, I simply tear off the top sheet, chuck it away and prepare a clean one. I don't have any magical arrangement of colors so we won't go into that. My choice of weapons consists of oil bristle brushes in 4 or 5 sizes, a couple of Winsor and Newton series 7 sable brushes, #4, 5 or 6, a small plastic sponge or two and a palette knife with a fairly small working surface. The sponge and the palette knife are mainly employed to create textures but they serve the additional purpose of keeping me loose. When I find myself going down the scale of brushes and getting too fussy, a swipe or two with the sponge, cut into triangular wedges, or the palette knife will restore my aim, which is to produce a carefully, often painfully worked out design and make it look easy. I am absolutely devoted to the use of the plastic sponge. It is a truly liberating tool to the artist. With it you can create a huge range of textures. As with all non-precise aids, you must be ready to undo the accidents it creates if these accidents do not serve you. You can become so addicted to accidental effects that you lose control of the painting. Don't. I should mention one additional device that can enliven the painting's surface. That is the use of spatter. The mechanics of spatter are too well known to go into. I use the technique sparingly but lovingly. On those occasions when I want to create an area of vibration, as for instance, in suggesting but not belaboring a patch of bright leaves rustled by the wind, the intelligent use of spatter is indicated. You can, if you like, mask off areas you do not wish to spatter, though I have no objection to a few errant splats on the painting surface. One final adjunct to my various paint applicators is a 2 or 3 B Wolff pencil. Perhaps because I am essentially a draughtsman I love to add crisp little accents to the painted surface with the pencil.

These then are my materials. Acrylic paint is not everybody's cup of tea. It dries very quickly and has a slightly tacky quality as you apply it. It also dries quite a bit darker than it appears as it is applied. But it is very versatile. It can be applied thickly, having much of the appearance of an oil painting or thinly, on a wet surface, looking very much like a transparent watercolor. When allowed to dry (which is very promptly) it is water fast and will not pick up if you work over it. Having worked with tempera for many years as an illustrator I am used to the fast drying characteristic of acrylic paint and I like it. I have grown accustomed to its other characteristics and on balance I think it the best medium for me.

One of the great enemies of productivity, as far as I'm concerned is the temptation to chase a bad idea too far. Though it is not always the case, you should be able to tell after two or three days work whether or not a painting is going to make it. Sadly, there are so many exceptions to this position that one is tempted to fight through to a solution, no matter how long it takes.

Some of my best efforts are the result of much trial and error. Some of my worst failures have consumed weeks of my time and ultimately provided a base coat for a new effort that arose from the painted-over ruins. I have satisfied customers who have no idea that they are the lucky owners of two of my paintings, one underneath and one on top.

If my original conception of a painting is clear, I tend to move along fairly smoothly, though almost always there are trouble areas that require some adjusting and testing. But some ideas, that look great in the

thumbnail stage, just simply don't deserve to go any further.

On one aspect of this subject I am very sure. The friend who suggests that if you don't like one of your near misses, why not give it to him, is not such a good friend after all. It is absolute idiocy to let sub-standard work see the light of day. Better by far to burn it. One of my most sincere regrets is that many of the mediocre or just plain bad illustrations I have churned out over the twenty five years I spent as a wildlife illustrator still moulder in attics and basements across the country. If I could gather all those old magazines up in a pile and the local regulations would permit a bonfire, I would strike the match and provide the marshmallows.

Specialists who know about such things say that there are two sorts of people—the actors and the reactors. Actors tend to be self starters. They can start from ground zero and produce something of value. Reactors, on the other hand, need some sort of stimulus to get them going. In fight parlance, a reactor is a counter puncher. He waits until the other guy does something, then reacts. As between these rather over-simplified categories, I am a reactor. The most mundane photograph or combination of colors in an ad or a single exciting gesture in an otherwise ordinary piece of source material can spark a voyage that ends in the completion of a painting.

What happens is that, in the process of looking at some sort of material, be it a photograph or a piece of sculpture or whatever, I say to myself — What if I took that little area and stuck in a watchamadidle and changed the time of day, Boy, it might be great. From that little seed of an idea until I have arrived at the moment of completion, the trail may be clear and straight or it may meander, flounder, change course but finally result in an interesting picture, or it may sink without a trace. What *is* important, I think, is that it is not very important *what* provides the spark. By the time you have translated and transmuted the thing that has turned you on into your own vision, it is usually unrecognizable.

I used to think that it was dirty pool to utilize any material other than my own. I no longer feel that way. All information is grist for the mill. If you have a concept that deserves to survive it will survive and it will be yours. Tip your hat to the provider of the spark and think no more about it.

Elsewhere in this book, I have mentioned that I occasionally draw excitement from the work of painters of widely varied disciplines. I believe that all approaches to painting are deserving of my attention. Some schools do not particularly move me while others emphatically do. My enthusiasms might not be yours. I happen to think that the drip paintings of Jackson Pollock had a liberating effect on painting, both by what he did and how he did it. Franz Kline extended the boundaries of what was considered legitimate in terms of contrast by his large exercises in black against white. Ben Nicholson delights me with his contrasting textures and use of bright color against soft areas of grey. And so on and so on.

A few years ago I entered a painting in a show that restricted its entrants to representational painters. After the exhibition was over, I was invited to join the association and become an annual participant. One of the stipulations attendant to joining was that I was asked to sign a credo of some sort, repudiating non-representational art and reaffirming the divine right of realists. After reading it a couple of times in astonishment I replied sadly that this was one document I couldn't sign. I think that realists can best defend themselves and their philosophy by turning out paintings that continue to appeal to collectors of discernment but much more important than that, that continue to test and stretch their capabilities.

53

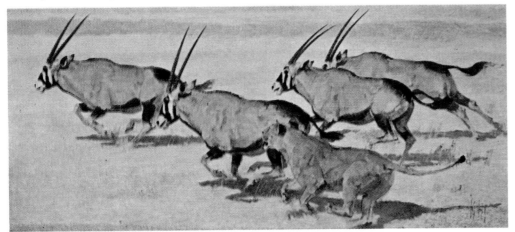

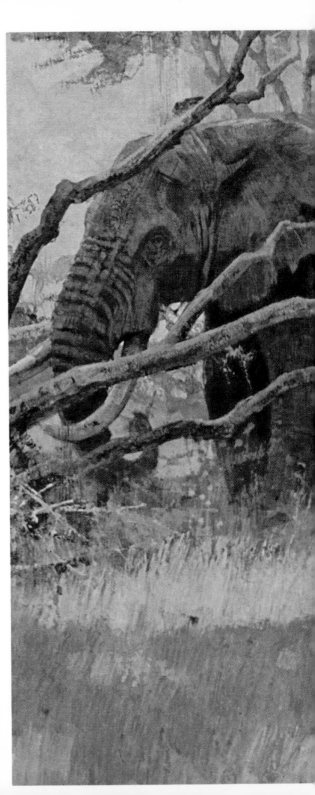

I am endlessly fascinated by the predator —
prey relationship. Much of the excitement
that permeates the stalk and chase, pitting one
animal against another, or several against one,
or one against several, is fleeting and
occupies a brief part of the participants'
time. With lions, the stalk may be of some
duration, but the rush and kill are over in
seconds or minutes, depending on the size
of the prey animals. Catching such a dramatic
moment and making all the components
work is a stern test of one's knowledge and craft.

There is no doubt about the out-
come of this drama. Wild dogs
simply run their prey into the
ground. They don't do it because
they are vicious; they do it because
they are hungry. The problem
here is to capture some of the
quality of inevitability which is at
the heart of the race about to end.

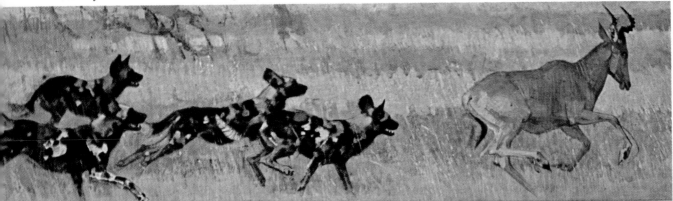

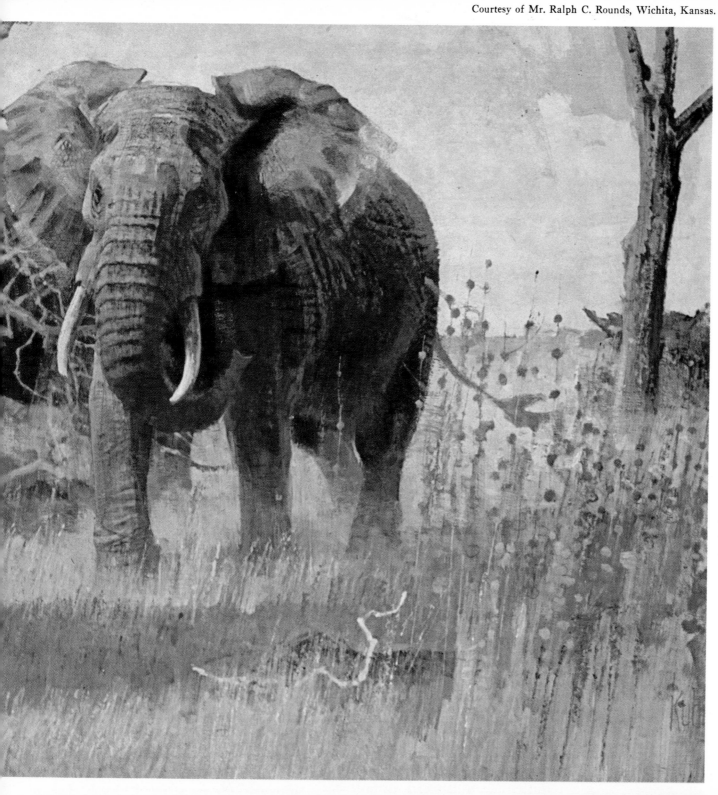

This painting depicts the big bull-askari relationship common among male elephants. A big old bull, past his prime, is frequently attended by one or more younger bulls which act as his eyes and ears and also as his bodyguard. When you get too close to the old boy you had better plan to cope with his short tempered chums.

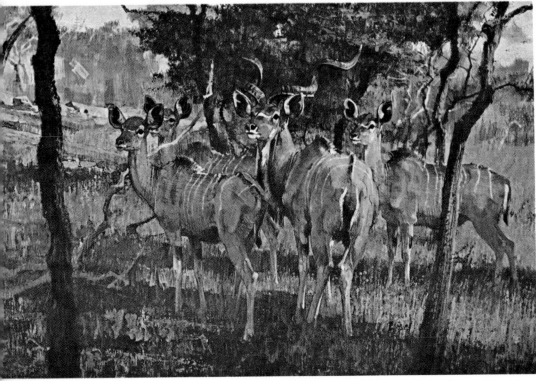

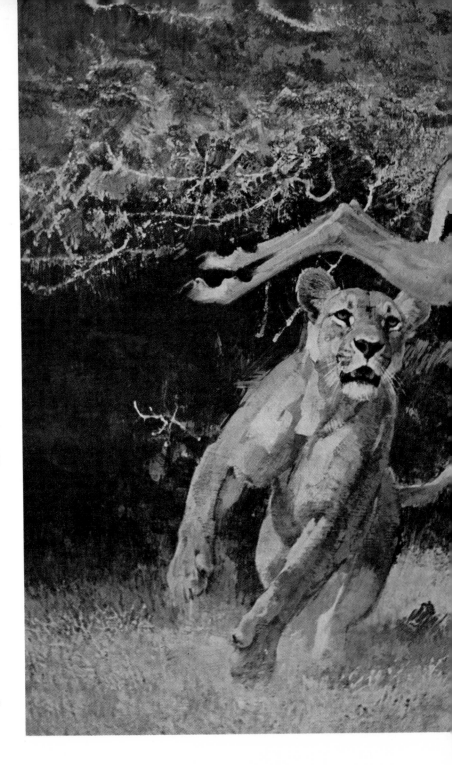

This painting, one of my favorites, combines the sere, orange and black setting of an early hunt in Tanzania (then Tanganyika) with some Kudu material I gathered on a large ranch, as we would call it, in Kenya. They are handsome and very wary antelope, much admired by trophy hunters. The palette is limited, both by the nature of the subject and because I think it better serves my own objectives in this instance.

In this long frieze of gemsbok and lioness the foreground become background has been kept as simple as possible. The gaudily marked antelope and attacking predator provide enough pattern and excitement to justify the ample and almost empty surroundings.

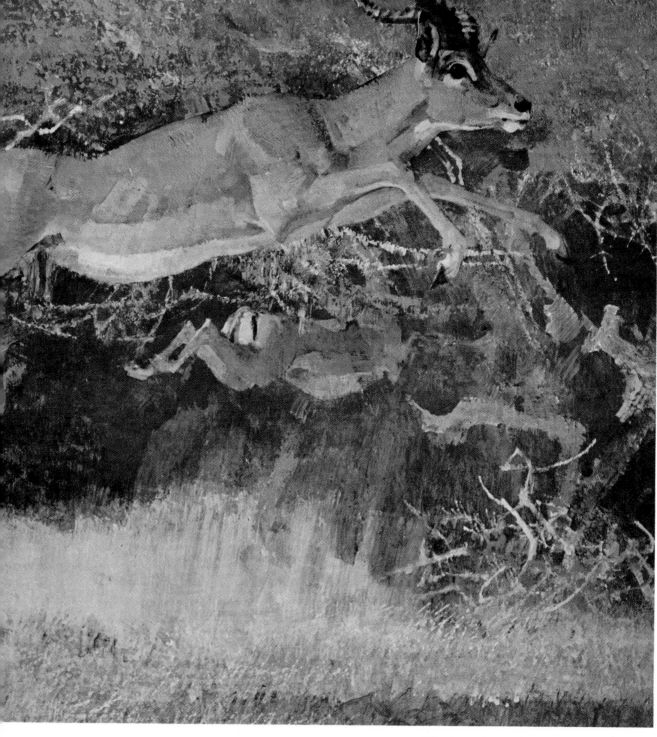

Courtesy of Mr. Shelby Longoria, Matamoras, Mexico.

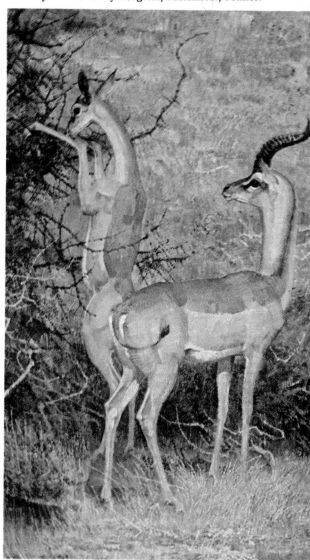

The gerenuk is such a perfect complement to the dry, monochromatic terrain it likes that I enjoy the challenge of trying to capture its pixie-like look and behavior. One meets them in the semi-arid stretches of East Africa and always with pleasure.

Collection of Jone Codding, Santa Rosa, California.

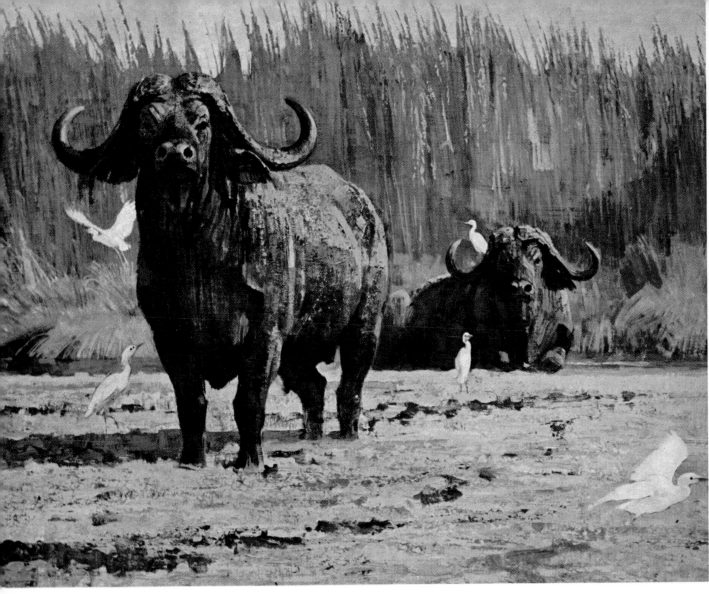

Courtesy of Mrs. Dean Porter, Brownsville, Texas.

The buffalo can look like a placid
range bull — almost but not quite.
Even at rest he conveys a sense
of power. I've been charged by a
couple in the course of getting
information for paintings. They are
very tough cookies and that must be
evident in any painting of them.

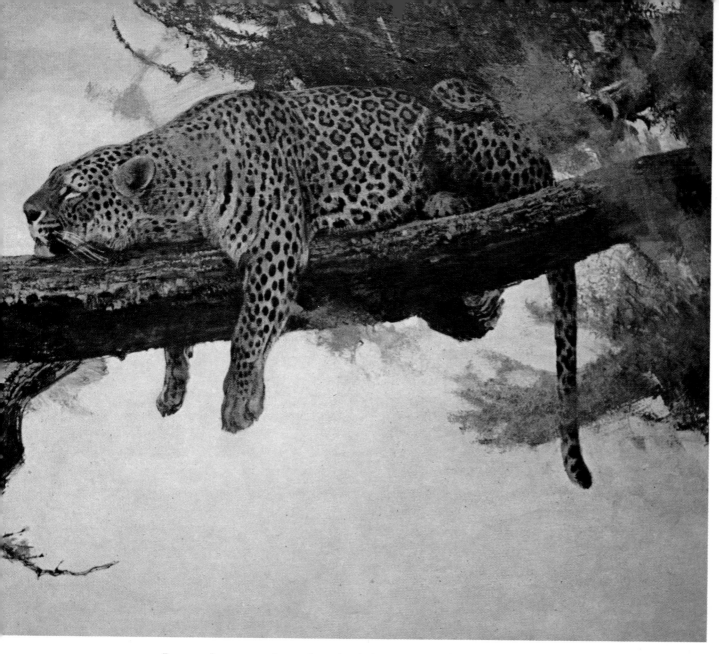

Leopards are so elegantly pelted that it is almost impossible to improve on that elegance with a brush. On the other hand, to hint at rather than put down the spots is to lose the character of the animal. Elsewhere in this book I have mentioned their fondness for draping themselves on tree limbs. I need not also observe that this tendency has spawned a cluster of leopard-on-a-limb painters, myself included, all earnestly striving to finally do justice to their subject.

I have painted cheetahs a number of times, with varying success. They are efficiently designed animals but so strangely proportioned that to paint one broadside is to court disbelief. I find them most interesting and paintable when they are flaked out, in broken light, still spare of body and leggy but full of grace.

In both his attitude and his expression, I tried to make this lion say "Get lost". Capturing the expressions of volatile animals such as the lion requires some knowledge of their range and meaning. The much abused snarl is a defense signal not generally used when the animal is hunting or confidently asserting himself as this big fellow is doing.

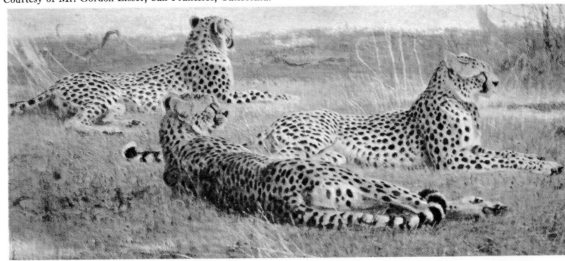

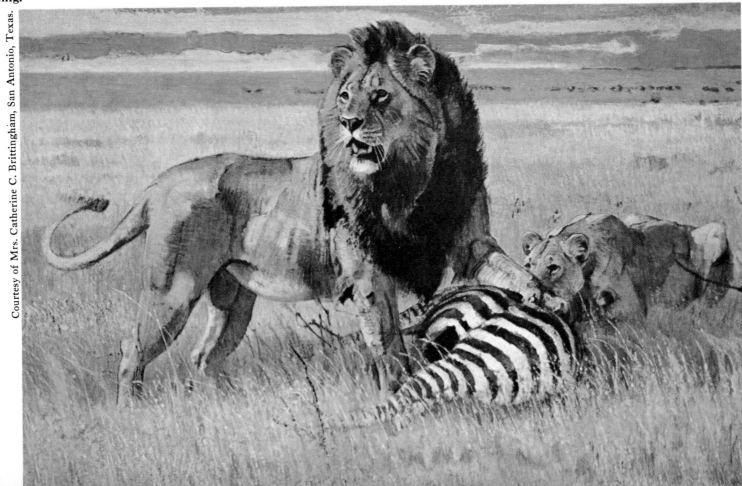

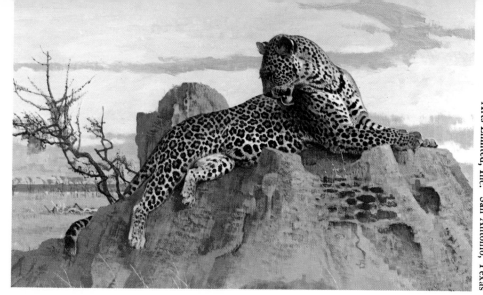

Character

My old mentor, Paul Bransom, repeatedly alluded to animal *character*. What he meant was that which makes one breed or species different than any other. Character is comprised of appearance and also behavior. A predator carries himself with the confidence born of a life style largely unaffected by fear. The prey animals are a much more fidgety bunch, for the obvious reason that they must be forever ready to perceive danger and react. Non predators of great power, such as elephants, rhinos, buffalos and the like, bear themselves with the confidence that their size and strength warrant.

Evolution within a class of animals, for instance among the members of the antelope family, has produced a wide variety of sizes and shapes. These variations, as to the shape of horns, heads, basic markings, carriage (example — the sable antelope carries his proud sweep of scimiter horns as befits an elegant creature, the wildebeest, combining a graceful body with ugly head, has a carriage and personality to match his looks) — must be understood before one can portray any of the member species convincingly. I have found in my own research that I need to make a number of studies of a particular animal before I get tuned in and the differences that identify his kind become clear to me and clear in my drawings. The capturing of character is really at the heart of this pursuit.

When pursuing the elusive but essential ingredient called animal character, it is almost imperative that one see his subject in its wild state. I'm speaking now of wild animals, not those with a long history of domestication. The difference between a wild and a zoo lion is astonishing. The untamed beast, unless ill, will be much more heavily muscled, with a coat that literally shines, the same can be said for most hooved animals. Bears, for some reason or other, seem to do well and look well in captivity. One aspect that has always impressed me about animals in the wild is the aura of overt masculinity exuded by the males of many species. Even so inoffensive a creature as the giraffe becomes a thick necked stud as he matures and assumes his role as herd sire. Witness the deer that live all around us. For a few weeks a year their necks swell and they become ornery and sexy and they look the part. With many male animals, these that live in climates which permit breeding throughout the year, this ultra-male demeanor persists and is part of their adult character.

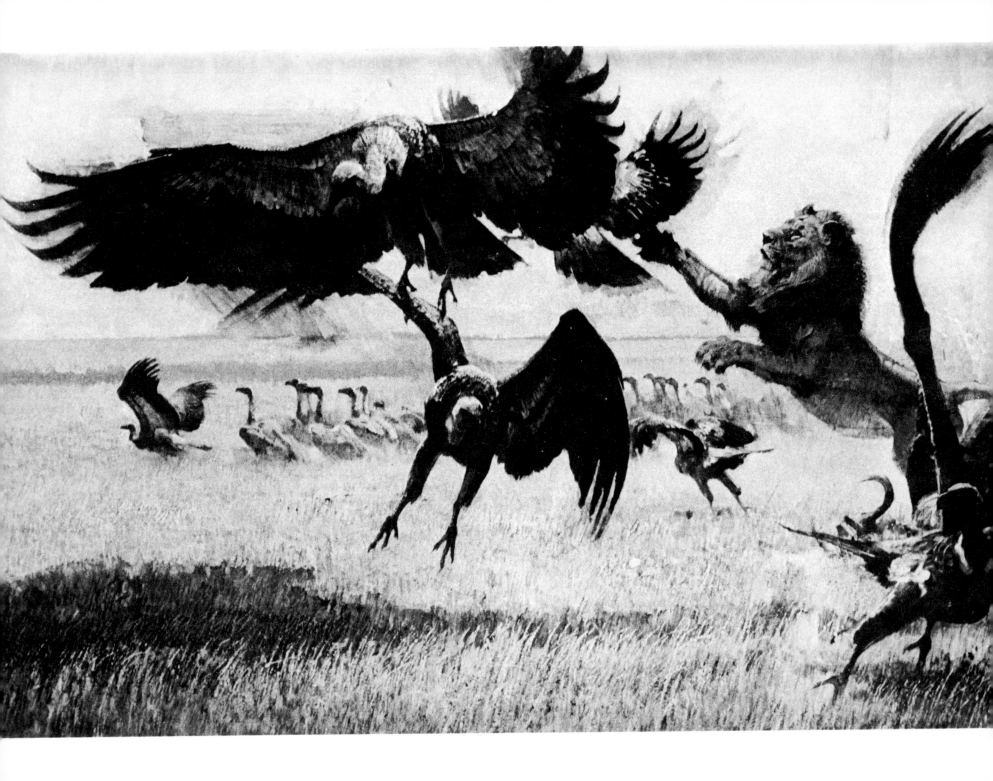

Whether this large panel of flapping vultures represents a victory or a defeat, it was, for over a year, a field of battle. I had a number of fine photos of these huge scavengers being driven from a kill. I knew that they could be organized into an interesting pattern, but when I finally arrived at a workable design, I found that they appeared to be hanging in the air. There was none of the hubbub that I know to be at the heart of this sort of episode. Then came the time of testing areas of tone that might provide a sense of motion. How much? How little? That was only resolved by testing, revising, putting the painting aside and then testing some more. It was neither an easy project nor is it a comfortable painting but it did make me reach a bit and encourages me to sally forth again when a notion seizes me that lies beyond the present perimeter of my competence.

Animals in Motion

The problem of approximating the wonder of animals in motion is one that continues to plague me. The flow of motion of a walking elephant, with all its appendages swinging, flapping or otherwise moving, is almost impossible to reduce to two dimensions, even though you have selected the perfect instant in the endless realignment of parts. Here one may learn something from the photographer. What the fast shutter freezes and therefore stops, the slow shutter captures. Extended forms and blurred edges, both characteristic of slow shutter photos of moving objects, are legitimate ways of heightening the illusion of motion. Having been shown the way, as a painter you can handle these devises, control them, as no shutter bug can.

Animals in dynamic action have a large measure of appeal, but so have animals in repose. In terms of livability I would tend to favor the less violent aspects of animal behavior but many people who collect my paintings respond to the action arrangements which are usually included in any representative group work. One might liken this interest in the baroque interplay of animal forms to the attitude of music lovers to the virtuoso embellishments of a soloist. It is regarded as a proof of skill. And, truth to tell, it is. Then there is the matter of impending action. Often it conveys a greater sense of drama than the action it presages. A crusty old buffalo bull, painted as he stands, exuding strength and truculence, says all you need to know about him and his kind. A leopard frozen on a tree limb, eyes fixed on prey you do not see but know is there, pleases you with his beauty and excites you with imaginings of what will follow. What I am trying to suggest is that all aspects of animal activity deserve the attention of the artist.

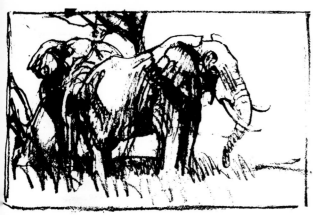
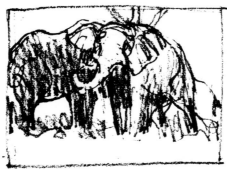

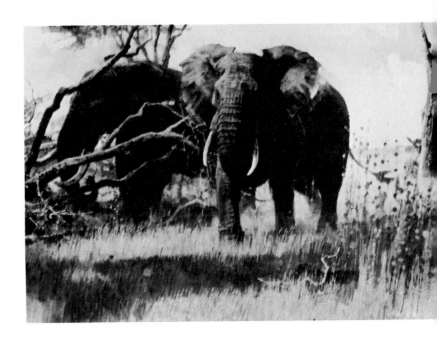

Gesture

Gesture is a vital consideration in painting anything animate and therefore is of prime importance to the animal painter. A very clear and readable photo of any sort of critter in an awkward stance is not of much use to you. A fuzzy, out-of-focus shot of the same animal in a pose that breathes with grace and vitality deserves your serious attention. With all my experience with improvising animals in every kind of situation, I very often find that the germ of a workable gesture eludes me. Then I depend on the flimsiest kind of a visual prod to get me off dead center. If you can arrive at an attitude that pleases you and suits your needs, you can usually find material to back you up as you deal with details within the form. This too, is a time when your background of work at the zoo can give you the confidence to build on your skimpy source material.

My way of doodling is to make endless arrangements of animal shapes on bond paper that I keep by my place at the kitchen table. Much of the stuff is junk and I systematically toss it in the basket. But, when a really good gesture (or arrangement) surfaces, I take it very seriously. For by building on that pleasing gesture, however simple, I very often press on to a more complete picture idea and from that to a viable painting.

With animals in motion, you ought to have some knowledge of the gaits of the creatures you are concerned with. For instance, some move along in a fashion similar to a horse's trot, moving a near front leg and a far hind leg forward at the same time, others very closely approximate the horse's pacing gait, where both legs on one side are moved at the same time. I'm not above cheating a little bit when my picture needs require it, but you are better off working from a base of knowledge as you make your decisions about a gesture if only because so many instances in any sequence of motion are beautiful as well as correct.

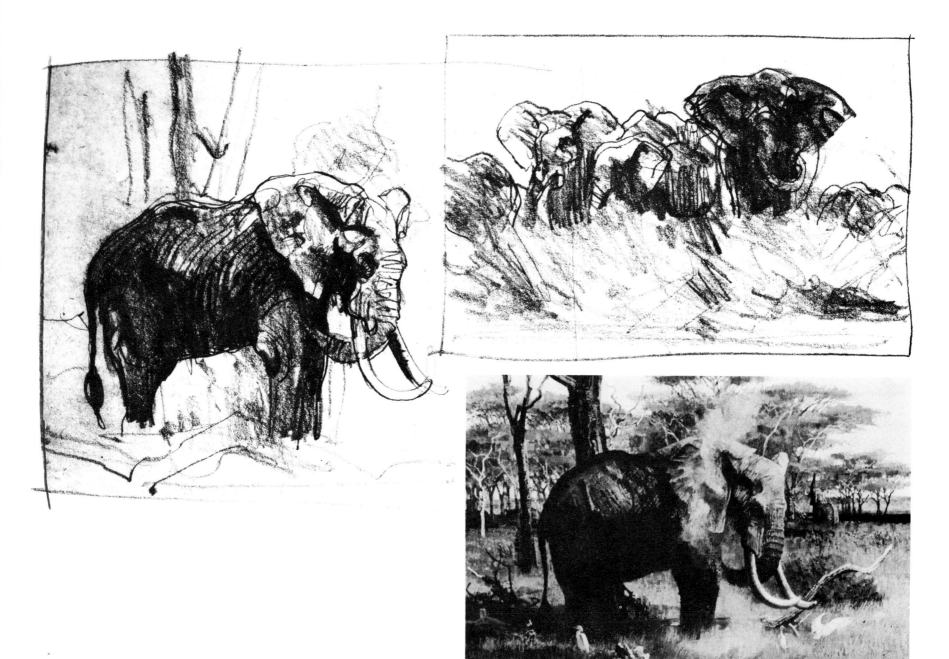

I'm rather proud of this page. Nowhere in my mountain of picture doodles can I find another page where two paintings had their genesis. When I was doing these it was an either-or proposition but since both had possibilities I eventually developed both.

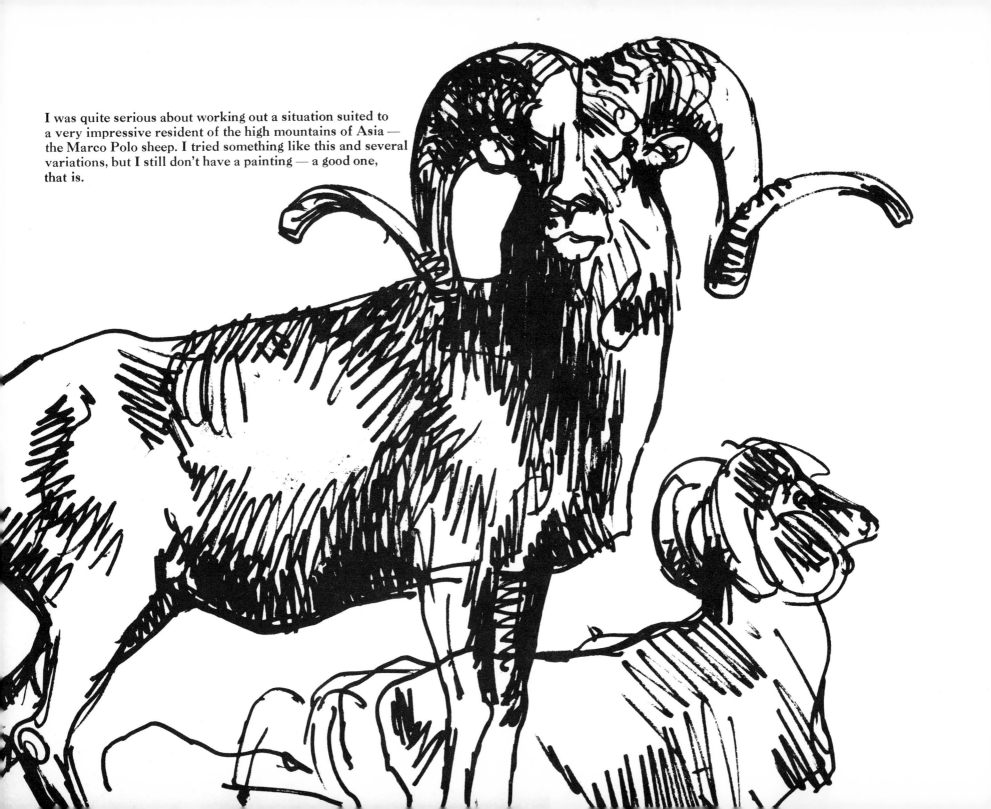

I was quite serious about working out a situation suited to a very impressive resident of the high mountains of Asia — the Marco Polo sheep. I tried something like this and several variations, but I still don't have a painting — a good one, that is.

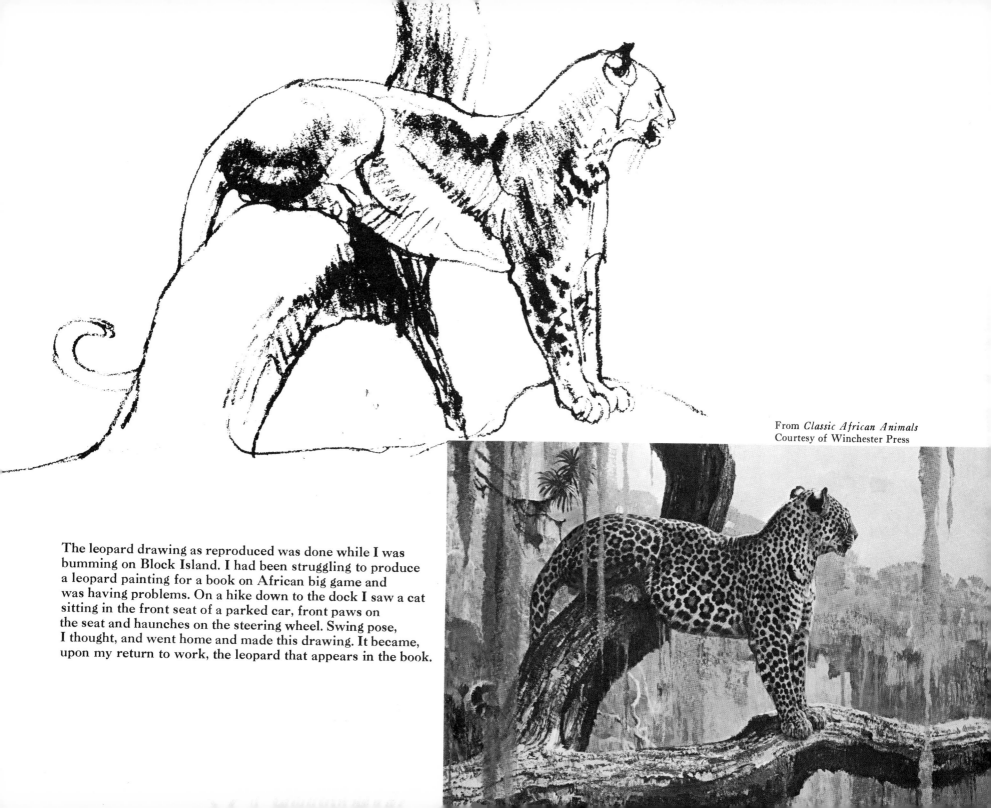

From *Classic African Animals*
Courtesy of Winchester Press

The leopard drawing as reproduced was done while I was bumming on Block Island. I had been struggling to produce a leopard painting for a book on African big game and was having problems. On a hike down to the dock I saw a cat sitting in the front seat of a parked car, front paws on the seat and haunches on the steering wheel. Swing pose, I thought, and went home and made this drawing. It became, upon my return to work, the leopard that appears in the book.

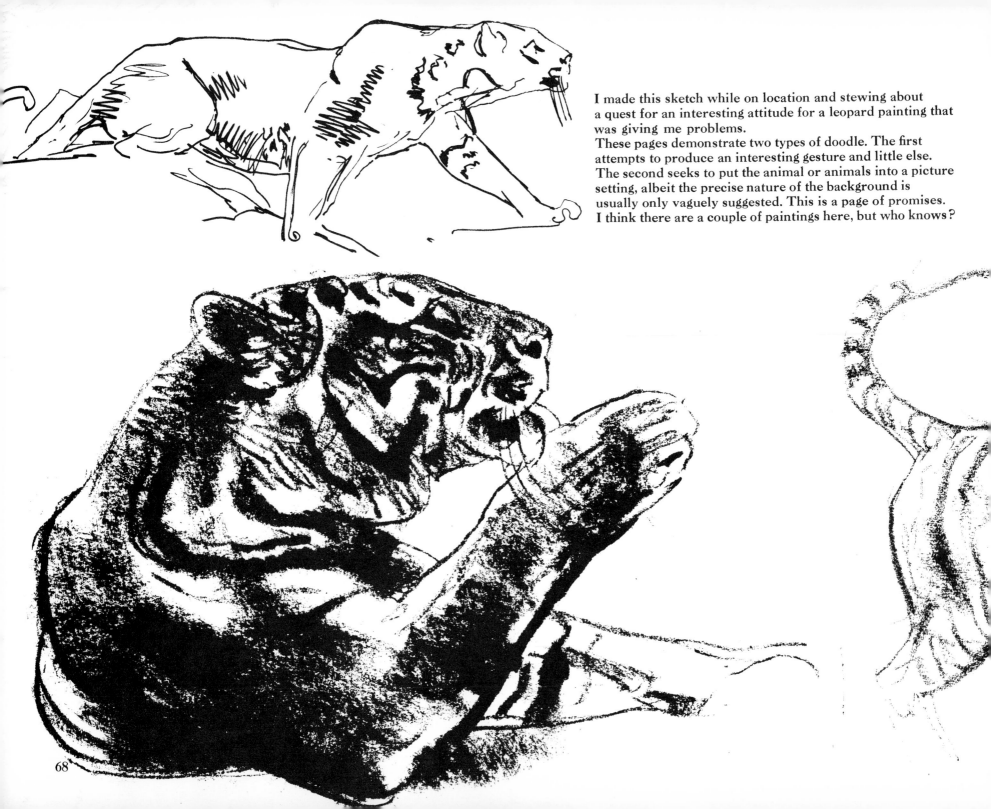

I made this sketch while on location and stewing about a quest for an interesting attitude for a leopard painting that was giving me problems.

These pages demonstrate two types of doodle. The first attempts to produce an interesting gesture and little else. The second seeks to put the animal or animals into a picture setting, albeit the precise nature of the background is usually only vaguely suggested. This is a page of promises. I think there are a couple of paintings here, but who knows?

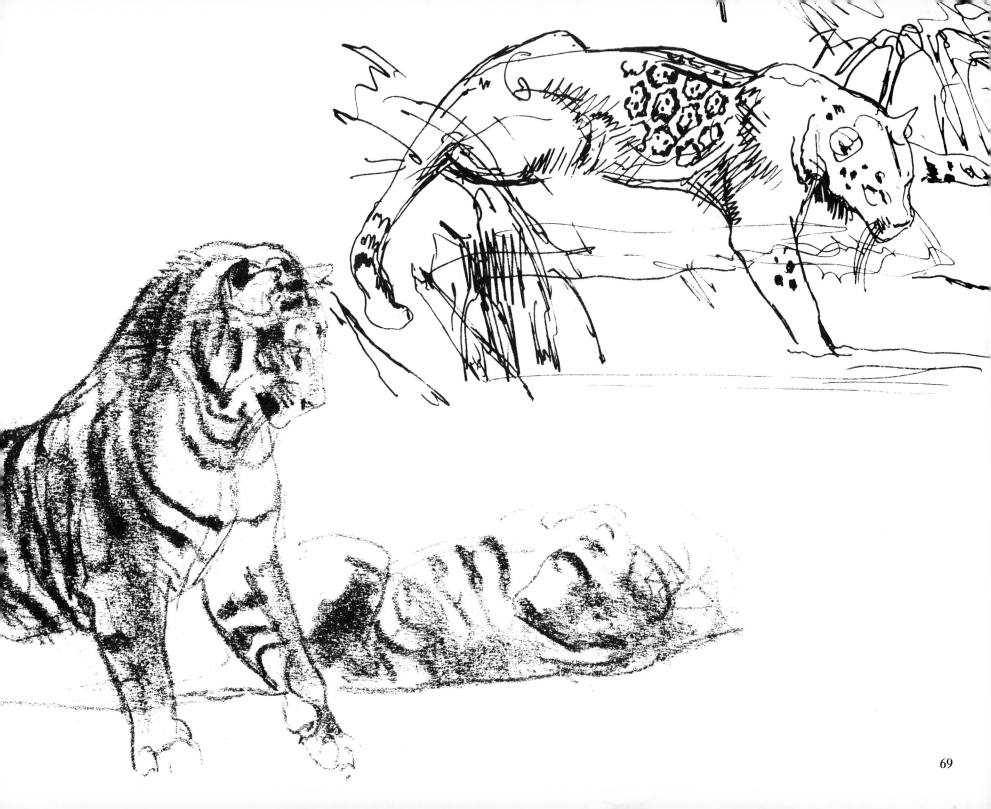

This rough squiggle became an effective painting when
I changed the proportion to a longer horizontal and made
the buffaloes in the background a procession instead of
a throng.
The bottom sketch has become a painting in progress.
Future unknown.

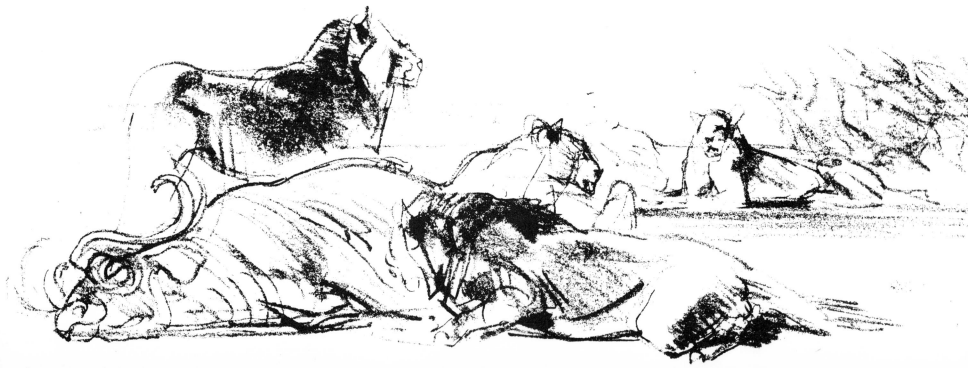

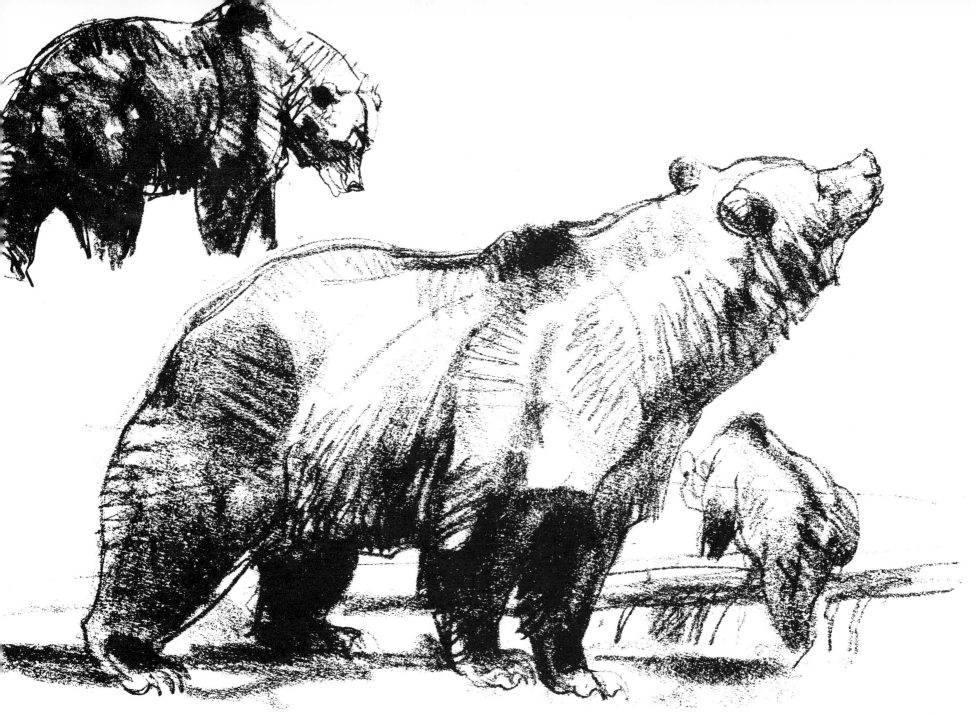

I was groping around for a bear situation. Nothing has come of this and I am not sure it ever will. Of the breakfast table preliminaries, perhaps five percent get further development. Of those that make it to the masonite panel, the success ratio is about 60-40.

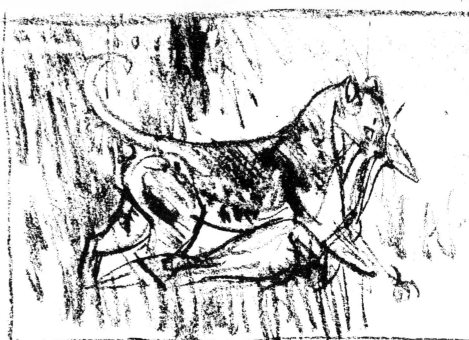

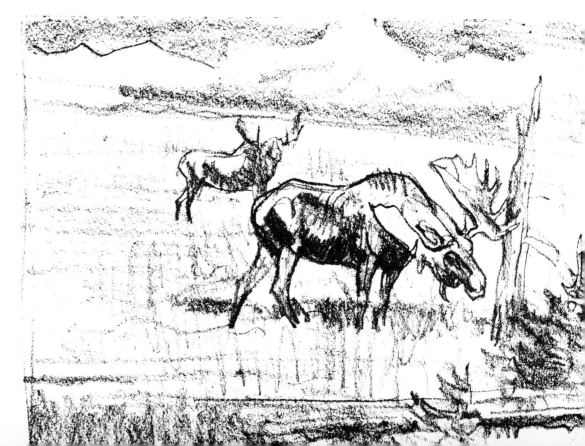

In thumbnail sketches such as these, I'm not unduly concerned with drawing excellence. With no more than is put down here, I can visualize enough to make a decision as to the prospects of an idea. None of these has been pushed further. At this stage, I do not bother with any reference material, assuming that I can develop the drawing and the precise gesture on tracing paper before transferring it to the primed board. At that point, I will use reference sources as needed.

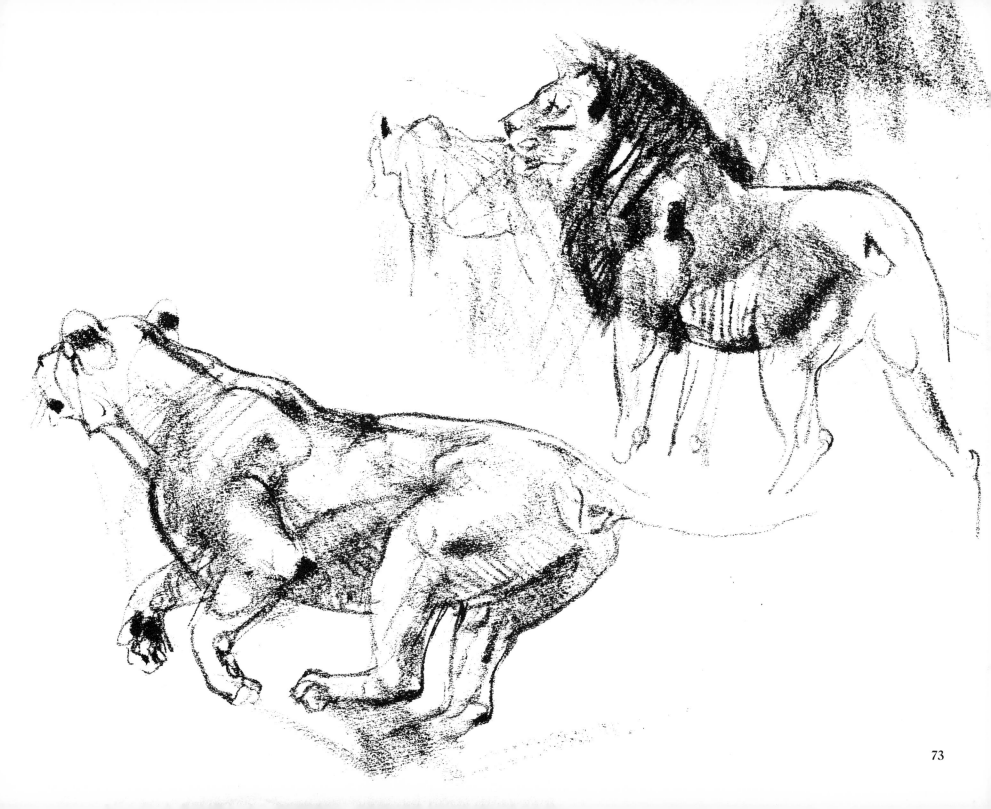

A 25-Year Apprenticeship

Though the bulk of this volume concerns itself with my present total involvement with easel painting, or so-called fine art, it would be dishonest and not a little foolish to ignore the fact that I made my living for twenty-five years as an illustrator. Whatever I'm able to accomplish now has certainly been affected by that experience. In the course of that considerable span of time, I produced hundreds of drawings and paintings at the behest of art editors or art directors good and bad. And the results of these assignments were also good and bad. A quick review of my file of my old illustrations suggests that there is as much bad as good.

Why does a professional like myself occasionally turn out work that is patently below his ability and even his standards? There are many reasons, no doubt, but two come to mind. Relations with good customers require that one execute assignments for which one has no enthusiasm. With me, indifference to the job guaranteed an indifferent result. In the case of magazine work, this lack of enthusiasm can be readily fostered by the art director who regularly selects the second or third best of the illustrator's preliminary sketches, ignoring the one that obviously excites him. Out of frustration and disappointment the fellow produces a picture that reflects his attitude. Not out of a spirit of vengeance, but because on this assignment the thrill is gone. The second factor that is built into a commercial career is the relentless battle with time. Sometimes one knows at the outset that he needs luck to finish a job on time — and more luck to make it a good one. When problems occur, as they frequently do, the quality option disappears and one then settles for adequacy. There is no time for reflection, no time to look at the object of your frantic attention with the fresh eye that a few days respite would permit you to do. When at last it appears in print, the disappointment and even embarrassment can be pretty shattering. The worst part of it is, there is no way of getting it back. It will exist, in the files of malicious or retarded collectors of research material, long after the original has been triumphantly burned.

I've thought a little about the qualities that make for a top flight illustrator. He has to be an enthusiastic researcher for one thing, and diligent and competent in selecting and directing models. He might benefit by being a bit of a dissembler. His job, after all, is to compose and then bring to life a character or group of characters in specific settings, many times with no real knowledge of the elements in his re-creation. What I mean is that he is not the one who has had the experience which he may be illuminating with his art. He must borrow the author's enthusiasm and conviction and create illustrations that ring true. This in addition to possessing the requisite technical skills and these of a very high order. There are many men and women of substantial talents who are unwilling or unable to function well in a directed or commercial context. It took me a long time to figure it out, but I now think that in my bones I'm not an illustrator, nor was I ever.

Nevertheless, and the above demurrer notwithstanding, I did function in the field for a long time and enjoyed a number of pleasant and productive associations with art directors and editors during this period and I regard this segment of my professional life as an invaluable training ground for what I am now doing. The examples reproduced in this segment will give you some idea of the pleasures and pitfalls to be encountered in the commercial art business.

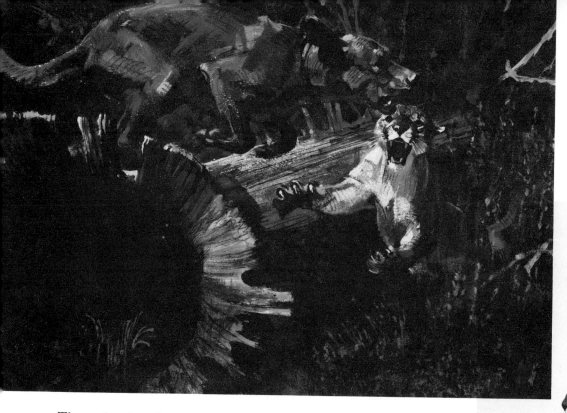

These sketches demonstrate one of the frustrations of the illustrator. In this instance, it is the *word oriented* editor. Often elements in a story that are well written offer limited pictorial possibilities. Conversely, minor references may open up dramatic possibilities to the artist. This editor always indicated the passage to be illustrated. Sometimes it foreclosed better opportunities for an exciting picture. I was very keen to do the finish of the sketch on the left. I did, instead, the one which pleased the management, but not me.

Why this distinction between commercial and fine art? In fact, the lines of separation are pretty fuzzy. To put it simply, the commercial artist performs at someone else's impetus and direction; the fine artist, in theory, paints at his own pace to his own specifications. Actually, it isn't quite that clear cut. The illustrator frequently is given wide latitude in his approach to an assignment, while many so-called fine artists find their freewheeling impulses, if they have any, curbed by the need to sell paintings to a public that exercises — by its option to buy or not to buy — a subtle form of direction. Not to mention the business of commissioning paintings where subject and treatment are discussed before the work commences. After all, wasn't Michelangelo an old, beset commercial artist as he labored on the ceiling of the Sistine Chapel? He was most certainly under orders. Having worn both hats I can offer as my opinion that, however small the real distinctions are, the life of the easel painter is the more fulfilling.

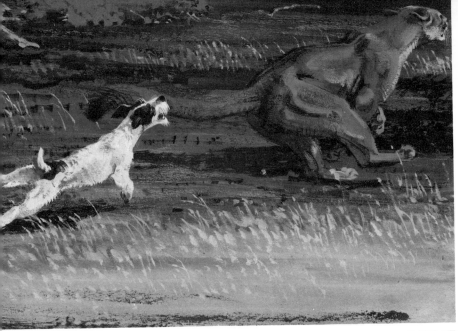

MINE

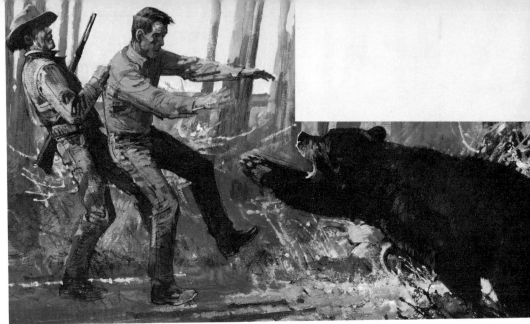

MINE

These two versions might have posed a dilemma to the art editor. The one chosen perhaps says more, but the reject says it better. I wanted to do the simpler solution.

THEIRS

The real point here is to demonstrate how a seemingly minor change can ruin a picture. The editorial request was to change the hand hauling the kid away from the bear. In the process of making it, the dynamics of the action were lost, along with my enthusiasm and the possibility of a good illustration.

THEIRS

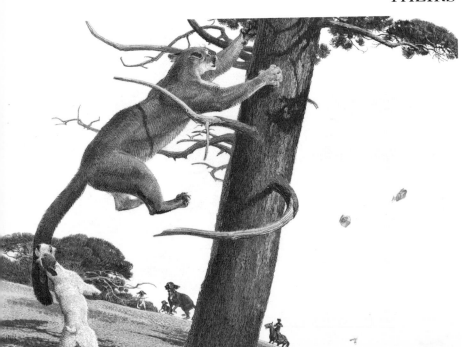

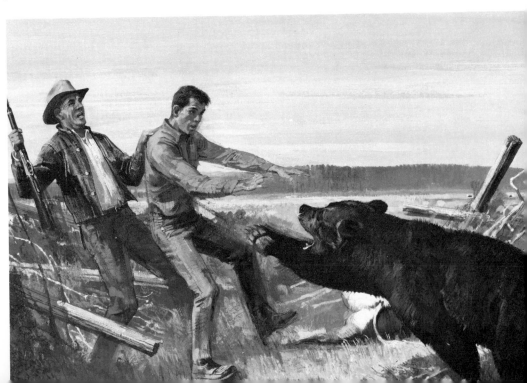

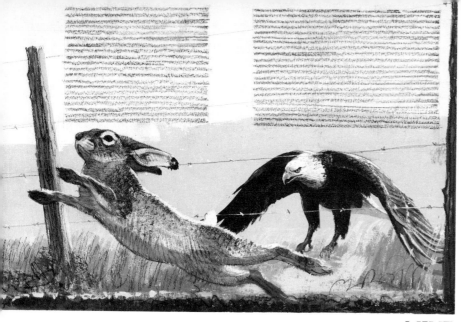

MINE

These sketches serve to affirm a good editorial choice. I think the sketch chosen and redone for purposes of reproduction was much the better of the two.

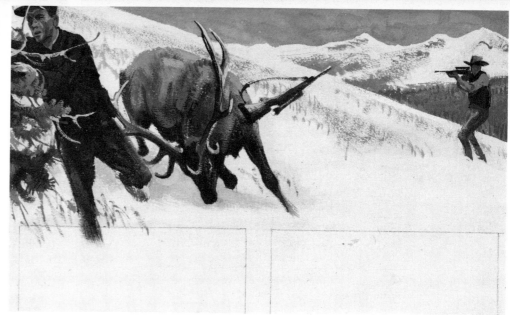

THEIRS

Here's a case where I really didn't have a preference. I think either one would have made a dramatic illustration, and I would not have sulked had the choice been the sketch above rather than the one shown as reproduced below.

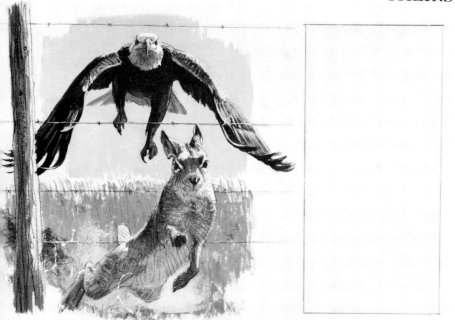

THEIRS

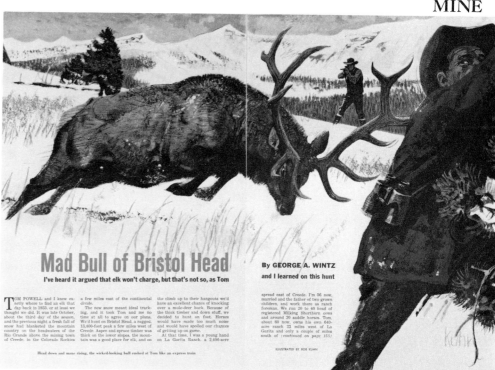

MINE

Mad Bull of Bristol Head

I've heard it argued that elk won't charge, but that's not so, as Tom

By GEORGE A. WINTZ

and I learned on this hunt

TOM POWELL and I knew exactly where to find an elk that day back in 1955, or at least we thought we did. It was late October, about the third day of the season, and the previous night a fresh fall of snow had blanketed the mountain country on the headwaters of the Rio Grande above the mining town of Creede, in the Colorado Rockies

a few miles east of the continental divide.

The new snow meant ideal tracking, and it took Tom and me no time at all to agree on our plans. We'd hunt on Bristol Head, a rugged, 13,600-foot peak a few miles west of Creede. Aspen and spruce timber was thick on the lower slopes, the mountain was a good place for elk, and on

the climb up to their hangouts we'd have an excellent chance of knocking over a mule-deer buck. Because of the thick timber and down stuff, we decided to hunt on foot. Horses would have made too much noise and would have spoiled our chances of getting up on game.

At that time, I was a young hand on La Garita Ranch, a 2,400-acre

spread east of Creede. I'm 56 now, married and the father of two grown children, and work there as ranch foreman. We run 20 to 40 head of registered Milking Shorthorn cows and around 20 saddle horses. Tom, about 60 now, owns his own 640-acre ranch 23 miles west of La Garita and only a couple of miles south of *(continued on page 123)*

ILLUSTRATED BY BOB KUHN

Head down and mane rising, the wicked-looking bull rushed at Tom like an express train

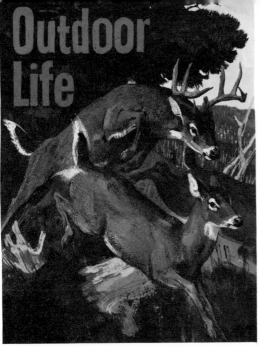

This is a good example of a sketch that was translated into the finished art with almost no modifications, except for certain improvements in the details of the deer.
I just enlarged the sketch by 50% and did it again.

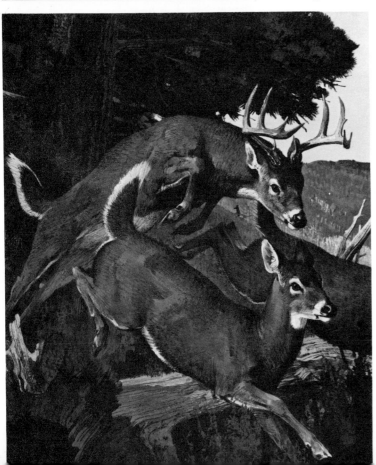

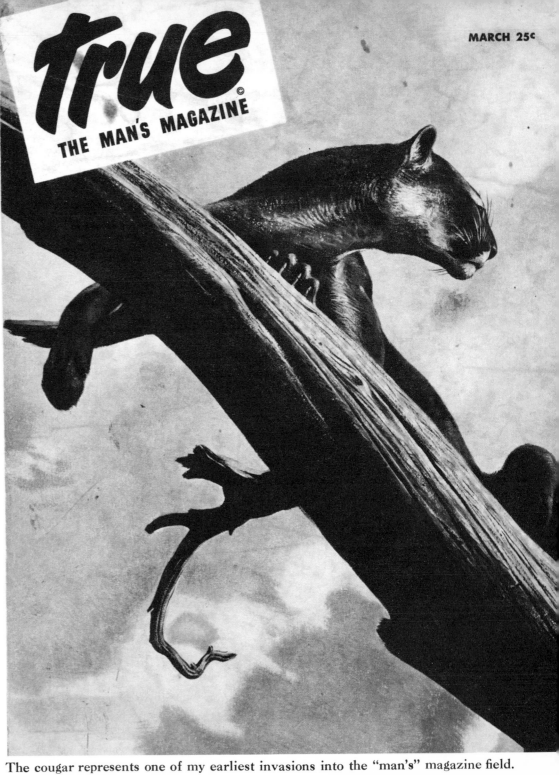

MARCH 25c

The cougar represents one of my earliest invasions into the "man's" magazine field.

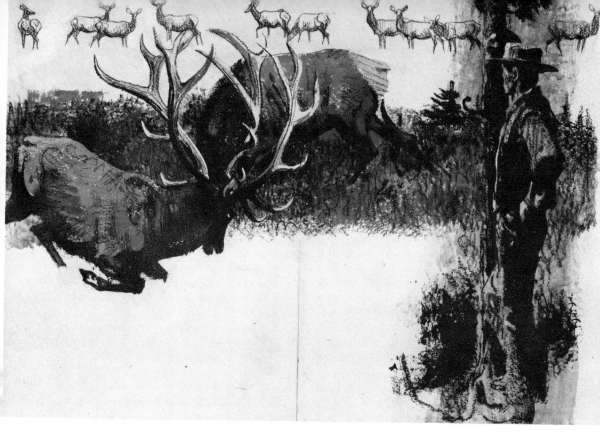

The sketches here are carried somewhat further than necessary. This must present art editors with a dilemma. There is no guarantee that the finished illustration will capture the spontaneity of a good comprehensive sketch, but to habitually opt for the artist's first effort is to give up their traditional role as shaper of the publication's graphic character. I wish that there was more willingness on the part of editors to use a superior sketch even if a finish has been subsequently done.

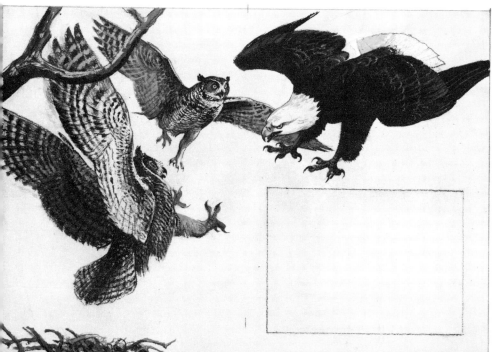

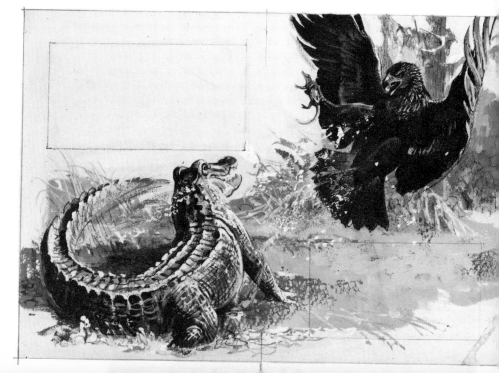

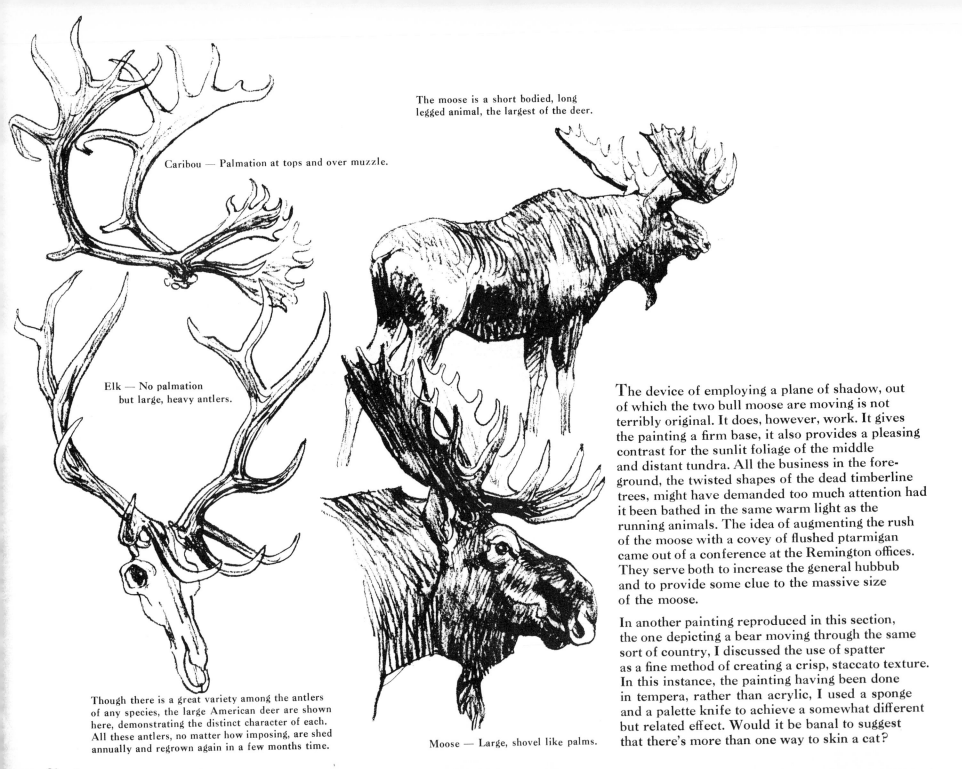

Caribou — Palmation at tops and over muzzle.

The moose is a short bodied, long legged animal, the largest of the deer.

Elk — No palmation but large, heavy antlers.

Though there is a great variety among the antlers of any species, the large American deer are shown here, demonstrating the distinct character of each. All these antlers, no matter how imposing, are shed annually and regrown again in a few months time.

Moose — Large, shovel like palms.

The device of employing a plane of shadow, out of which the two bull moose are moving is not terribly original. It does, however, work. It gives the painting a firm base, it also provides a pleasing contrast for the sunlit foliage of the middle and distant tundra. All the business in the foreground, the twisted shapes of the dead timberline trees, might have demanded too much attention had it been bathed in the same warm light as the running animals. The idea of augmenting the rush of the moose with a covey of flushed ptarmigan came out of a conference at the Remington offices. They serve both to increase the general hubbub and to provide some clue to the massive size of the moose.

In another painting reproduced in this section, the one depicting a bear moving through the same sort of country, I discussed the use of spatter as a fine method of creating a crisp, staccato texture. In this instance, the painting having been done in tempera, rather than acrylic, I used a sponge and a palette knife to achieve a somewhat different but related effect. Would it be banal to suggest that there's more than one way to skin a cat?

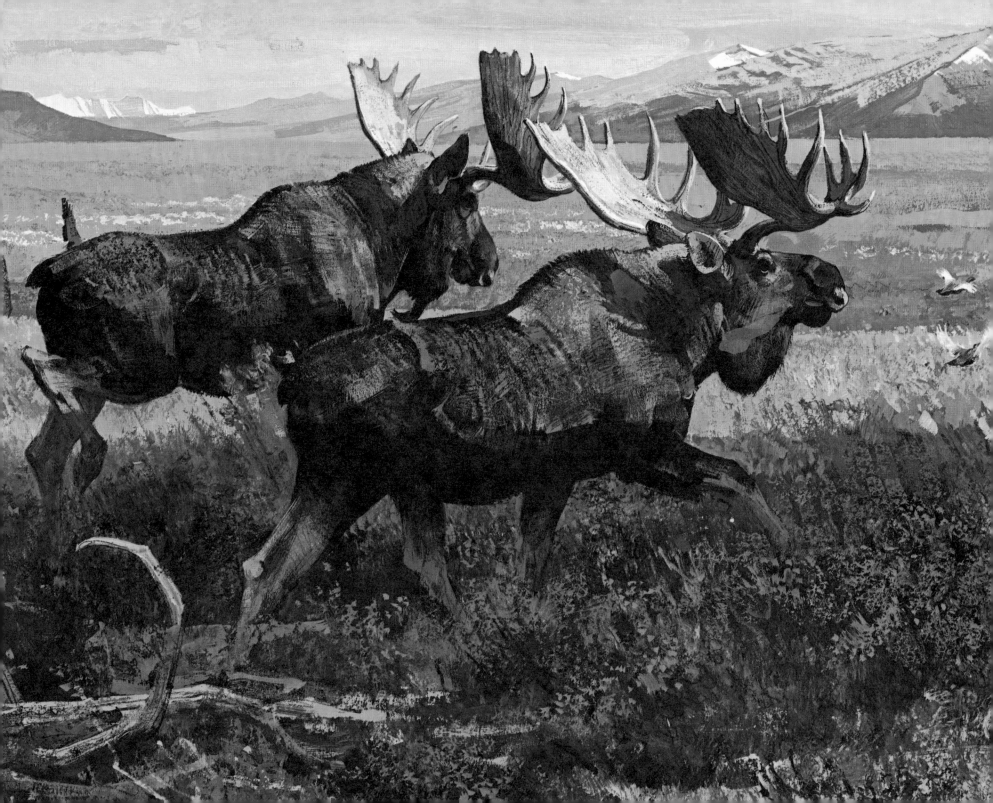

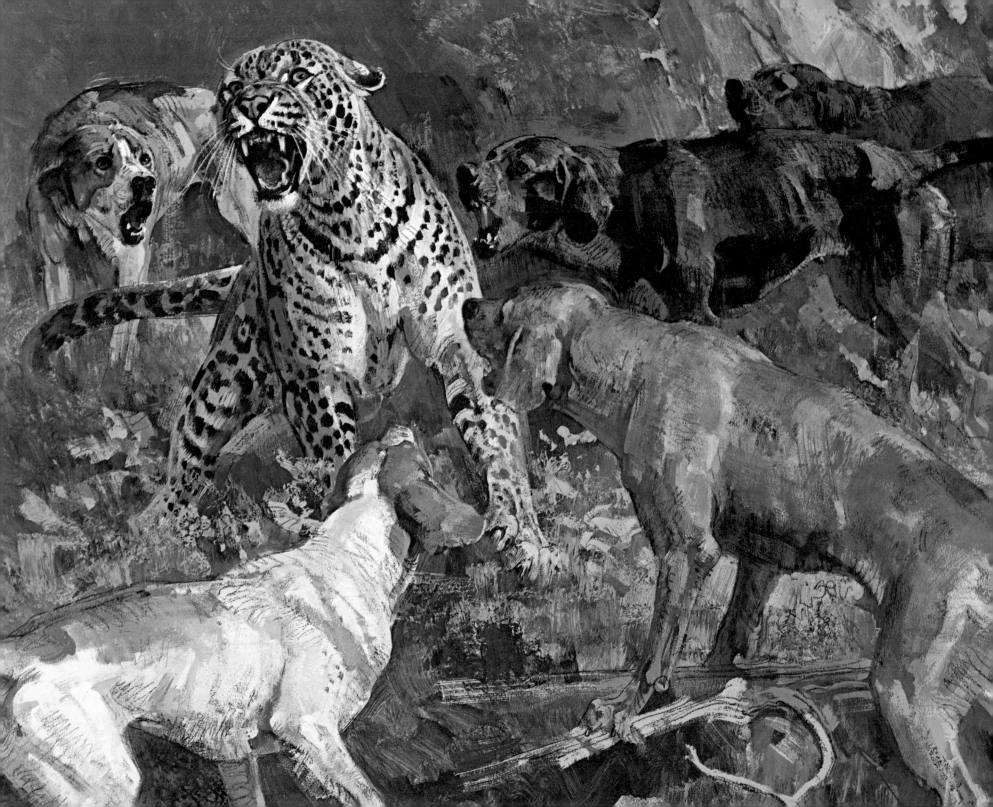

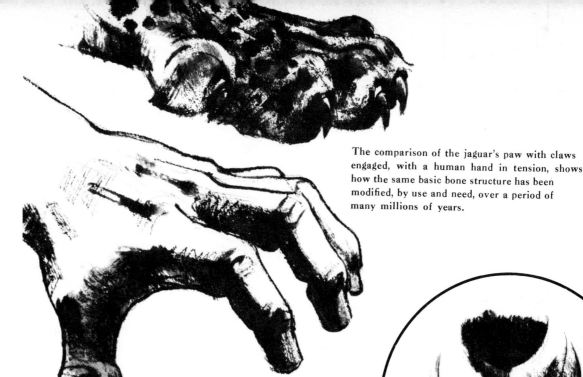

The comparison of the jaguar's paw with claws engaged, with a human hand in tension, shows how the same basic bone structure has been modified, by use and need, over a period of many millions of years.

All predators' jaws interlock. When painting a snarling cat, bear in mind that there is a pattern to the teeth — that the mouth — so formidable when open, must be able to close.

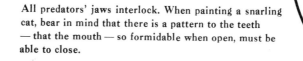

← It is very difficult to resist the temptation to freeze the action in a situation such as this. Yet, you know that such a confrontation of hounds and cat is a riot of sound and movement. Something of that spirit must be caught in the painting by any means at all. Here, for one thing, the setting is largely unexplained because a riveting battle of this sort would totally dominate your awareness. As the stage director of this scene, you can make certain that the viewer shares your pre-occupation with the action by supplying him with few if any diversions. There is an overall brightness of light and color, this to further underline the excitement of the situation. The placement of the hounds serves to lead you to *their* center of attention and yours — the very angry jaguar.

Look for those places where the bones are closest to the skin. These areas are the most descriptive of an animal's anatomy and action.

The sables fighting over the gallery of mildly interested females are doing what adult males of many horned species do, but none with more enthusiasm than they. I have never been in the part of Africa where these elegant animals are common so I leaned a little harder than usual on published reference material. I have made some constructive changes in the attitudes of the males and added the females which are always the motivation for such skirmishes even when not in view. The juxtaposition of vivid green with areas of red brown and grey is a pleasing one to me and very much in order in many parts of Africa. One can play with these colors with a degree of abandon since the discipline imposed by the need to paint recognizable trees and shrubs can be largely ignored. One can work within such a background area in almost abstract terms, bound only by a need to preserve the sense of place. Is the tree in the foreground unnecessary? I think it heightens the three-dimensional quality of the painting, but perhaps it is more diverting than usual.

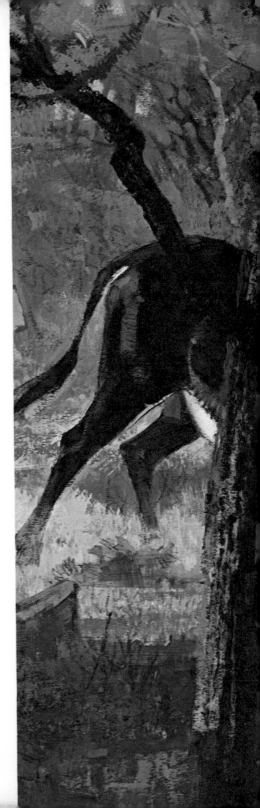

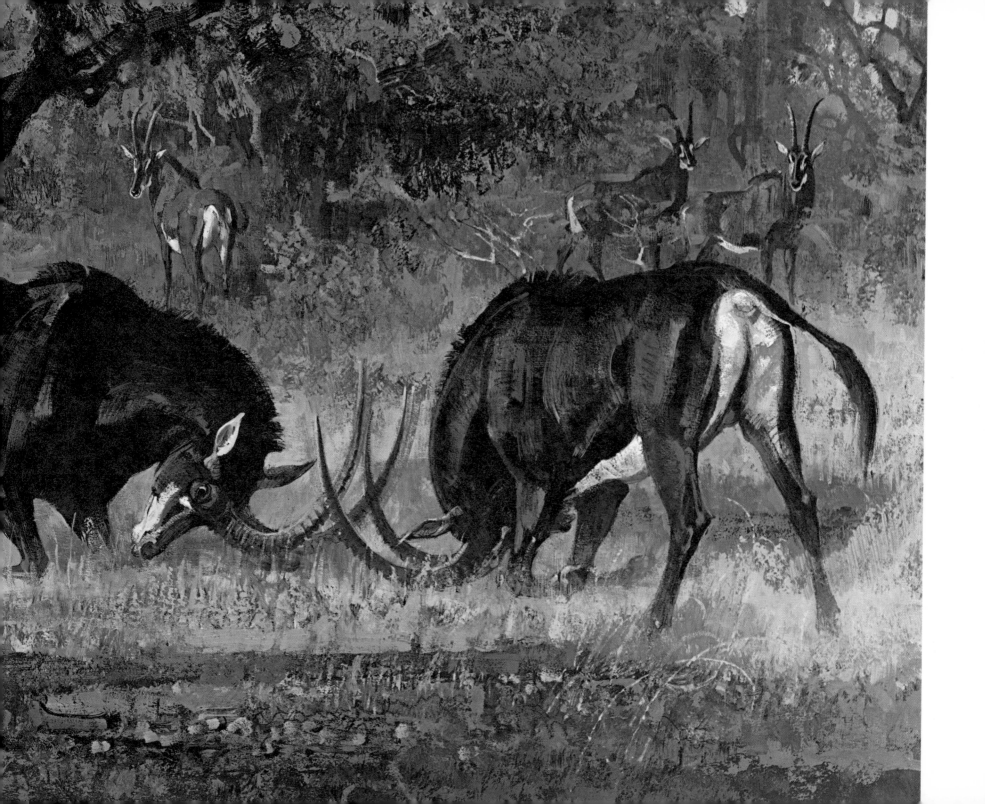

The rather simple diagram shows the main lines of force underlying the painting. All motion (except the rabbit) opposes the strong diagonal of the stone wall. The general direction of tree and grass shadows repeats this diagonal. The flow of action of the beagles curls over the wall in opposition to it, then back along it. At the end of this curve, in effect extending it, is the center of all attention — the fleeing rabbit.

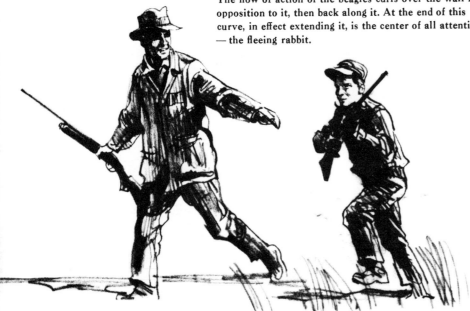

The figures in the painting were, as were all important figures in my illustrations, photographed with a Land camera: first, to capture the gesture, then refined if additional animation proved necessary. Sometimes I had models posed and photographed professionally, but more often a good clear "instant replay" photo was the source that was translated into an element in the illustration or painting, engaged in some sort of outdoor activity.

Such problems as were posed by this painting are largely organizational. Some painters, Harold Von Schmidt for one, can juggle many picture elements without losing control of them. I don't relish complex situations and avoid them when possible. I was fortunate here to have most of the landscape details handy to my studio and could venture forth whenever I needed fresh ideas of color or texture. In painting the beagles, I borrowed some action from photos and improvised the rest. Father and son were posed and photographed and then fitted into the composition. The key to the painting is the much embellished diagonal line of the stone wall. Opposing it is the line of motion of the hunters and two of the beagles. It is the focus of much of the interesting detail in the painting. The shadow on the snow and the most obvious branch of the background oak tree repeat its major thrust. But enough of this, I do not thusly reason out a composition. I put down what is essential and modify it or oppose it as instinct and not reason dictates. The ultimate test is . . . does it balance? And this my eye and not my mind tells me.

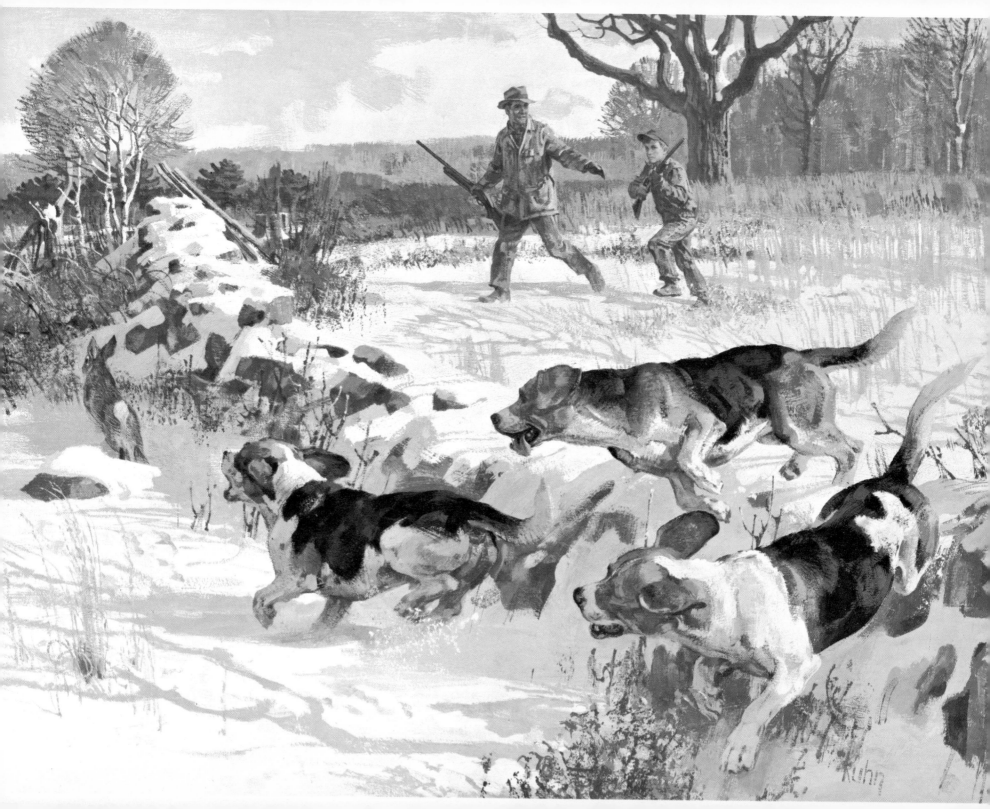

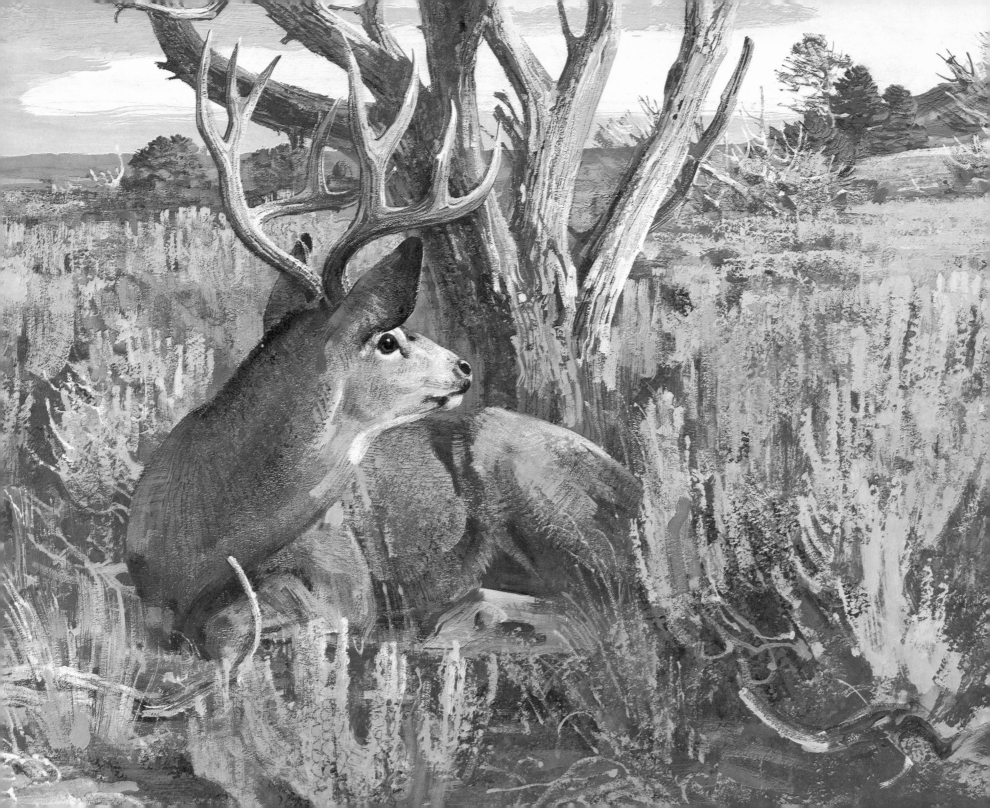

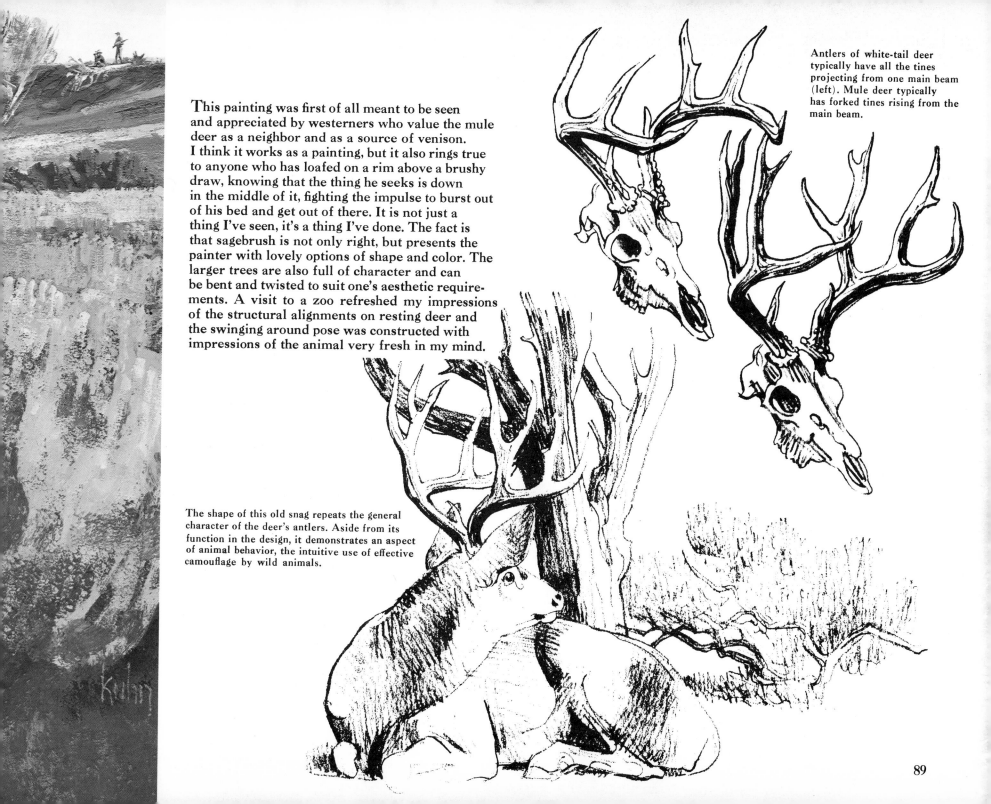

This painting was first of all meant to be seen and appreciated by westerners who value the mule deer as a neighbor and as a source of venison. I think it works as a painting, but it also rings true to anyone who has loafed on a rim above a brushy draw, knowing that the thing he seeks is down in the middle of it, fighting the impulse to burst out of his bed and get out of there. It is not just a thing I've seen, it's a thing I've done. The fact is that sagebrush is not only right, but presents the painter with lovely options of shape and color. The larger trees are also full of character and can be bent and twisted to suit one's aesthetic requirements. A visit to a zoo refreshed my impressions of the structural alignments on resting deer and the swinging around pose was constructed with impressions of the animal very fresh in my mind.

Antlers of white-tail deer typically have all the tines projecting from one main beam (left). Mule deer typically has forked tines rising from the main beam.

The shape of this old snag repeats the general character of the deer's antlers. Aside from its function in the design, it demonstrates an aspect of animal behavior, the intuitive use of effective camouflage by wild animals.

89

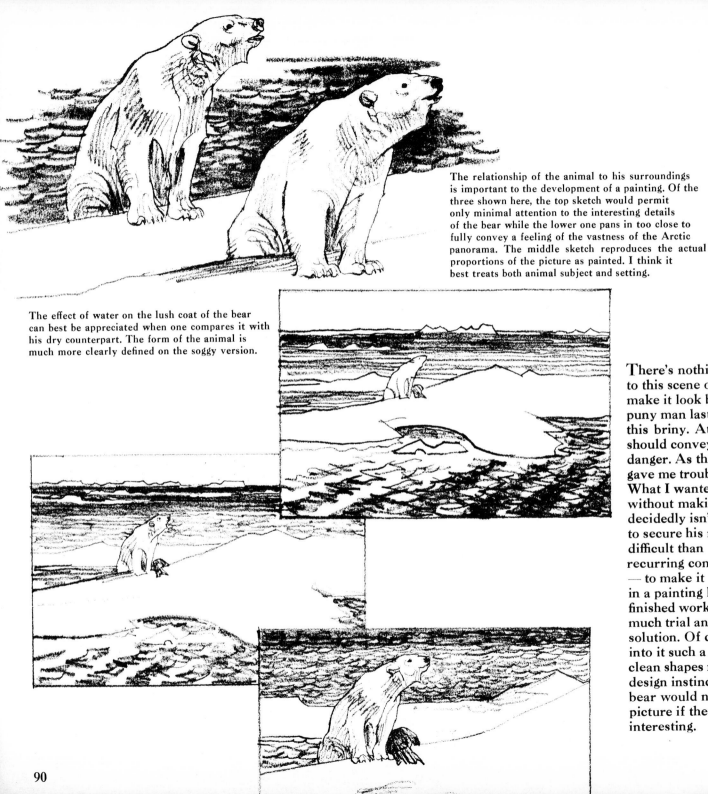

The relationship of the animal to his surroundings is important to the development of a painting. Of the three shown here, the top sketch would permit only minimal attention to the interesting details of the bear while the lower one pans in too close to fully convey a feeling of the vastness of the Arctic panorama. The middle sketch reproduces the actual proportions of the picture as painted. I think it best treats both animal subject and setting.

The effect of water on the lush coat of the bear can best be appreciated when one compares it with his dry counterpart. The form of the animal is much more clearly defined on the soggy version.

There's nothing exceptional about the approach to this scene of ice and water. The trick was to make it look both bright and cold. It's a fact that puny man lasts about fifteen minutes if dunked in this briny. At these latitudes, the water as painted should convey the dual qualities of beauty and danger. As the painting developed, the thing that gave me trouble was the near foreleg of the bear. What I wanted to convey was his total wetness without making him look scrawny which he most decidedly isn't. To hint at the power just employed to secure his meal, but not overdo it, was more difficult than it should have been. That is a recurring consideration in most of these paintings — to make it look easy. No matter that an area in a painting has been redone many times, the finished work must give no hint of the agony of much trial and error, only the pleasure of the final solution. Of course, any situation which has built into it such a fine opportunity to arrange large, clean shapes requires the application of one's design instincts to the fullest. A beautifully painted bear would not be enough to carry this sort of picture if the overall pattern were not also interesting.

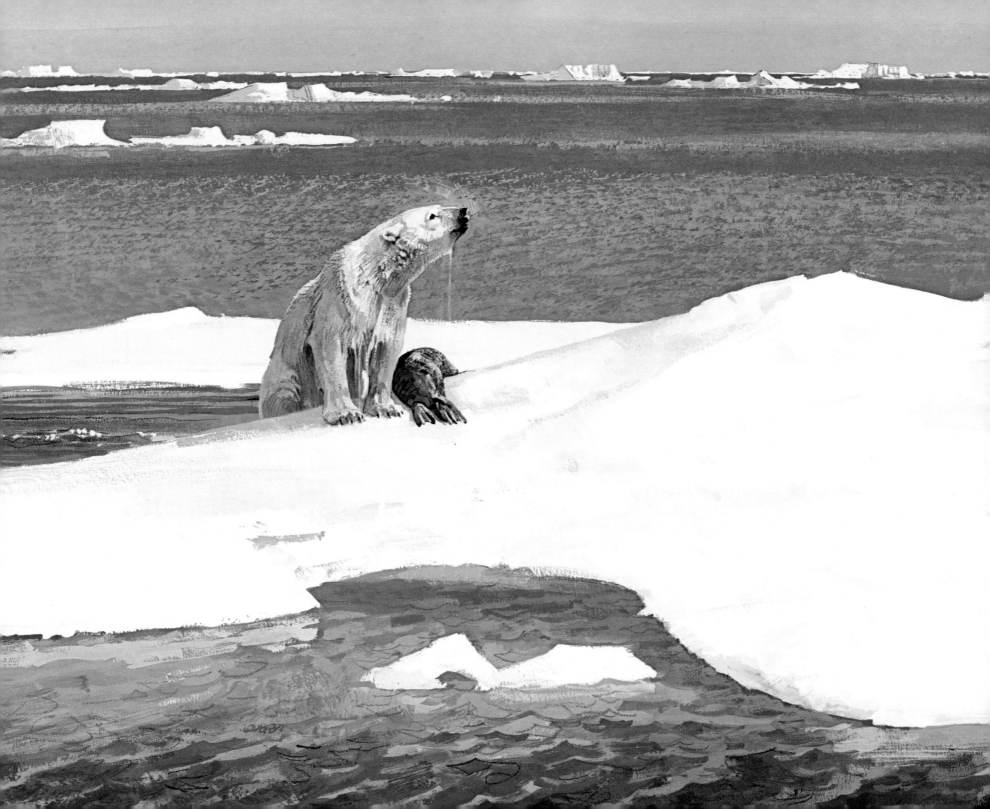

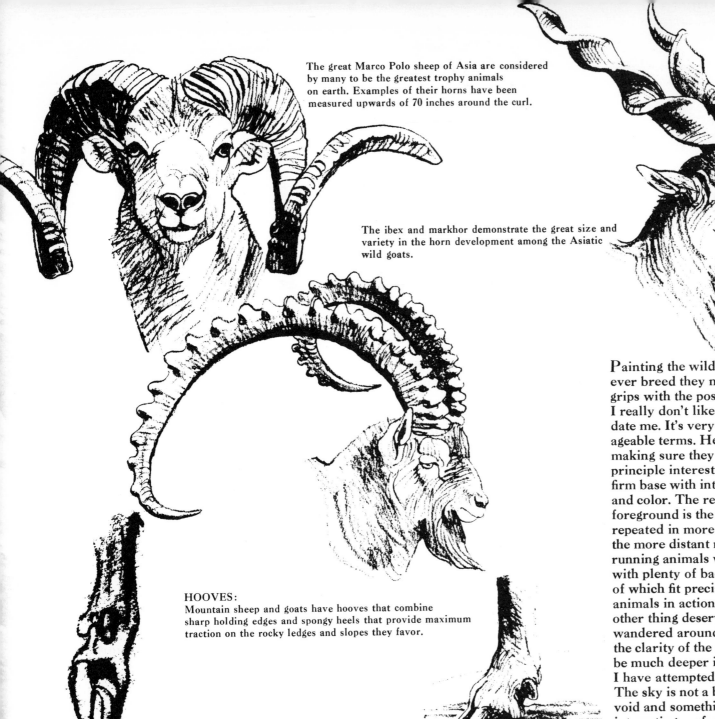

The great Marco Polo sheep of Asia are considered by many to be the greatest trophy animals on earth. Examples of their horns have been measured upwards of 70 inches around the curl.

The ibex and markhor demonstrate the great size and variety in the horn development among the Asiatic wild goats.

HOOVES:
Mountain sheep and goats have hooves that combine sharp holding edges and spongy heels that provide maximum traction on the rocky ledges and slopes they favor.

Painting the wild sheep of the mountains, whatever breed they may be, requires one to come to grips with the postcard backgrounds they live in. I really don't like to paint mountains. They intimidate me. It's very tough to reduce them to manageable terms. Here I have just put them down making sure they stay where they belong. My principle interest lies in giving the animals a good firm base with interesting shapes and strong values and color. The red in the plant growth in the foreground is the brightest color note but it is repeated in more muted form in the sheep and the more distant mountains. The gestures of the running animals were worked out on tracing paper, with plenty of back-up reference material, none of which fit precisely. After all, re-creating animals in action is what they pay me for. One other thing deserves mention. Anyone who has wandered around in high country will remember the clarity of the air. While the sky might actually be much deeper in color than as I have painted it, I have attempted to capture the quality of vibrancy. The sky is not a blue curtain. It is a throbbing void and something of that will make for a more interesting surface and truer response to the subject.

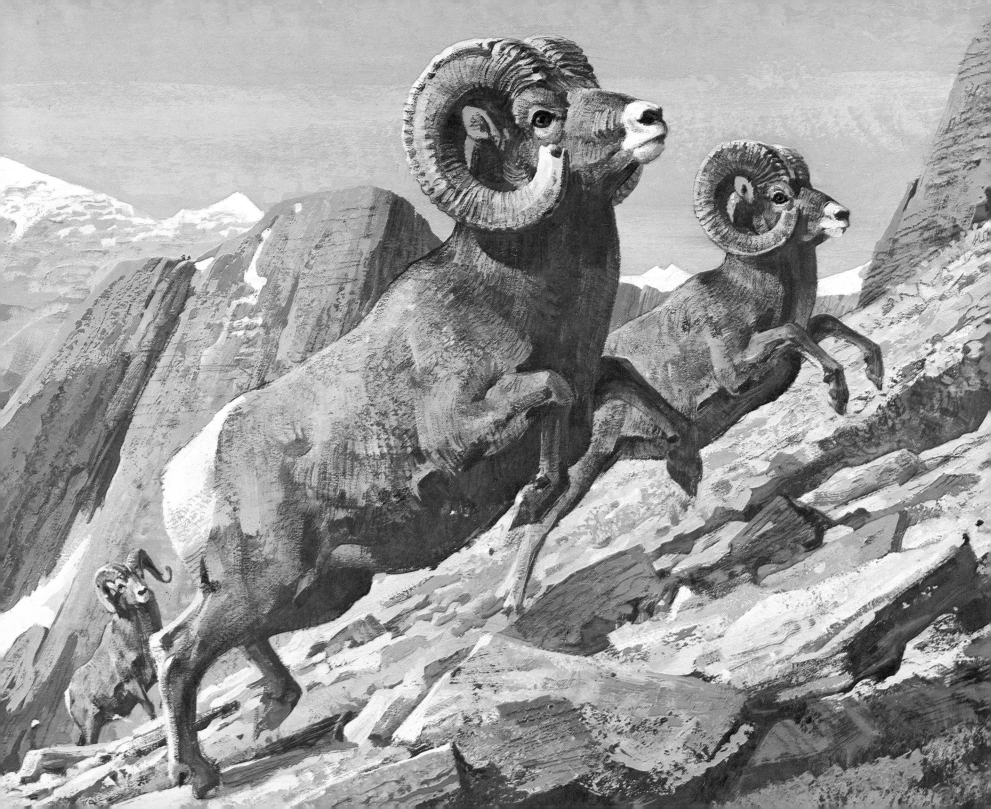

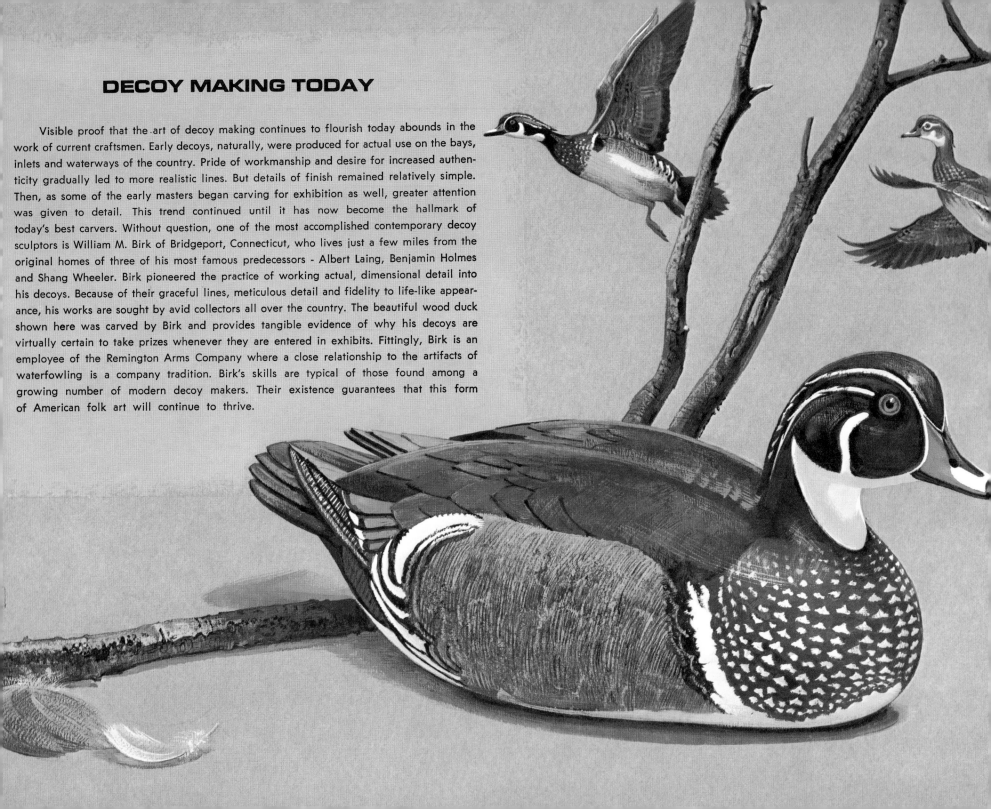

DECOY MAKING TODAY

Visible proof that the art of decoy making continues to flourish today abounds in the work of current craftsmen. Early decoys, naturally, were produced for actual use on the bays, inlets and waterways of the country. Pride of workmanship and desire for increased authenticity gradually led to more realistic lines. But details of finish remained relatively simple. Then, as some of the early masters began carving for exhibition as well, greater attention was given to detail. This trend continued until it has now become the hallmark of today's best carvers. Without question, one of the most accomplished contemporary decoy sculptors is William M. Birk of Bridgeport, Connecticut, who lives just a few miles from the original homes of three of his most famous predecessors - Albert Laing, Benjamin Holmes and Shang Wheeler. Birk pioneered the practice of working actual, dimensional detail into his decoys. Because of their graceful lines, meticulous detail and fidelity to life-like appearance, his works are sought by avid collectors all over the country. The beautiful wood duck shown here was carved by Birk and provides tangible evidence of why his decoys are virtually certain to take prizes whenever they are entered in exhibits. Fittingly, Birk is an employee of the Remington Arms Company where a close relationship to the artifacts of waterfowling is a company tradition. Birk's skills are typical of those found among a growing number of modern decoy makers. Their existence guarantees that this form of American folk art will continue to thrive.

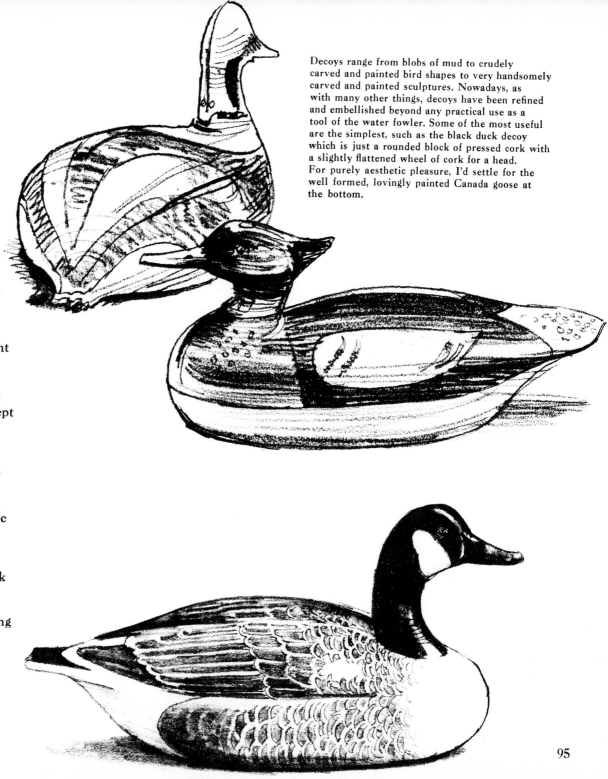

Decoys range from blobs of mud to crudely carved and painted bird shapes to very handsomely carved and painted sculptures. Nowadays, as with many other things, decoys have been refined and embellished beyond any practical use as a tool of the water fowler. Some of the most useful are the simplest, such as the black duck decoy which is just a rounded block of pressed cork with a slightly flattened wheel of cork for a head. For purely aesthetic pleasure, I'd settle for the well formed, lovingly painted Canada goose at the bottom.

During the years that I was doing the Remington calendar, I painted many subjects that were comfortable for me. Even so, there was much gathering of background material, the usual bringing of elements together, creating a consistent light source and then producing a painting of convincing reality.

It was really fun, therefore, to be able to assemble the components of this decoy arrangement (except the flying ducks) bathe them in a field of unchanging light and just paint what I saw. The branch that runs through the composition and becomes the tree the ducks are flying through, the wood duck breast feathers that were used to create the dry fly sticking out of the branch, were exercises in ingenuity that had little or no aesthetic value but made the whole creation more fun. The editor of this volume, Howard Munce, and I were discussing the odd truth that changing subjects (or projects) as one attacks a heavy work load is like spending two days at the beach. Well, maybe not quite, but there *is* a new surge of interest and enthusiasm attendant to this shifting of gears. Thus this atypical effort was refreshing and turned out well, I think.

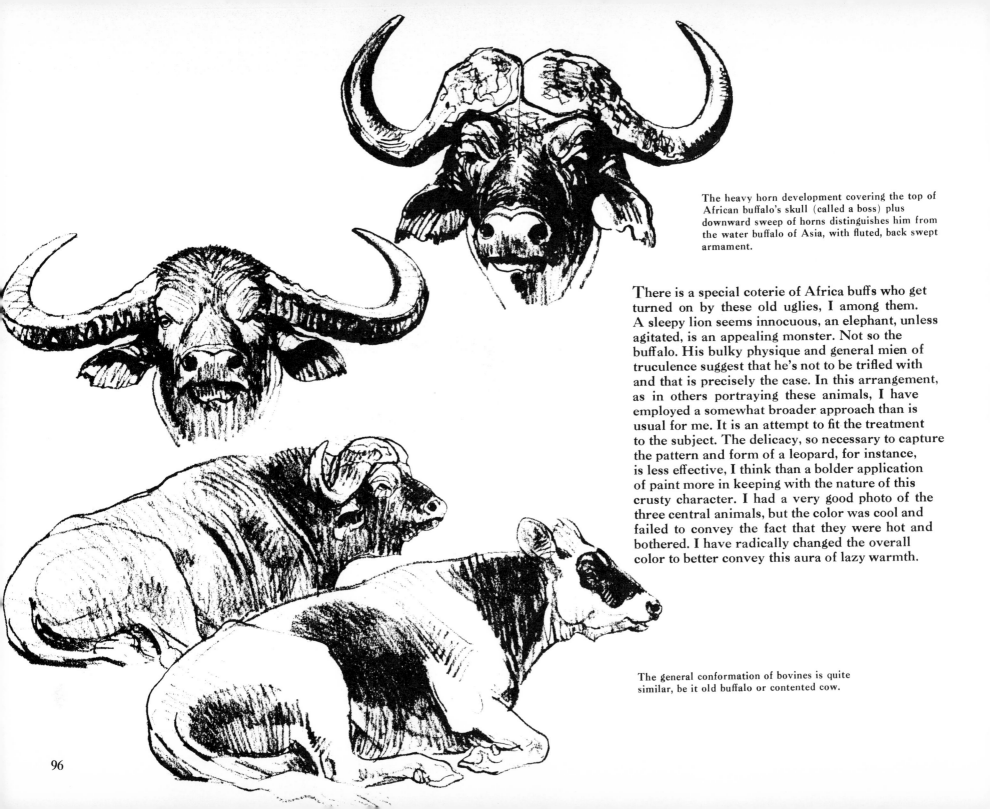

The heavy horn development covering the top of African buffalo's skull (called a boss) plus downward sweep of horns distinguishes him from the water buffalo of Asia, with fluted, back swept armament.

There is a special coterie of Africa buffs who get turned on by these old uglies, I among them. A sleepy lion seems innocuous, an elephant, unless agitated, is an appealing monster. Not so the buffalo. His bulky physique and general mien of truculence suggest that he's not to be trifled with and that is precisely the case. In this arrangement, as in others portraying these animals, I have employed a somewhat broader approach than is usual for me. It is an attempt to fit the treatment to the subject. The delicacy, so necessary to capture the pattern and form of a leopard, for instance, is less effective, I think than a bolder application of paint more in keeping with the nature of this crusty character. I had a very good photo of the three central animals, but the color was cool and failed to convey the fact that they were hot and bothered. I have radically changed the overall color to better convey this aura of lazy warmth.

The general conformation of bovines is quite similar, be it old buffalo or contented cow.

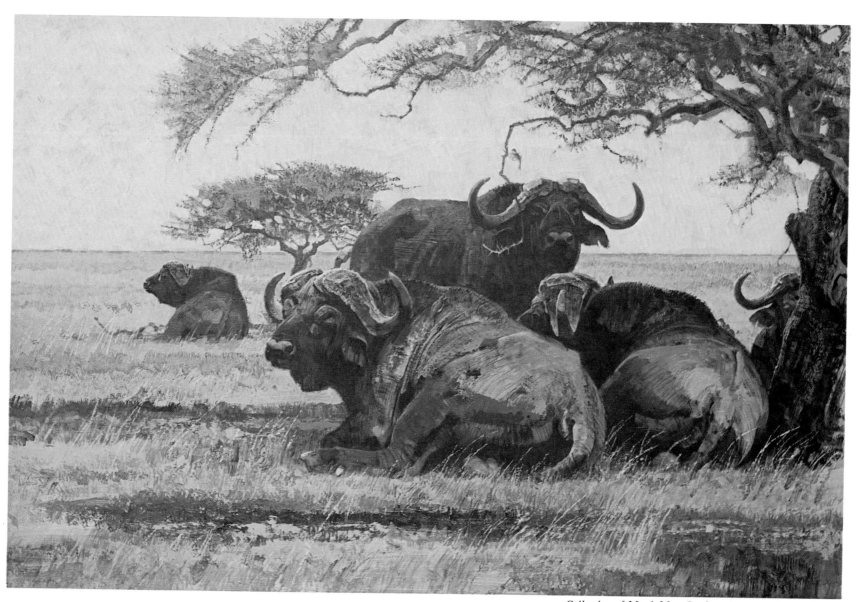

Collection of Mr. & Mrs. Gordon Lisser, San Francisco, Ca.

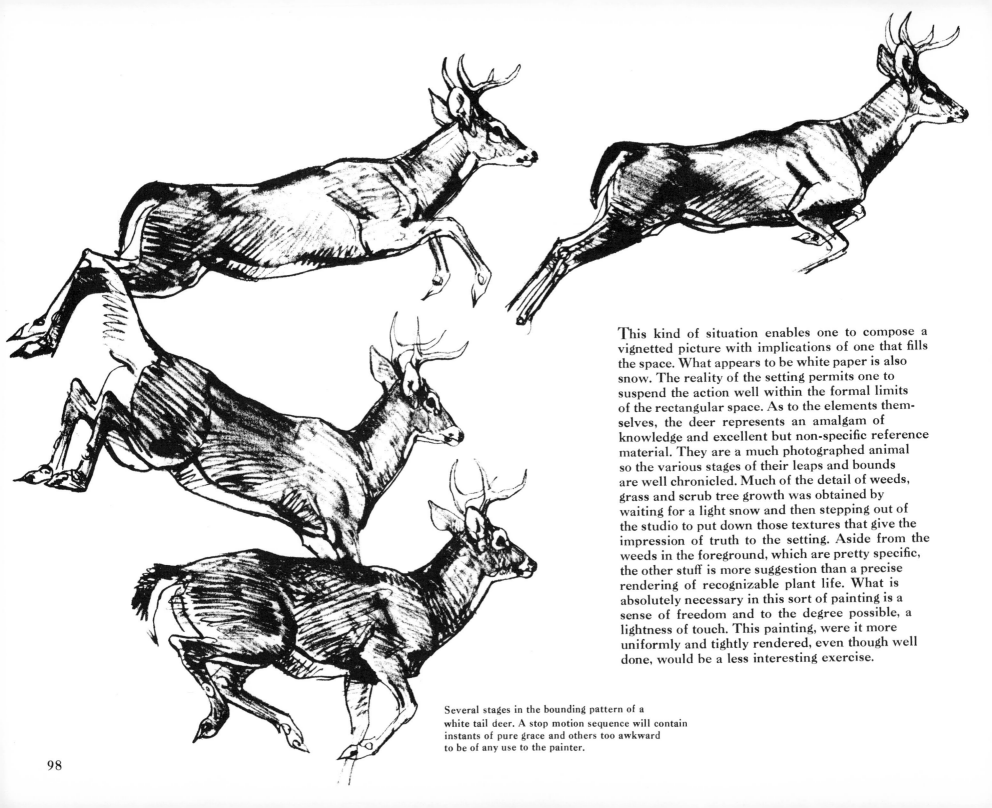

This kind of situation enables one to compose a vignetted picture with implications of one that fills the space. What appears to be white paper is also snow. The reality of the setting permits one to suspend the action well within the formal limits of the rectangular space. As to the elements themselves, the deer represents an amalgam of knowledge and excellent but non-specific reference material. They are a much photographed animal so the various stages of their leaps and bounds are well chronicled. Much of the detail of weeds, grass and scrub tree growth was obtained by waiting for a light snow and then stepping out of the studio to put down those textures that give the impression of truth to the setting. Aside from the weeds in the foreground, which are pretty specific, the other stuff is more suggestion than a precise rendering of recognizable plant life. What is absolutely necessary in this sort of painting is a sense of freedom and to the degree possible, a lightness of touch. This painting, were it more uniformly and tightly rendered, even though well done, would be a less interesting exercise.

Several stages in the bounding pattern of a white tail deer. A stop motion sequence will contain instants of pure grace and others too awkward to be of any use to the painter.

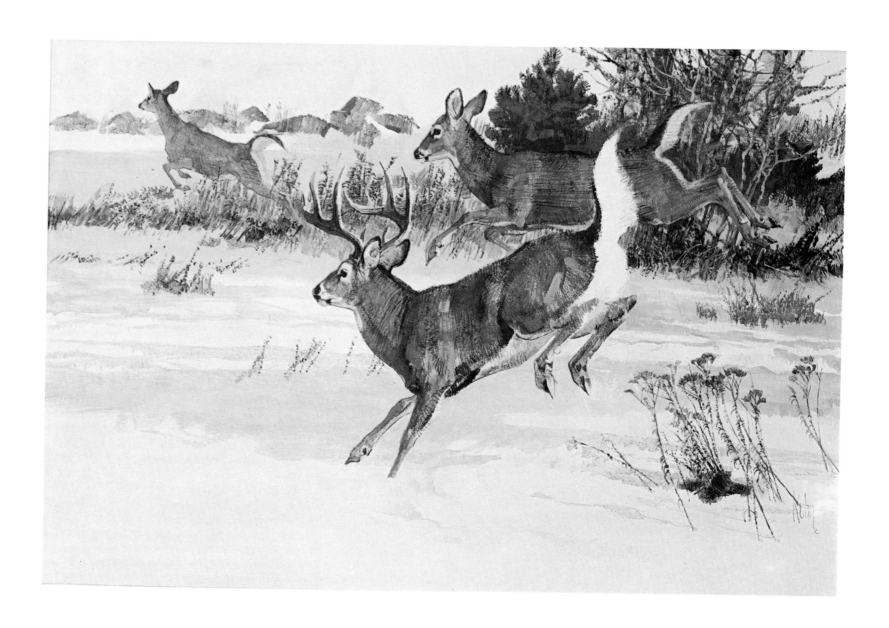

The elegant giraffe lends itself to some atypical picture shapes.
While one might expect it to fit neatly into a narrow vertical,
it can be equally amusing if the same shape is tipped sideways.

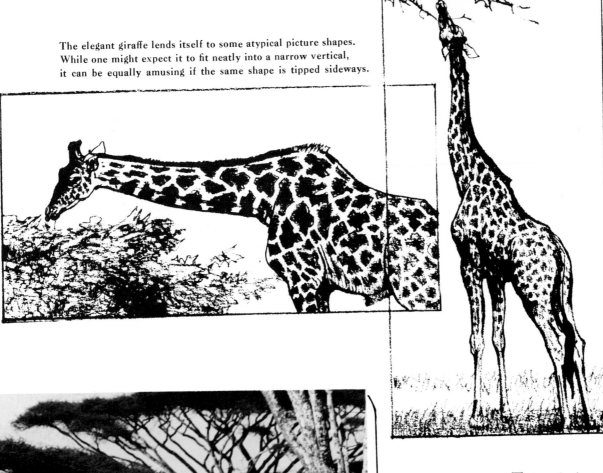

Eliminate most
broken branches
which negate
sweep of tree

Remove tree

Condense vertical
dimension

Add wall to wall
wilde beeste

Bring the giraffe up to same plane as others

More light on giraffe

This painting started out as a fairly literal translation of a photograph I took on my last African trip. I loved the arrangement of trees, the pervading sense of peace. When I started painting, I began removing the extraneous stuff such as fallen branches which broke the sweep of the branch masses, a small tree or two that didn't help the pattern but merely confused. It is one of my infrequent efforts in which the animal elements are essentially a part of the overall pattern, but not a dominating part. In this case, there is a second reason for this approach. Giraffes are truly a part of the African landscape. They are a movable prop in the stage setting which is their habitat — a bright warm note in a field of green and grey.

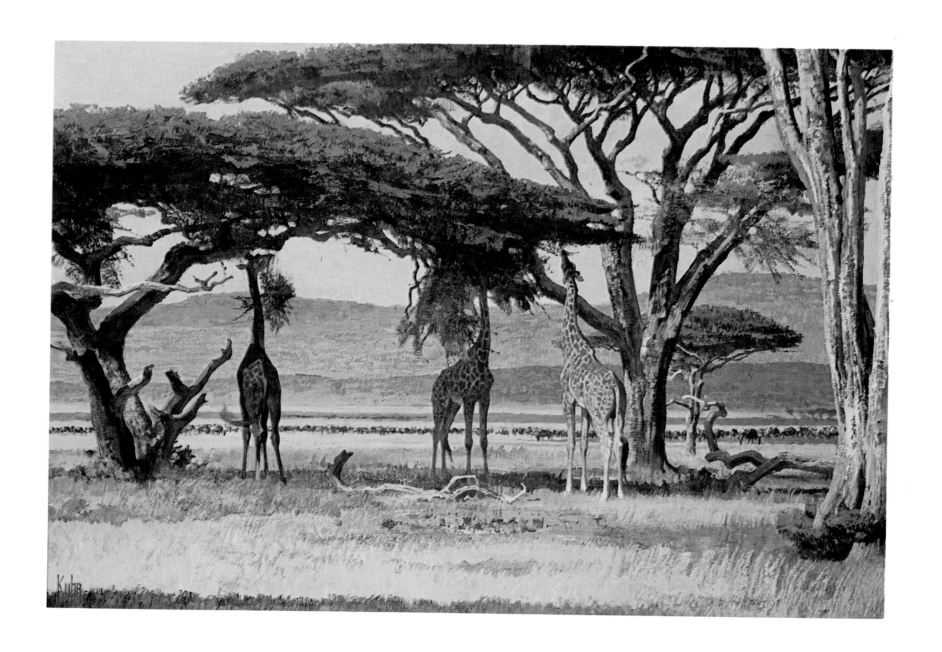

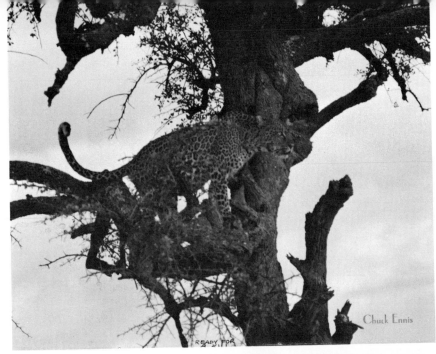

Make foliage more of a mass
Less shrubbery
Streamline cat's full belly
Simplify tree shape. Silhouette leopard's face
Add color

This vignetted leopard demonstrates the capacity of acrylic paint to masquerade as watercolor, if applied thin and wet. Actually, the device of creating a painting in which large areas of white paper are an important element in the pattern is commonly used by wildlife painters. John James Audubon exploited this approach as expertly as anyone ever has because he was a superb designer.

I have shown the photograph from which this painting was developed. It shows the very definite kinship of one to the other but also the changes that I made. As is always the case in such a translation, I have simplified the complex tree shape and also the superfluity of twigs and branches that the Almighty provides for us arrangers to edit and make manageable. There are two aspects of the real, as opposed to the re-created, that make this process of clarification necessary. One is motion, which is always eye catching in the real world and never available to the two dimensional scribbler. The other is the ability of the viewer of a three dimensional situation to move and thus change the relationship of things within his field of vision. The painter can offer no such options and thus must be more lucid. The leopard in the photo is grossly fat with whatever he has just consumed. I have slimmed him down. Some areas of his form are barely seen. I have chosen to show more, both because I know what the curtain of leaves has hinted at and because I think the picture benefits by a better view of the animal.

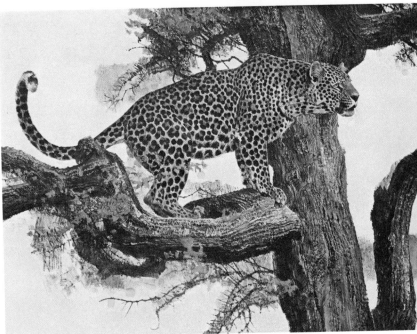

This is to reaffirm this observer's firm conviction that all photos must undergo a transformation in becoming the basis for a painting. If they don't, they needn't be painted at all. The photograph should be left unmolested to be judged on its own merits.

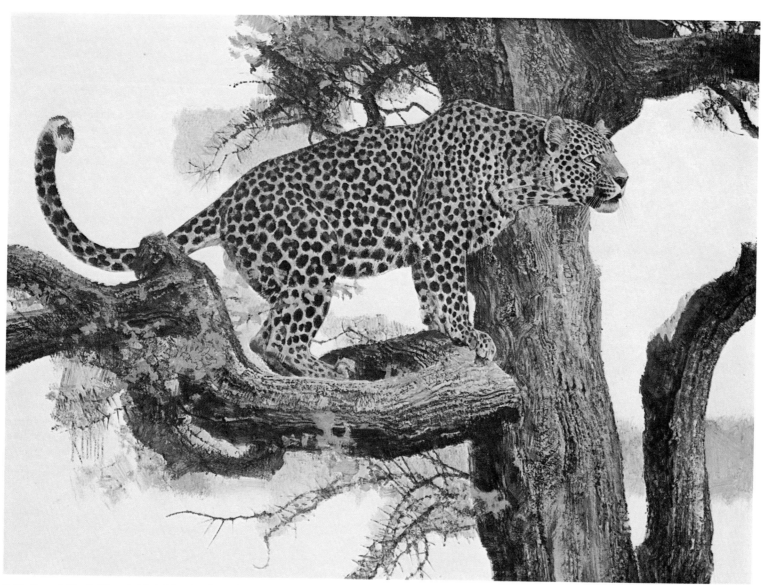

Collection of Mr. & Mrs. A. F. Sulak, Seattle, Washington

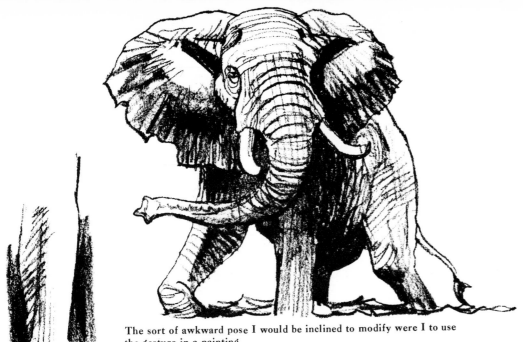

The sort of awkward pose I would be inclined to modify were I to use the gesture in a painting.

Contrary to some artists' efforts, the sturdy leg of an elephant has a distinct albeit subtle shape.

The most moving evidence of the elephant's highly developed social sense occurs in the occasionally described efforts of Askari bulls to prop up a sick or wounded cohort, and walk him away from the source of danger.

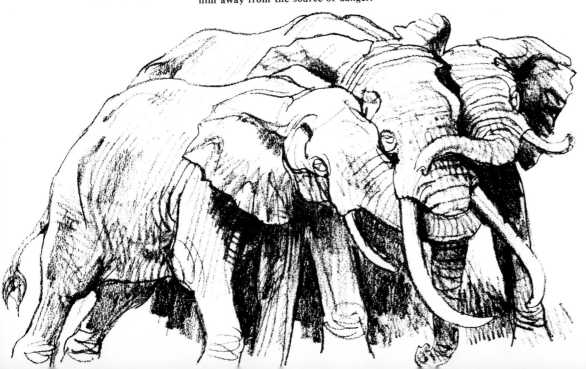

Elephants fascinate me but I don't think I've yet done them justice. The essence of these wonderful creatures is motion. That is why the painter's task is so formidable. To catch an instant that dramatizes the lumbering but graceful flow of movement takes a bit of doing. To add to the difficulty, the elephant is not a pretty creature and many aspects of its gait that go unnoticed as you watch one are downright silly as perceived in action-stopping photos. The three animals in this group are drawn from a number of my own shots and of course have been rearranged to the extent necessary to make their separate strides understandable and not mutually contradictory. One must frequently take liberties with the limbs of moving animals, in the name of clarity or aesthetics. I've tried here as in other groupings of elephants to convey the sense of solidarity among them that is such a key aspect of their character.

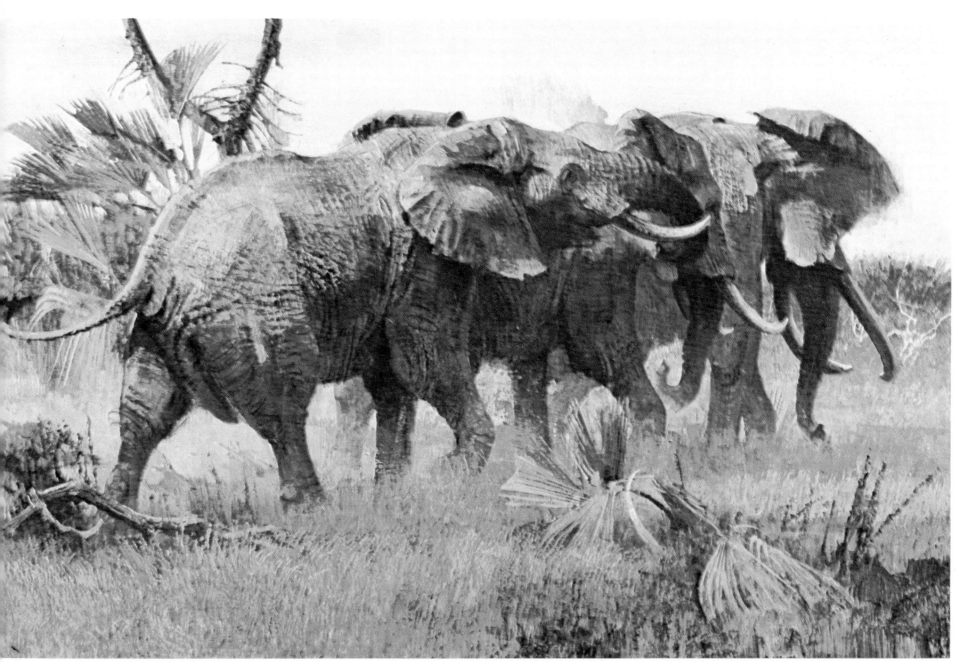

Collection of Pablo Deutz Jr., Mexico City, Mexico.

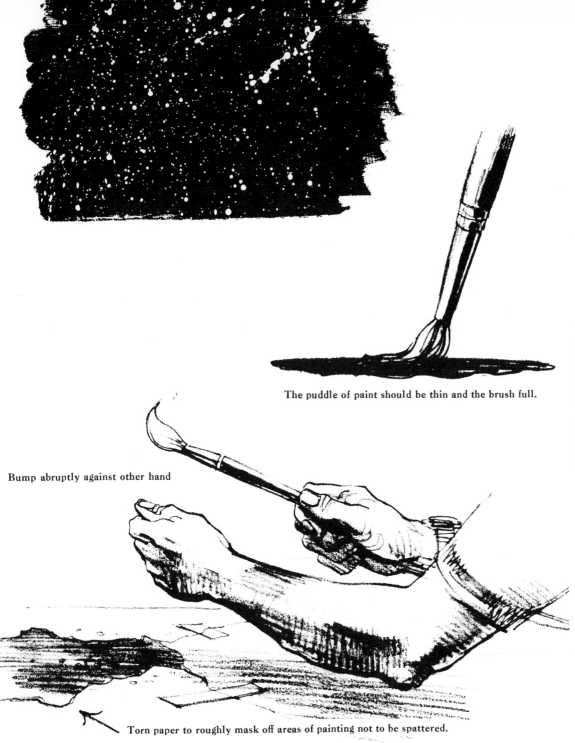

The puddle of paint should be thin and the brush full.

Bump abruptly against other hand

Torn paper to roughly mask off areas of painting not to be spattered.

Years ago I made a trip to Alaska during the early fall. It was the time of changing color and it was brilliant. I have occasionally dipped into my pool of background photographs taken on that expedition, as I did for the setting for my wandering bear. The grizzly is a true glamour animal, not only for his air of bouncy self-sufficiency, but because of the folklore that has evolved about him. The Indians, who have shared his home for thousands of years, regard him with a mixture of awe and fear. By putting him well back in the painting I have chosen to stress the relationship of the bear to his environment rather than produce a study of the animal. I have attempted the latter approach a time or two and stubbed my toe on the elusive but seductive effect of wind playing on the grizzly's lush pelt, as it might through a field of wheat. One reason for selecting this painting is to demonstrate the use of spatter technique. Nothing, I repeat, *nothing* will produce this kind of bright, staccato texture as does spattered paint. Without this device or trick, if you will, I wouldn't attempt this kind of landscape. It must be applied with control and removed when it doesn't work but, with a nod to Jackson Pollock, I say throw the paint and be glad.

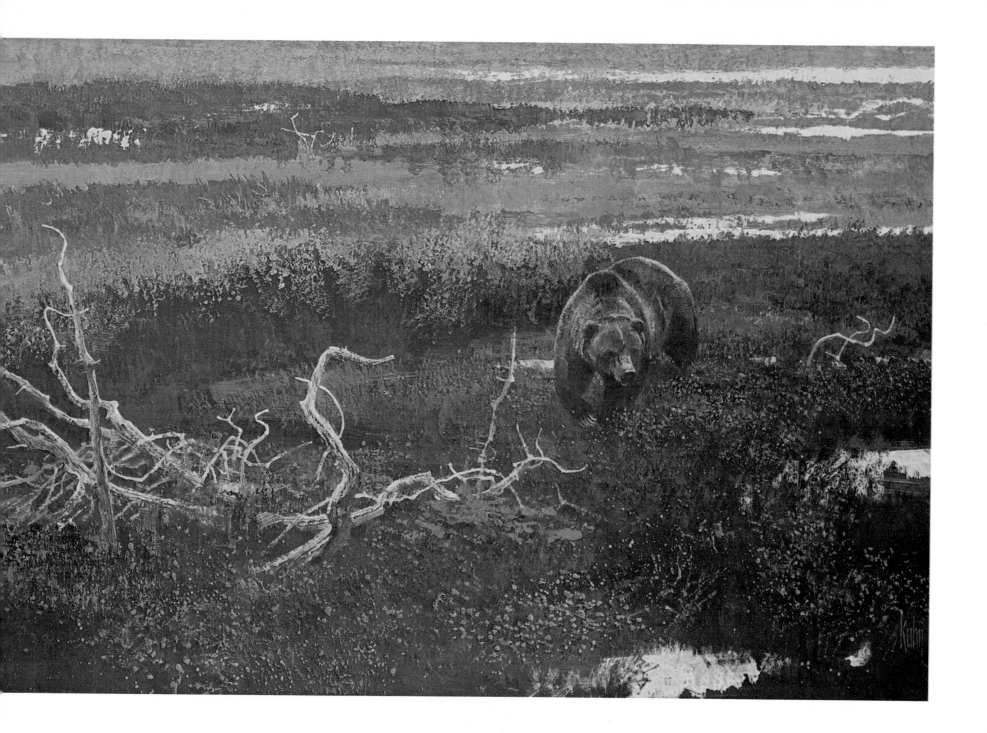

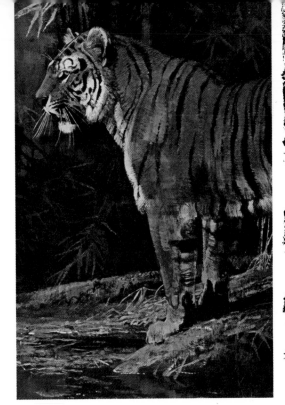
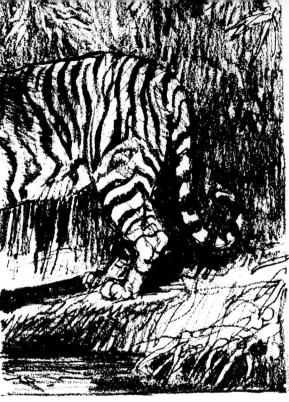

This projection of the vertical painting indicates how one might have conceived the portrait. I think the painting as done is more inventive and just as true to the nature of the animal.

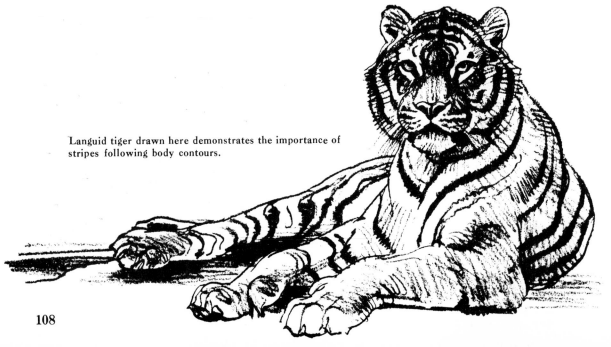

Languid tiger drawn here demonstrates the importance of stripes following body contours.

"Tiger, tiger, burning bright, in the forests of the night." Words that capture the essence of the animal. Your objective should be the same as Blake's — *get the essence*. I've painted a number of tigers over the years. None has more than hinted at the elegance of the subject. This one comes as close as any. I've never seen a wild tiger, but would venture the guess that it is simply more and better than its zoo counterpart. These big, lethal, beautiful cats range in color from dull yellow through bright orange to warm brown. The shade you pick should be one that best fits your color scheme, though to me it is just as sinful to opt for one of the blander hues as it is to paint a dirty Rocky Mountain goat because they sometimes get that way, instead of the clean, warm white they most typically are. In this painting I've pushed the color as far as I dared and I think it accentuates the special character of the tiger. As to the stripes, in spite of their random appearance, they follow a general pattern easily observable if one studies a number of animals. The same might be said about any spotted or striped species — infinite variety within a broad plan. Where the markings contrast strongly against the background color, one must take special pains to make them stay put and further, to fit them to the undulating form of the wearer. The narrow vertical format was perhaps arbitrary but I find this proportion interesting and it enables me to move right in to the business end of the tiger.

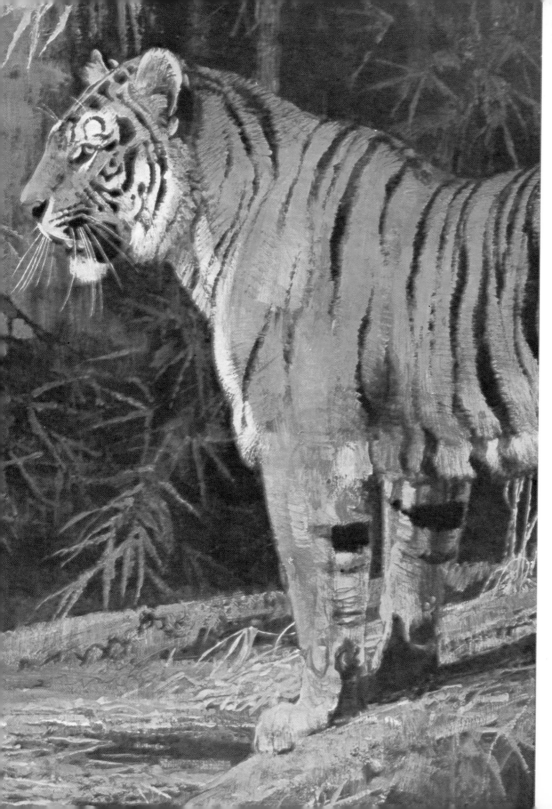

Courtesy of Edward G. Brittingham,
Nuevo Laredo, Mexico

There are obvious differences in the patterns of the three major spotted cats. The cheetah's coat is covered with rounded spots, loosely arranged in lines running diagonally across the body. The leopard's spots enclose a richly colored patch of fur. With the jaguar the spots are quite large and frequently contain, within the enclosed circle of the rosette one or more smaller dots of black. There are also differences in conformation, most noticeably between the cheetah and jaguar, with the leopard somewhere in the middle.

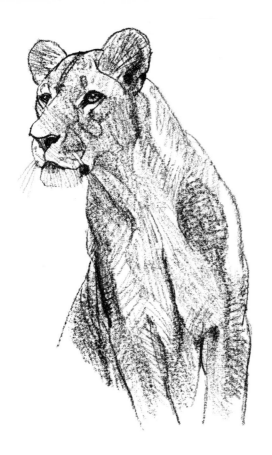

By keeping the shape of the hunter below the horizon, the illusion of its concealment from the zebras in the background is re-enforced.

The lioness stalking zebras is a favorite of my friends who have lived and hunted in Africa. The painting was built around a photo I borrowed from George Schaller. I thought the gesture was very dramatic and I only changed the viewpoint a bit, to get more of a side view of the animal. Other than that key element, the picture is pure fantasy. The hot sky, the twisted tree shapes, the nervous zebras all serve to heighten the sense of excitement which is so evident in the taut, hunting cat. One final thought — there are bits of the lioness that are not articulated, notably the raised hind leg. This is principally because it looked awkward as originally painted and better suggested the flow of motion when the particulars of the foot were lost. My late friend, Donald Kennicott, who edited BLUE BOOK for many years volunteered a quote at lunch one day that bears repeating, "To suggest is to create, to state is to destroy".

The poised hind leg of the stalking lioness seemed graceless and static as it appeared in photo. By losing the details of the foot, the sense of guiding motion was increased and the ugly shape removed. Lions (or any cats) watching or stalking game are totally attentive. They seem oblivious of everything save the thing their eyes are fixed on.

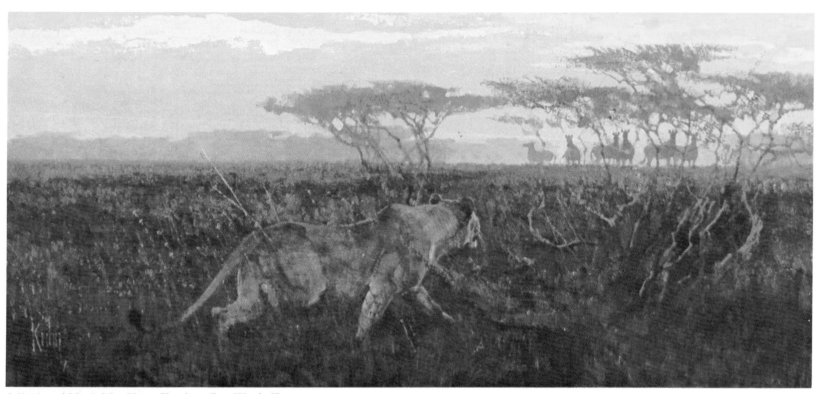

Collection of Mr. & Mrs. Harry Tennison, Fort Worth, Texas.

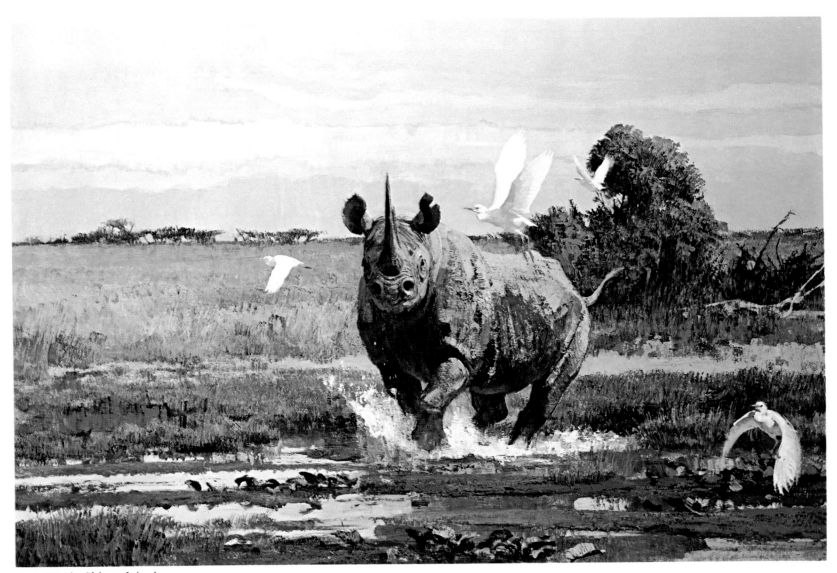

From *Classic African Animals*
Courtesy of Winchester Press

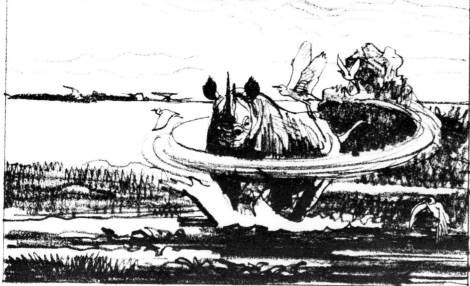

The herons in flight, framing in a roughly circular shape the charging rhino, lend something of the effect of the vortex of a cyclone, to the violent progress of the animal. (Both of these natural phenomena are to be avoided when possible.)

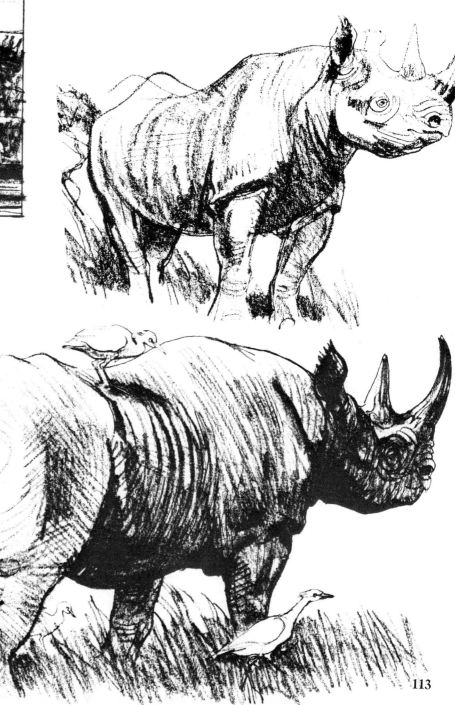

The rhino painting opposite is one of six to be reproduced in a book about African big game. In this sort of a parley, I try to include paintings of animals in action and others depicting impending action or none. The pristine egrets make an interesting contrast to the mud splotched, blundering rhino. This use of birds is typical of other paintings where a flurry of motion abets and heightens the violent movement of the central element. In assembling material for the painting, I found the setting I wanted in a photo of an elephant drinking. Since it served my purpose better than any of my own rhino backgrounds, I took the liberty of moving out Tembo and substituting his truculent neighbor. There was an excellent opportunity in this painting to arrange the color and form of the lily pads, grass, mud and water in the foreground to form a rich and interesting base for the ground shaking action of the middle distance and the high key backdrop of the sky.

The same herons who share the agitation of the host rhino in the painting are the beneficiaries of its heavy footed progress through the grass. Any insects thus disturbed are snapped up by the birds. Such a relationship is called symbiotic since both parties benefit by it.

113

The Importance of Setting

Each painter uses background material to suit himself. Some are really landscape painters who enliven the picture with an element of wildlife. Others fill the painting with the subject animal and pay little or no attention to the surroundings. It's a matter of preference.

It is important, however, to use landscape material intelligently if you use it at all. It's no good to excuse a poor background in an animal painting by stating that you are not a landscape painter. If you include background or foreground motifs drawn from nature they ought to belong with the animal subject and contribute to the interest and excitement of the painting. It is always you who establishes the terms of your effort. Once established, the burden is on you to produce something that deserves to survive. If the result of your decisions as to subject, treatment, etc. is a resounding ho hum from those who view it, then you can assume that either you started with a poor concept, executed a reasonable concept badly, or both.

I am not a compulsive outdoor painter. To me it is the hardest kind of work. But, I do make small tempera sketches on my field trips and I consider them well worth doing. As with the endless sketching animals from life, it plants a feeling of confidence within you and enables you to make better use of the background photos you will be accumulating at every opportunity.

The sketches reproduced on these pages have been done in one sitting, usually of three or four hours duration. I carry a box of Winsor and Newton's Designer's Colours with me on extensive field trips (by that I mean a sketching kit, with paint, brushes, pencils, plastic sponge and container for water). I don't use a stool or an umbrella though I would be glad to if someone would come along with me and lug the extra accouterments which make field work more comfortable. I just plunk myself down on a log or a clump of grass and have at it. In preserves I stay in the car and do the best I can.

To even a greater degree than with animal subject matter, the abstract factor in any landscape included in your picture can be the real determinant of the painting's success or failure. Aside from the animal's position, which can be aesthetically pleasing or otherwise, one is fairly well locked into the limits imposed by the form of the creature being portrayed. Not so with the surroundings. The variety offered by tree, grass, rock forms is such that there is no justification for boring or poorly designed areas in a painting, areas that do not abet the central element of the picture. This is true whether the background is a flat tone or complex arrangement of natural elements.

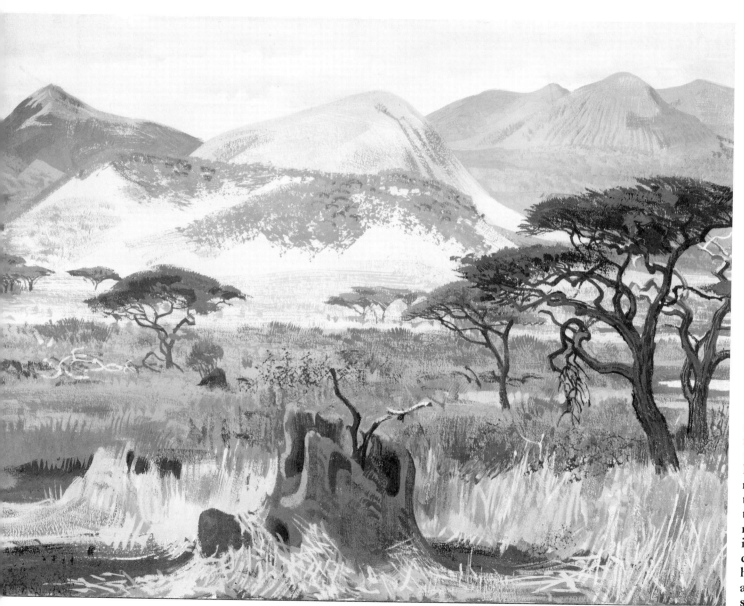

VISTAS

Vistas such as shown here usually contain so many elements that it is advisable to find some unifying device, be it a cloud shadow, a large band of forest or whatever. My principle motive in producing such little exercises is the very act of *doing* them. While I occasionally build a larger studio painting from a background sketch, most of the time they stand as pleasant reminders of places where I've sat and really looked at my surroundings. It makes the normal procedure of extracting the information I need from my huge store of transparencies no less necessary but somehow the photos are more readable and thus, more useful. If shadows move as I paint, I don't think it too important. It's the tone and color that interest me more than having a consistent light source apply to all elements in the sketch.

TREES

Trees of a kind have a character of their own. There are certain types that are prevalent and contribute to the special look of Africa. Most are thorny and flat topped. The convolutions of some of the acacias are so baroque and varied that I would much prefer to observe and edit real shapes, as one finds them in the field, than to attempt to create them entirely from my imagination. As with every other aspect of nature, there is such a limitless store of branch formations that you need only employ a little diligence and judgment to find the ones that will best serve your design needs. I make liberal use of both the sponge and soft Wolff pencil to add to the textural variety in the on-the-spot studies. With the sponge you can quickly suggest the nature of foliage or the scaly surface of some tree bark. With the pencil you can add accents with a crispness very difficult to duplicate with a brush. If you do use a pencil, it's a good idea to apply a little workable fixative which won't change the values but will serve to prevent smearing.

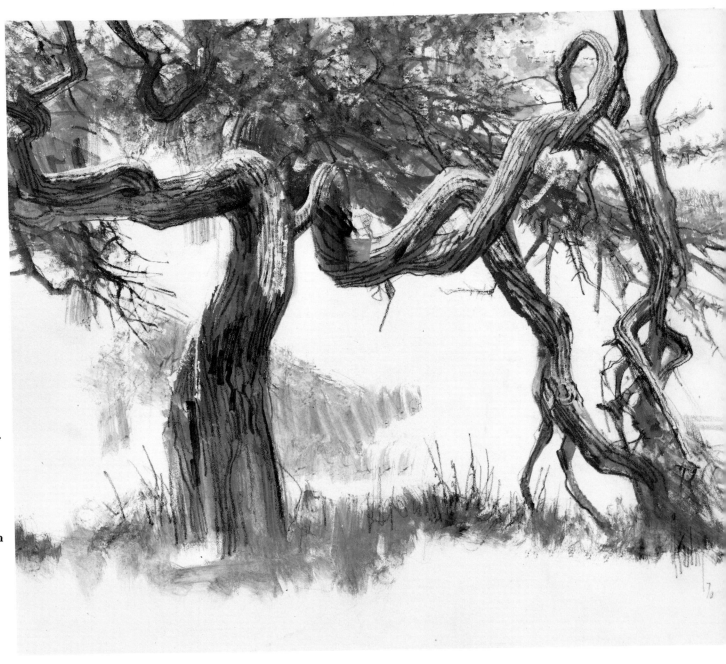

116

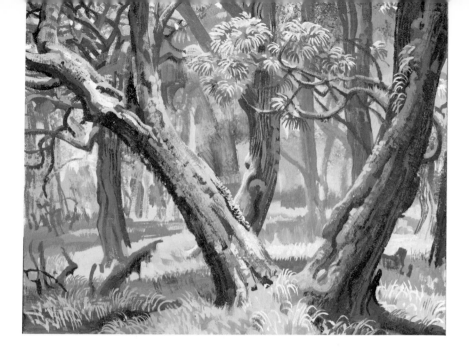

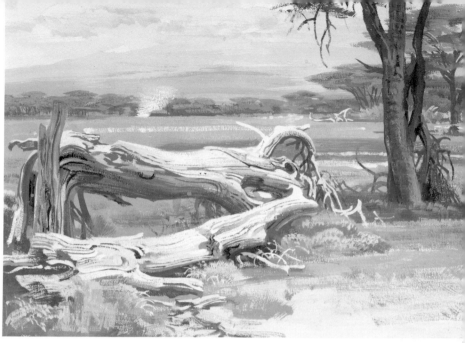

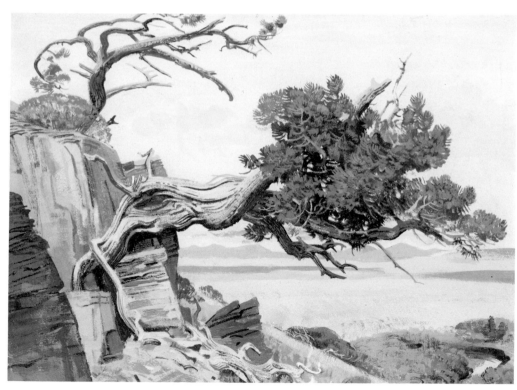

ROCKS

I suppose a geologist reads things
into rock forms and textures
that are unknown and un-needed
by the artist. It is very helpful
to me to paint the typical rocky
outcrops of Africa on the spot.
There is a very obvious three
dimensional aspect to them that
can be tricky if one is impro-
vising but quite manageable to
the painter-observer. The
numerous veins of color which
are part of the stone as well as
lichens and stains of one sort or
another all are subject to the
artful ministrations of the out-
door painter. Here too, the
textural tools — the sponge and
pencil, lend character to the
nubbly surface and sharp, broken
edges so characteristic of these
formations. The sketch of the
vertical boulders in this spread
would not be possible to do now.
It is the site of a hotel which
has been designed to nestle right
in among them in a fashion
pleasing to tourists and no doubt
to the architect, but not to one
who loved them as they were —
looking out across a game-filled
plain which has changed little in
a million years.

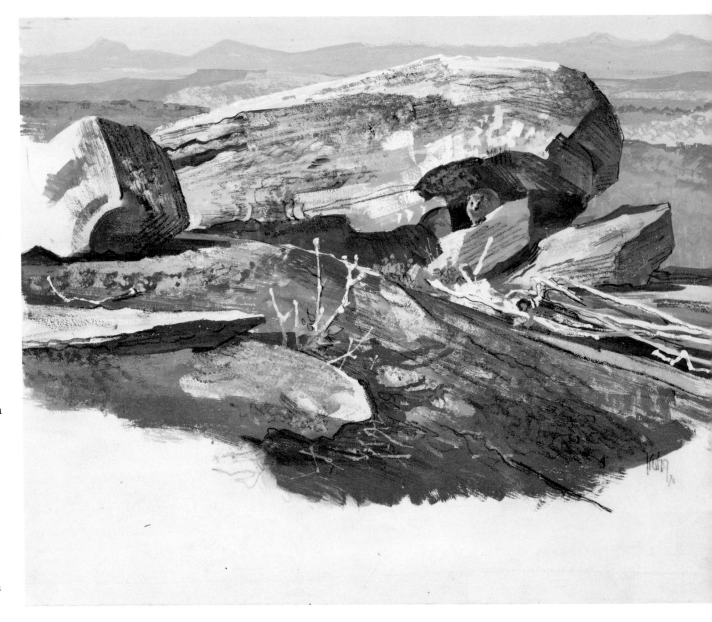

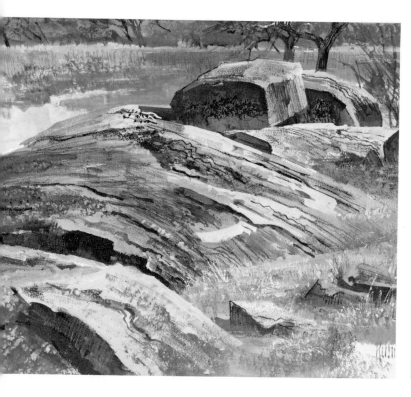

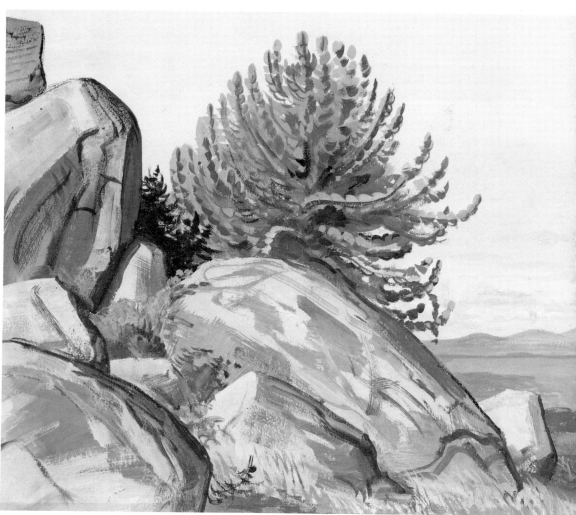

Though I consider on-the-spot sketching as a very important part of the process of developing painting skills, I don't often use a single study as literally as I have in this case. The pile of rocks, a Kopje (pronounced copy) as the Dutch call it, was located very near the old tourist headquarters at Seronera, Tanzania. It will never tempt another painter as a logical setting for resting lions. A new hotel has been constructed which envelops the Kopje and it is, at this writing, a resting place for little old ladies from Dubuque. When I first saw it, though, it projected unembellished from the surrounding tree dotted plains and fairly begged to be recorded as it had stood for eons, a haven for predators and a land-mark for migrating herds. Since the sketch provided all the facts I needed, I made few changes in the final painting other than adding the lions and repeating the upward thrust of the rocks with an upward thrust of clouds in the background.

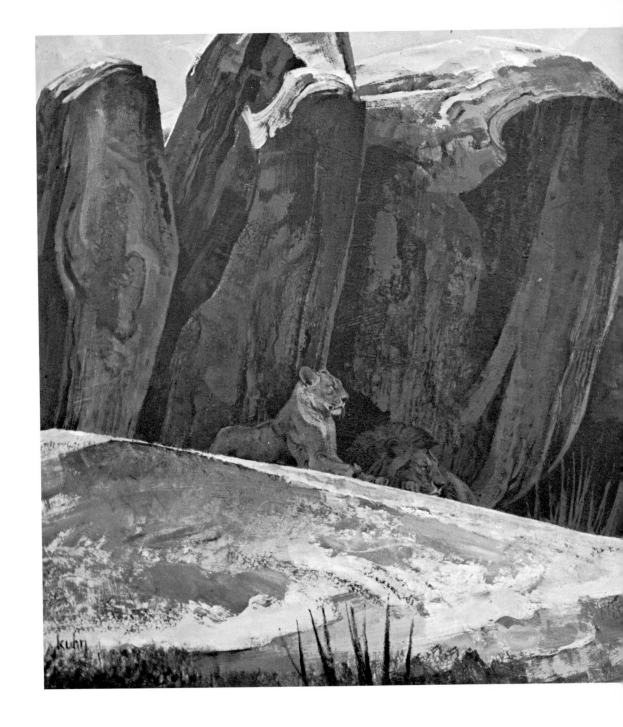

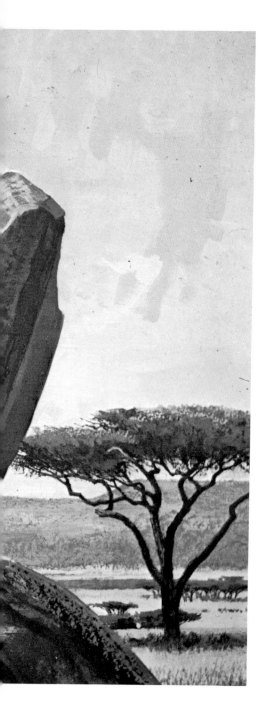

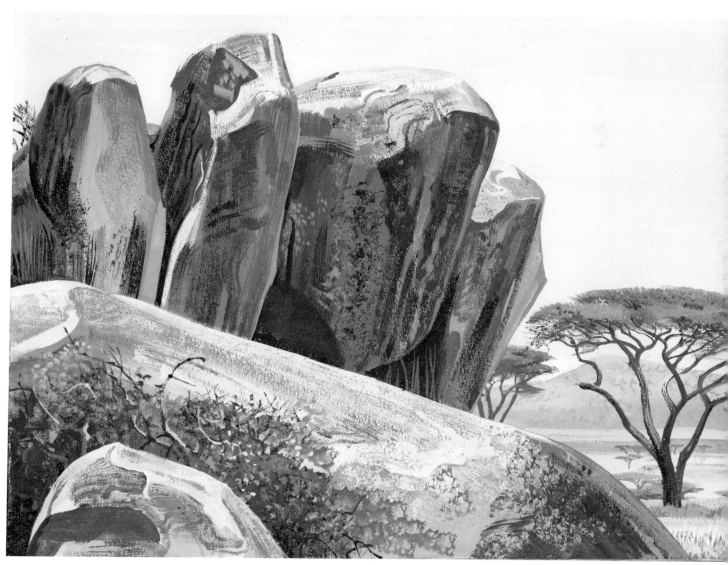

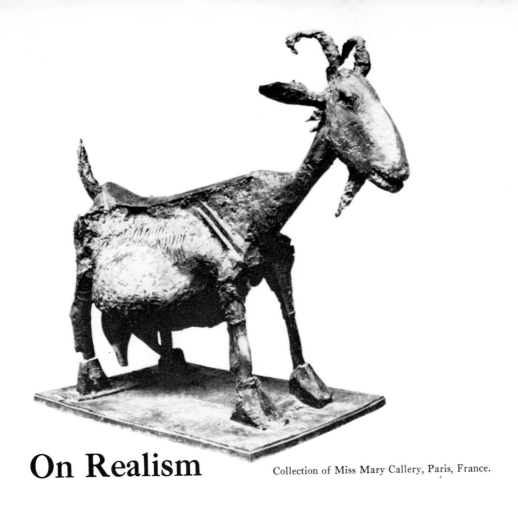

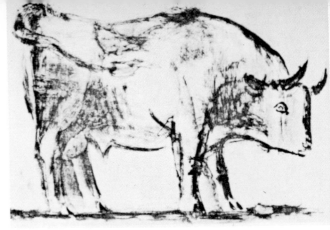

Picasso: She-Goat, 1950. Mrs. Simon Guggenheim Fund. The Museum of Modern Art, New York.

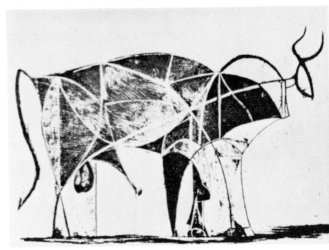

On Realism

Collection of Miss Mary Callery, Paris, France.

Realism is a dirty word in certain circles these days. To me it is one of many languages one may employ to express one's self. Since I am irrevocably a realist, I can only speak about that approach to painting. This is not to say that I am uninterested in other schools of painting. When you find yourself picking away at a picture, when you know you should be *attacking* the problem, a few moments spent leafing through pages of Pollock or Kline or some other bold spirit can lift your own spirit and with it the level of your performance.

Contrary to pretty widespread assumption, realism, at least good realism, is not the re-creation of the limitless details observable in any subject one chooses to paint. Good realism gives the illusion of actuality but reveals more by dint of intelligent editing. It becomes a kind of short hand. Any good Winslow Homer water color, any of dozens of the wonderfully controlled paintings of Edward Hopper give proof to the value of simplicity. There is never any doubt about who is running the show. The choice of subject, the choice of light, the choice of what in the subject will be revealed to you and what will be eliminated or muted; these are all in the hands of the artist. To the extent that he manipulates the thing he is painting so that his

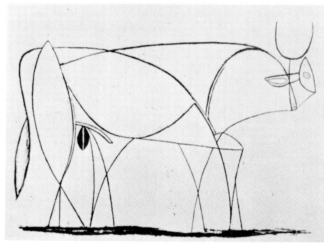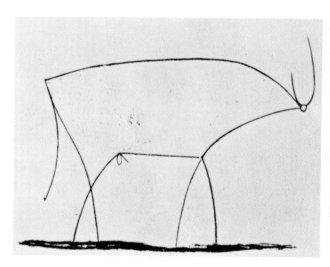

feelings about it can be seen in the result, he is functioning as an artist. If he merely puts down what he sees, in all its detail, it may be an impressive effort but it isn't art.

Perhaps the point can be made another way. If you wrote something in the vein of — "The lions we shot were soon skinned and the hides rolled up. The flayed carcasses showed clearly the source of the lion's strength," you would have made an accurate but pedestrian statement about an event. Now read this excerpt from "Out of Africa" by Isak Dinesen — "The dead lions, close by, looked magnificent in their nakedness, there was not a particle of superfluous fat on them, each muscle was a bold, controlled curve, they needed no cloak, they were, all through, what they ought to be." Here the ordinary has been made extraordinary.

Pablo Picasso, a twentieth century giant, had a sound early training in the fundamentals of drawing and painting. He was a strong realistic painter while still in his mid-teens. As he explored new directions for his great energy and talent, he spoke out against realism by decrying "the tyranny of the thing seen." The subject we paint is still a tyrant and only by asserting our independence, — our right to bend and stretch and soften elements of what we see can we give that which we paint new life and meaning.

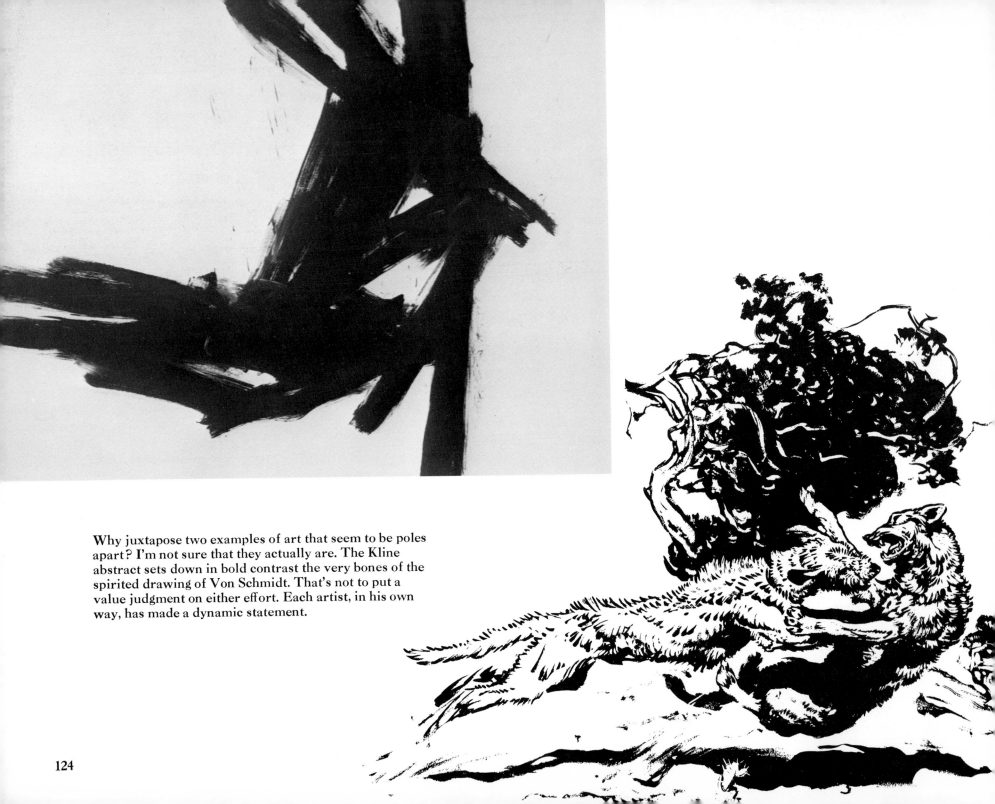

Why juxtapose two examples of art that seem to be poles apart? I'm not sure that they actually are. The Kline abstract sets down in bold contrast the very bones of the spirited drawing of Von Schmidt. That's not to put a value judgment on either effort. Each artist, in his own way, has made a dynamic statement.

Edward Hopper: Cape Cod Evening, 1939.
Collection of the Honorable and Mrs. John Hay Whitney.

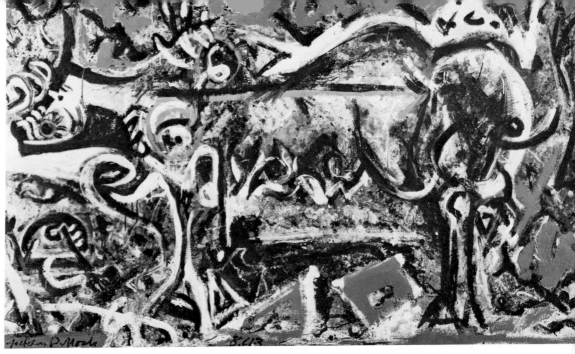

Jackson Pollock: The She-Wolf, 1943.
The Museum of Modern Art, New York.

"ART"

Those who have pressed on to this point in the book will perhaps wonder at the absence of the jargon of critics and art theorists. It is missing from the text because mine is a largely intuitive response to the animal world that has always filled me with awe. What I have written does not grow out of a feeling of accomplishment but out of the hope that some fellow artists or craftsmen or those who aspire to increase their knowledge about this very special area of expression, might find my particular quest interesting.

I take a very broad view of the term "art." I think you can wield a paintbrush for a lifetime without producing an artful thing. On the other hand, you can build a wall or sing a song or decorate a room or take a photograph, any of these things and more, and if you function in a highly personal way which strikes a chord in others and reveals truth in a new way, you will be producing art.

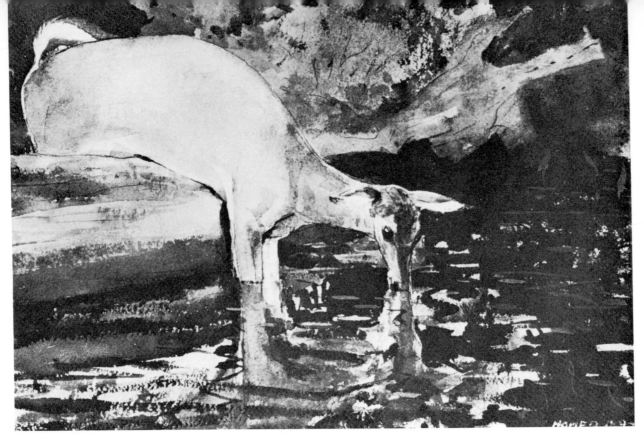

Winslow Homer: Deer Drinking, 1892. Collection of Mr. & Mrs. Courtlandt P. Dixon.

Along with the animal painters and illustrators mentioned in the preamble, all of whom shaped my development in one way or another, there is one additional artist I wish to mention. He spent a long and lonely life painting the moods of nature in a sometimes dour, sometimes lighter than air way. This man, Winslow Homer, was like some wine; he improved with age. From a fairly routine early career as an illustrator, he turned to easel painting which grew in simplicity and sureness all his life. He serves as a profound example of the value and worthiness of plowing one's own furrow. Lloyd Goodrich, author of an important biography of Homer puts it this way; "He was an eye more than an artistic intelligence. He loved the most solitary aspects of nature, sea, forest and mountains and the hardy men who inhabited them. He painted certain elemental things that had never before been painted with the same power and utter authenticity." Though the pursuit of a career as a nature painter is not as lonely as it used to be, it is still a special calling that one must pursue with a singleness of purpose and a love of the subject. Your diligence will pay off with increasing skill and better pictures. Your love may turn craft into art.

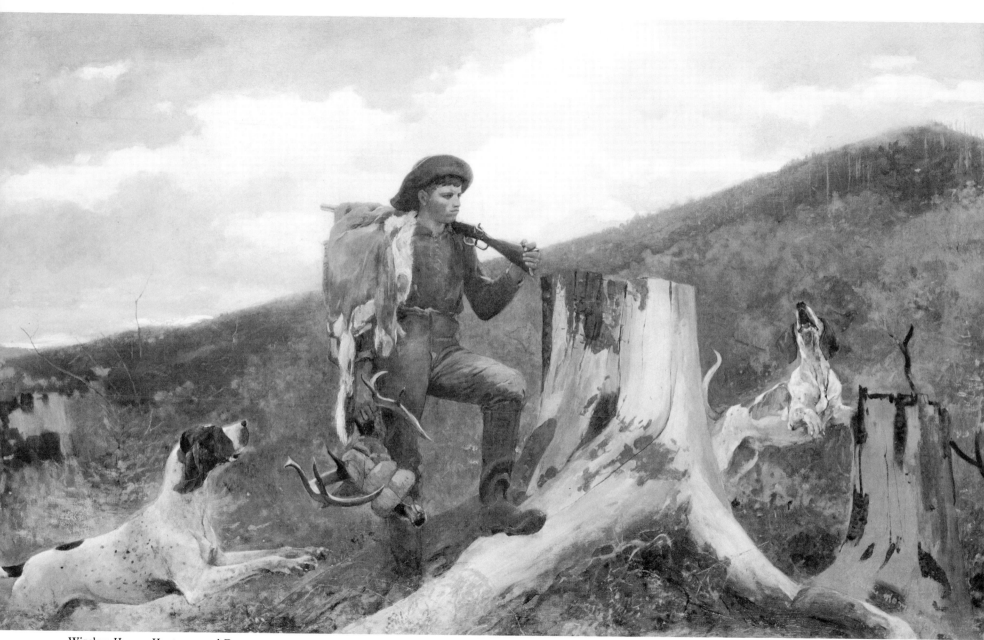

Winslow Homer: Huntsman and Dogs.
Philadelphia Museum of Art.
The William L. Elkins Collection

Hunting...and one's conscience

For many people, the idea that one who purports to love animals and makes his livelihood painting them can also kill them is incomprehensible. It is a paradox to be sure but not as completely absurd as it seems. First of all, the impulse to hunt is deep in the bones of all of us. We have been primate predators for hundreds of thousands of years. Only within the last fifty or seventy five years have the unrestricted pressure of man's increasing numbers on wild herds and flocks begun to be understood and to be acted upon.

My own involvement in hunting began when I entered the art market as a young man and found that the so-called outdoor magazines were the logical ones to approach. As I became involved professionally I found that opportunities to go into the field were a by-product of the business and I took advantage of them. When one is involved in the overall objectives of a big game hunt it is an easy step to being a participant and for many years I was. I felt at the time that it gave my outdoor illustrations an aura of authenticity that they would not otherwise have had. In addition to that, the hides and horns I was accumulating were in constant use as sources of information in my pictures. In recent years my shooting has been limited to a few pheasants, grouse and ducks for the pot. I truly see no great distinction between eating a fowl whose neck has been rung by someone else and a fowl you have brought in from the field yourself. But there is really more to it than that. There's a strange human trait of wanting to possess that which you love and many professional hunters of my acquaintance can be truly said to love the wilderness and its wild life. There is something strongly sensual about a great curling pair of horns, perhaps once worn by a kudu or a Marco Polo sheep, and there is something in many men that makes them want to possess them. Partly this is because they are beautiful and partly it's that they are to some a symbol of manliness, as well as a reminder of a soul healing sojourn in the wild.

Having said that let me add this. Some of the most elegant and sought after of the world's game animals are in serious trouble. None of these aforementioned observations attempting to justify or at least explain hunting have an ounce of validity as regards any of the many species of animals and birds whose numbers have been reduced to the point where their survival is in question. And I might add that many of those who take a gun into the wild country are in the forefront of the forces working to save them. The great enemy of all wild life is human numbers. Unless we solve that problem, all discussions relating to the moral acceptability of killing animals are fairly silly.

Though they lived and worked in a simpler time, many of the great painters of wild life were inveterate hunters. Audubon, Liljefors and Carl Rungius, among others, saw nothing inconsistent in wielding a life imbuing brush on the one hand and a death dealing weapon on the other. It might be said that they could not have created their beautifully seen and understood studies in fur and feathers without the close study of their subjects that their hunting prowess made possible. I cite this as a matter of history. Whether the practice was justified then or is now is something one must judge for himself.